MASTERS of
SCIENCE FICTION
and FANTASY ART

First published in the United States of America by
Rockport Publishers, a member of Quayside Publishing Group
100 Cummings Center, Suite 406-L, Beverly, Massachusetts 01915-6101
Telephone: (978) 282-9590
Fax: (978) 283-2742
www.rockpub.com

Library of Congress Cataloging-in-Publication Data is available

ISBN-13: 978-1-59253-675-7
ISBN-10: 1-59253-675-1

10 9 8 7 6 5 4 3 2 1

Design: John Foster, Bad People Good Things LLC
www.badpeoplegoodthings.com
Cover Image: John Picacio

Printed in China

MASTERS of
SCIENCE FICTION
and FANTASY ART

BEVERLY MASSACHUSETTS

ROCKPORT PUBLISHERS

A COLLECTION OF THE MOST INSPIRING SCIENCE FICTION, FANTASY,
AND GAMING ILLUSTRATORS IN THE WORLD

by Karen Haber

Foreword by Joe Haldeman,
author of *The Forever War*

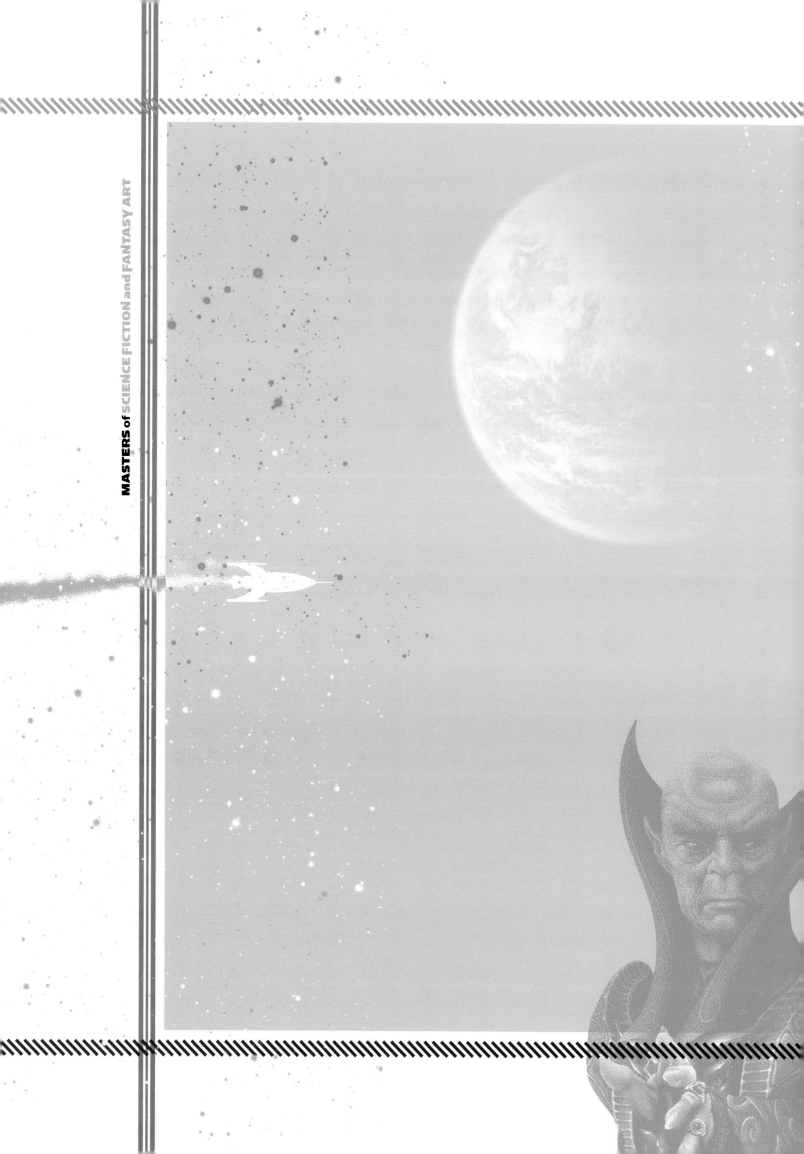

CONTENTS

6 FOREWORD BY JOE HALDEMAN

8 INTRODUCTION

COMBINED TRADITIONAL AND DIGITAL TOOLS

12 Jim Burns
20 Shaun Tan
28 Dave Seeley
36 Avi Katz
42 John Picacio
50 Pavel Mikhailenko
56 Ken Wong
62 Brom
70 Greg Spalenka
78 Bruce Jensen
84 Scott M. Fischer
90 Todd Lockwood

DIGITAL TOOLS AND TECHNIQUES

100 Stephan Martiniere
106 Tomasz Maronski
114 Camille Kuo
122 Galan Pang
128 Marta Dahlig

TRADITIONAL TOOLS AND TECHNIQUES

134 James Gurney
142 Kinuko Y. Craft
150 Charles Vess
158 Donato Giancola
166 Rebecca Guay
174 Dan Dos Santos
182 Petar Meseldzija
188 Terese Nielsen
196 Bob Eggleton
204 Don Maitz
212 Gregory Manchess

222 DIRECTORY OF CONTRIBUTORS
223 ACKNOWLEDGMENTS
224 ABOUT THE AUTHOR

FOREWORD

JOE HALDEMAN

For some people this could be a very dangerous book. If I had read it at the age of twelve, I might have put aside my fledgling writer's typing machine and picked up a brush—and embarked upon a life marked with very different hazards and rewards.

The life stories here are that interesting. The worlds to which they provide entry could be that alluring.

Karen Haber asked me to write this introduction because we share a love of art, and she knows that I'm a compulsive dabbler in it. My wife and I have traveled all over the world with Karen and her husband Robert Silverberg, and she knows that for decades I've kept a travel diary of watercolor sketches.

I've never been a serious artist, in the sense of knuckling down to spend the necessary years of study and practice. But I do carry a notebook and watercolor spitbox wherever I go, and every Saturday I bike down to a studio to spend the morning with brush in hand, staring at a nude woman, supposedly in the service of art. So my interest in art may be less than professional, but it's more than casual.

At this writing, the book itself does not exist, of course; I only have the draft manuscript of the interviews and URLs I can type in to see the artists' various homepages and galleries. So while I was reading the manuscript, I felt like I was listening in on something marvelous that was transpiring in the next room—but it will be another year before I get a peek over the transom, to see what was really going on!

For instance, when Scott Fischer says, "I'll often use nothing but the polygon lasso tool, and brightness and contrast to build up the planar shapes of a painting . . . I have whole folders with nothing but scanned traditional brush marks that I will lay on top of a piece, playing with opacity, overlay, dodge and burn, then erasing out areas where I don't like the effect," there's a whole nutshell lesson in how to use a computer to make a picture. But without actual pictures to illustrate the process, my visual imagination can't finish the job.

Computers and other high-tech tools do figure strongly in all of these stories, of course. None of these artists goes through the time-consuming and nerve-wracking rigmarole that was the life cycle

of science fiction artists when I started writing, in the precomputer days. They would pick up manuscripts at the editorial offices in New York and then drive or take a train back to where they lived (not many could afford to live in the city, or wanted to), and draw and paint in relative solitude. Then they carried the still-drying artwork back to the editor in time for an unreasonable deadline. They waited for judgment, and then either returned with changes or, if successful, picked up another armload of manuscripts and headed back to the studio.

Most artists now, and even most school kids, have computers and scanners that make all that tension and drama obsolete. Manuscripts and illustrations go back and forth at the speed of light. It saves a lot of gasoline and shoe leather, not to mention stomach lining.

The actual creation, for all but a couple of hyper-modernists, still does involve the smell of paint and the scratch of pencil or pen, the accretion of marks that turns a white space into a miracle of line and color. Some might then just snap a picture and send a jpeg of it off to the editor, but almost everybody messes with the image a little first. It's hard to resist the seductive lure of photo-editing software—change the image all you want, one aspect at a time, because you can always change it back with the click of a button.

Maybe in some future that's all there will be: pictures created onscreen with stylus, fingertip, voice, and keyboard, and then wrestled into shape with photo-editing software. For most of these artists, though, it still starts with the sharp pencil, the charcoal stick, or the loaded brush. And for some of us on the side-lines, they're poised exactly where the excitement is: classical technique sharpened and heightened by technology that still seems futuristic.

—*Joe Haldeman*

Joe Haldeman is the internationally acclaimed author of numerous science fiction novels and winner of many Hugo, Nebula, and international awards. His Hugo- and Nebula-award winning novel *The Forever War* is currently being adapted for the big screen by Ridley Scott. Haldeman's most recent novels include *Starbound*, *Marsbound*, *The Accidental Time Machine*, and *Camouflage*. He received the Grand Master Award from the Science Fiction and Fantasy Writers of America in 2010. He enjoys painting when he's not writing, traveling, playing guitar, or observing the heavens through his telescope. His daily diary can be found online at sff.net and his website is http://home.earthlink.net/~haldeman/.

INTRODUCTION

Science fiction and fantasy artists face a daunting task: to depict the unknown, the unreal, and the impossible, and make it believable, compelling, and beautiful. They are asked to envision imaginary places, populating them with strange, wonderful beings, and they must do it all on a deadline. That's a tough job.

The digital revolution has brought science fiction imagery into the mainstream and thus to a wider audience. What was once seen as magical and improbable is now commonplace. Modern technological advances have raised the bar for artists, making it that much harder for them to invent fresh science fictional images. The job must have been easier in decades past when great artists such as Frank R. Paul and Chesley Bonestell had far less competition from reality. Luckily, artists come equipped with that most powerful of tools, imagination. In an age of technological miracles, they need it more than ever.

This is an exhilarating and challenging time in science fiction and fantasy art for both artists and art lovers. Computers have put exciting new tools into artists' hands while creating a more competitive environment in which to make a living. Previously reliable art markets, such as publishing, are struggling to change with the times, while other markets, such as film and gaming, are exploding with new opportunities for artists. Armies of computer graphics (CG) artists are employed to bring fantastic visions to life for each blockbuster, television show, or game release. And yet in the midst of this tumult, young artists clamor for instruction in traditional art techniques. Which tools they select and how they use them are the choices of each artist. Some rely on hand skills while others employ only digital tools, and still others swear by varied combinations of each.

Thanks to the Internet, there's also been an explosion in the number of artists creating science fiction and fantasy art around the world. The communication between them—especially between beginning artists and their more experienced, savvier colleagues—has never been more dynamic and exciting. Websites and blogs devoted to teaching technique and promoting discussion are abundant. Video tutorials are available at the click of a mouse, while in the nonvirtual world artists gather for workshops where maestros can be observed in process and later questioned by novices. It's an exciting time to embark upon a career in science fiction and fantasy art.

Here is a look at twenty-eight of the most creative science fiction and fantasy artists working today, with examples in pencil, paint, and digital media. The artists in this book are both masters and rising stars in the many-faceted realms of science fiction and fantasy art. They range from dedicated devotees of brushwork to artists on the cutting edge of technological change working in 3D effects for movies and gaming. Each artist describes his or her professional journey and provides a mini-workshop on techniques, such as concept development, use of digital tools, and traditional brushwork.

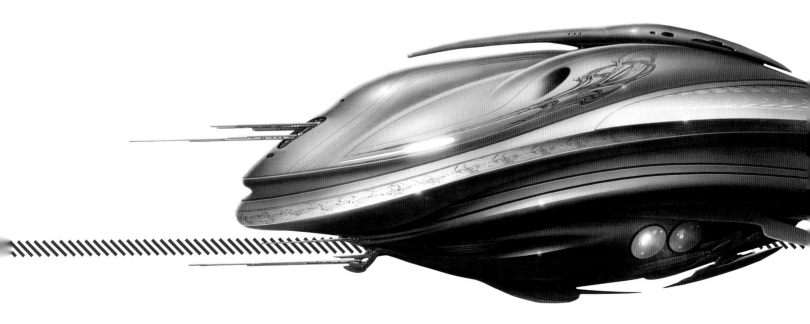

COMBINED TRADITIONAL and DIGITAL TOOLS

JIM BURNS

"I like to think that one medium feeds the other. Although I'm a big fan of Photoshop, I don't think I'll ever completely abandon traditional painting for a purely digital easel."

Martian Romance. Photoshop.

There are no hard angles to a painting by Jim Burns. Everything—and everyone—looks sleek, sexy, slippery, and built for speed. One of the best-known science fiction artists in the United Kingdom, Burns is also a star in the United States. His book covers for major publishers and magazines have garnered many awards, including two Hugos, and inspired a generation of artists.

A paradox of Burns's work is his ability to handle delicate detail that is balanced against massive mechanical power.

"I have a certain passion for depicting machinery," says the acclaimed artist, "and projecting it forward. The look of the machine changes with time. It's a curious evolution and one I find fascinating. I'm drawn toward curves rather than angularity, but I must admit that I prefer the word *organic* to *sexy*."

The Temporal Void. Acrylics on primed gessoed fiberboard. Powerful machinery balanced by delicate handling of details and vivid color are hallmarks of the "Burns Look."

Burns learned traditional painting skills at Newport College of Art in South Wales and St. Martin's School of Art in London, and spent the early years of his career alternating between brushwork and airbrush. When Photoshop made its debut in the 1990s, he embraced it.

Strafer. Photoshop. Taking a photograph of the soil in his garden for background, Burns then uses Motion Blur in Photoshop to provide a sense of speed, scans in a pencil sketch of a spacecraft, and clones it for the second craft in the image. He paints in the wrecked enemy craft and sets it ablaze with cloned images of an oil rig fire.

EMBRACING THE NEW AND OLD

"I don't think traditional painting will ever disappear. Certainly it won't in my studio," Burns says. "But I think one must regard the computer as a marvelous tool. Photoshop has distinct parallels to the painting process. It's so flexible. At times I find it easier to conjure up what I see in my mind's eye on the computer than in paint. It's brilliant, amazingly editable, and I enjoy using it to build up an image. That said, one of the perils of working in Photoshop are the pre-set effects—in particular, filters—which are very seductive, but whose overuse ultimately results in the boring predictability of computer art. In the past I've worked to distress what I see as the over-perfect computer rendering. What Photoshop really needs are some grime filters!"

Burns's deep involvement with the work begins with the manuscript. "As I read I tend to check and double-check items as I go along, noting scenes and descriptions that have obvious potential. At the end I have a filmic, very visual image of the book. I try to freeze-frame elements and then work up a sketch from appropriate incidents.

"Generally speaking, my initial 'marks' for a given project are done in pencil on a sketch pad—very rough and ready—then scanned. In Photoshop I play around with bits of color and texture, found or photographed objects and surfaces, adding them to the sketch. When I'm happy with the result, I transfer it back to the canvas and the business of painting can commence," Burns says.

"Sometimes it happens a little differently: a more finished sketch stage can be transferred to Photoshop and then further refinement and coloration can take place digitally, right up to the finish. A piece that I recently completed in this way is the cover for Ricardo Pinto's novel *The Third God*."

"I spent many years working on a variety of flat boards, such as illustration, line, or fashion plate board and gessoed accordingly. I then painted with an airbrush—the heavy artillery of many a science fiction artist's arsenal. After that I picked up Photoshop, and enjoyed that immensely. I like to think that one medium feeds another. And although I'm a big fan of Photoshop, I'll never go completely digital. I like to have that finished product to hang on the wall."

SHIFT TO CANVAS

In the past, Burns admits that canvas made him nervous and he avoided it. "It was the tried-and-tested choice of artists for some centuries, but it was a thing which I'd rather foolishly developed an irrational fear of. I mistakenly

believed that canvas required a process that was too sophisticated for the kind of demands made on me by the commercial milieu I'd found myself in for nearly four decades. How wrong I was! I'm now working on stretched canvas in the good old-fashioned way and enjoying it hugely," he says.

Photoshop is now mostly reserved for use in mid-process, to revise pencil and paint studies before Burns transfers the work to stretched canvas and acrylics. "This is a new direction for me. I make greater use of larger, rougher hog's-hair-style brushes without any sacrifice of detail."

"I'm still working in acrylics, though the very latest products have become even more oil-like in their characteristics," he explains. "And, of course, I still use the Mac. It's admirably suited to the early process of image composition and rough stages, but no longer an end in itself."

He continues, "I find it impossible to see the advent of digital tools as either a wholly good thing or a bad thing. It's simply a new thing and it's a question of whether an artist wants to employ the new thing or not. As for this artist, I certainly don't intend to limit myself when it comes to choice of tools. Right now I prefer working on canvas, I'm enjoying something quite new for me: large, crude brushes loaded with paint. Neither the Mac nor the airbrush were 'sensual' tools. A brushful of buttery olive green or alizarin crimson most certainly is."

Pod Shift. Acrylics on canvas board. Burns pushes strong contrasts rather than hue in this image of a pilot in space. After creating a preliminary sketch, he scans it into Photoshop and works up detail, then transfers it to canvas. Painting in acrylics, he concentrates on shape and mass, light and shadow. When he's satisifed with the contrast and portrait he goes back into the image with a large hog's-hair brush loaded with paint to highlight details such as the pilot's hair and the creases in her seat.

Sorcerers of Majipoor (above). Acrylics, on primed gessoed fiberboard. *The Dryad of the Oaks* (below). Acrylics, on primed gessoed fiberboard.

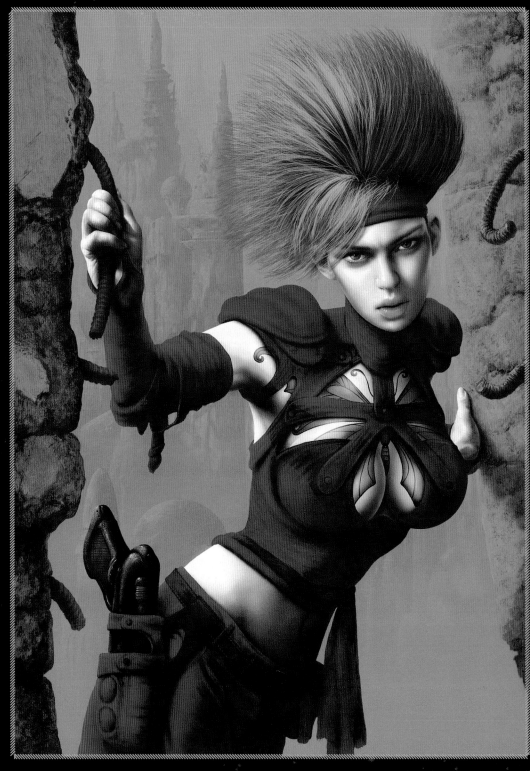

Threlxepia's Little Sister. Photoshop. Cover illustration for *Heavy Metal* magazine.

THRELXEPIA'S DEVELOPMENT SEQUENCE (digital): ❶ The first pencil sketch; ❷ After the sketch is scanned, the first digital color is added; ❸ Next, background color and texture are laid in digitally.

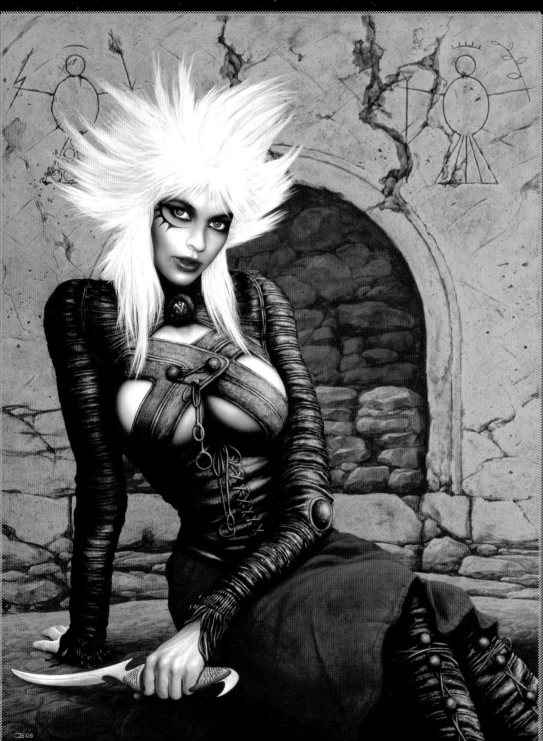

Sirpa of the Guild of Vammatar.
Acrylic on primed gessoed fiberboard.

**SIRPA DEVELOPMENT
SEQUENCE: ❶** This cover
illustration for *Heavy Metal*
magazine begins with
a pencil sketch. ❷ Burns
next scans the sketch and
colorizes it in Photoshop,
❸ and then refines the
approved sketch, ❹ adding
textural details to the wall
based on a photograph he
took in Greece and archaic
Finno-Ugric inscriptions.
Among his image reference
sources: his eldest daughter's
hand clutching a bread
knife, the Greek photos,
and highly modified found
facial references.

The Third God. Photoshop.

THE THIRD GOD DEVELOPMENT SEQUENCE (digital): ❶ *The Third God* early color. Burns develops this cover illustration in Photoshop beginning at the sketch stage as a full color digital piece to which details and changes are added by stages. ❷ *The Third God* sketch. He uses the painting tools in Photoshop, in particular the airbrush tool, and scans textures in, using photographed rhino hide for the skin of the beasts. A major element of the scanning stage is a halved pomegranate whose scanned image forms the entire background of the illustration. The artist uses the actual fruit for scans, which make a sticky mess of his scanner.

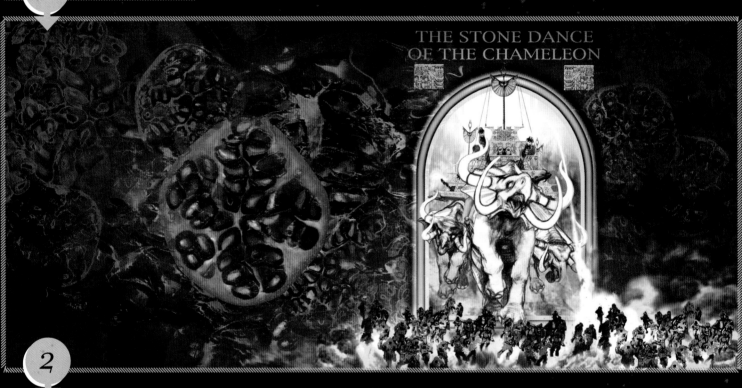

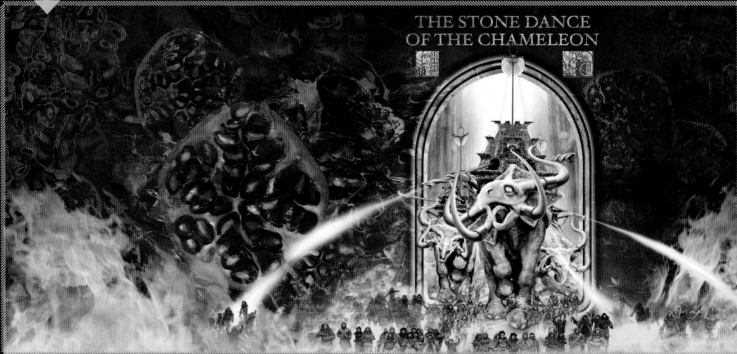

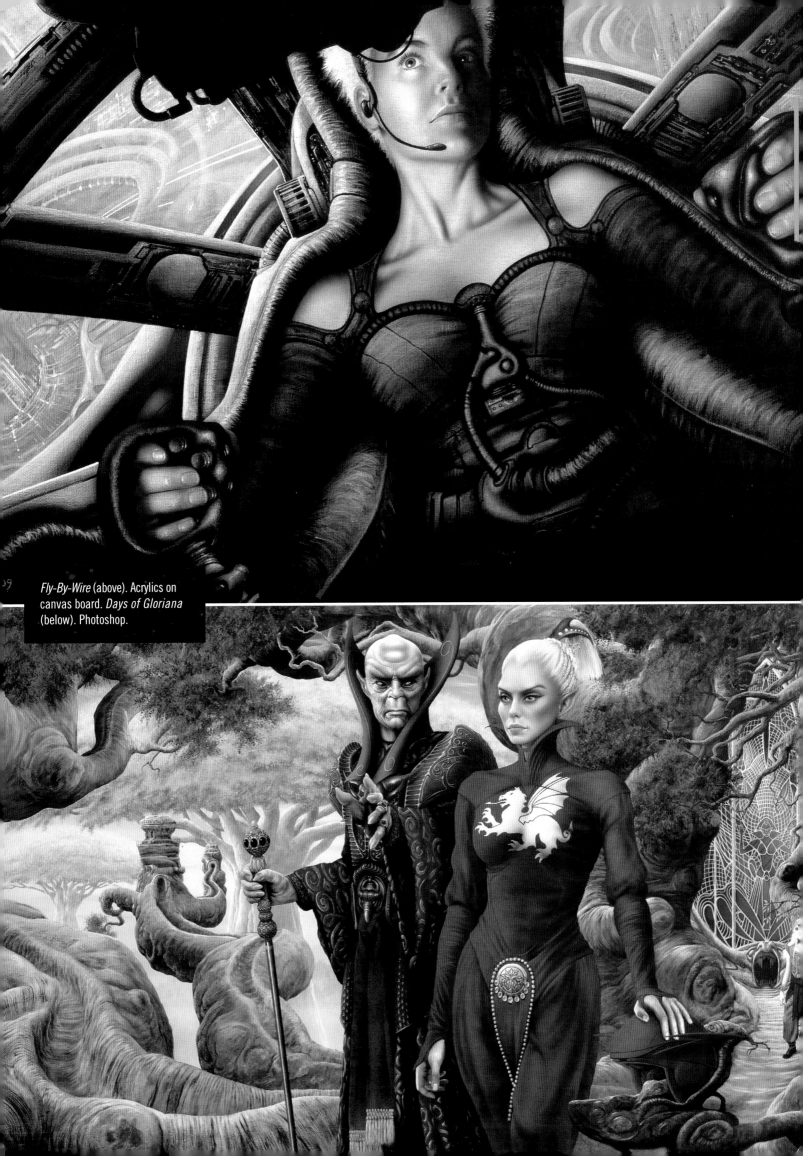

Fly-By-Wire (above). Acrylics on canvas board. *Days of Gloriana* (below). Photoshop.

SHAUN TAN

"Art is about getting to that point of stopping and examining something for long enough that you actually see how unique and weird it is. In a way it's about taking things out of context."

Saying Hello. Collage/acrylic/oils. From *The Lost Thing.*

Shaun Tan is a brilliant artist, writer, and filmmaker whose imagination conjures remarkable, often poignant visions that celebrate both the universal and the strangeness of the human experience. He can find extreme oddities in suburbia, and humanity in a lost alien stranded upon a hostile planet. Emotions drive his work, as do textures and unusual color effects, which is why he often uses collage as part of his complex, varied technique.

Tan notes: "I tend to be quite conservative with digital effects, and only use them for things that can't be done in a more traditional way."

The artist was born in 1974 and grew up in the suburbs of Perth, Western Australia, where he showed an early talent for drawing. He graduated from the University of Western Australia in 1995, with joint honors in fine arts and English literature, and currently works as a freelance artist and author in Melbourne.

Wonderful Things are Passing You By. Acrylic/oils. From *The Red Tree*. The artist's goal is to show a girl looking out a window at something the viewer sees only as a tantalizing reflection. For the object, Tan reworks an idea for a strange craft modeled after butterflies. The complexity of this image makes it difficult for the artist to draw it freehand using perspective lines and vanishing points. Instead, he builds a cardboard model of the craft, photographs it in sunlight, and traces the outline of the wing shapes and shadows onto his painting. Once he has painted everything roughly in a layer of acrylic, he revises everything with oils. Reference for the clouds comes from a collection of cloud photographs that the artist keeps on hand.

Tan began creating images for science fiction and horror stories in small-press magazines as a teenager, and has since become best known for illustrated books that deal with social, political, and historical subjects through surreal, dreamlike imagery.

Many of his books have received awards and acclaim, including *Tales from Outer Suburbia* (Allen & Unwin, Australia, 2008), *The Arrival* (Lothian Children's Books, Hachette Australia, 2006), *The Lost Thing* (Lothian Children's Books, Hachette Australia, 2000), *The Red Tree* (Lothian Children's Books, Hachette Australia, 2001), and *The Rabbits* (by Tan and writer John Marsden, Lothian Children's Books, Hachette Australia, 1998), which won picture book of the year from the Children's Book Council of Australia in 1999, the same year that an image from that book won the *Spectrum* gold award.

One Small Step. Graphite pencil/digital. From *The Arrival* by Shaun Tan, Lothian Children's Books, an imprint of Hachette Australia, 2006.

more as an academic than a practitioner. However, I was also illustrating small-press science fiction, a hobby I did not really expect would become a career at the time."

Tan chose freelance art by default. "When I graduated from the University of Western Australia, I decided to try freelancing full time, just to see where it might lead—given I had no other employment qualifications—and through a series of twists and turns, I ended up doing what I do today: a combination of picture books/graphic novels, film design, and painting," he explains. Tan establishes his own context—or lack thereof—bringing familiar-seeming objects together in new ways that engage and/or unsettle the viewer.

He says, "Art is about getting to that point of stopping and examining something for long enough that you actually see how unique and weird it is. In a way it's about taking things out of context, particularly the 'context' of day-to-day passive recognition."

Tan has also worked as a theater designer and a concept artist for animated films, including Pixar's *WALL-E*. He directed the short film adaptation of *The Lost Thing* in association with Passion Pictures. The short, released in 2010, won the award for best short animated film at the 57th Sydney International Film Festival that same year, and the Cristal Award for best short film at the 34th Annecy International Animation Film Festival, the world's largest animation festival.

"Like most artists, my career development was a little convoluted," Tan says. "I wanted to be an artist when I was six, but after that had serious doubts. As a teenager my focus was more toward science, while still having a strong interest in drawing, and a growing interest in creative writing." He adds, "I ended up getting an arts degree and studying fine arts and English literature, though

Tan adds, "I like the term *defamiliarization*. The idea of an artist and reader alike operating from the viewpoint of, say, a Martian or maybe a time-traveling archaeologist. I see creativity as a kind of transforming exercise. It's not so much about expressing preconceived themes or a mastered delivery of statements but rather a process of slightly absentminded discovery, of seeing where certain lines of thinking take you if you keep stoking the engine." Tan notes, "I know I'm on the right track when there is a sense of unfamiliarity about what I'm doing, that I'm actually being surprised by the way mixed drawings and words make their own novel sense."

STRANGER IN A STRANGE LAND

"My picture books are essentially an attempt to subversively reimagine everyday experience," he says. "I don't think I've ever painted an image as a reproduction of what I'm seeing, even when I'm working in front of it.

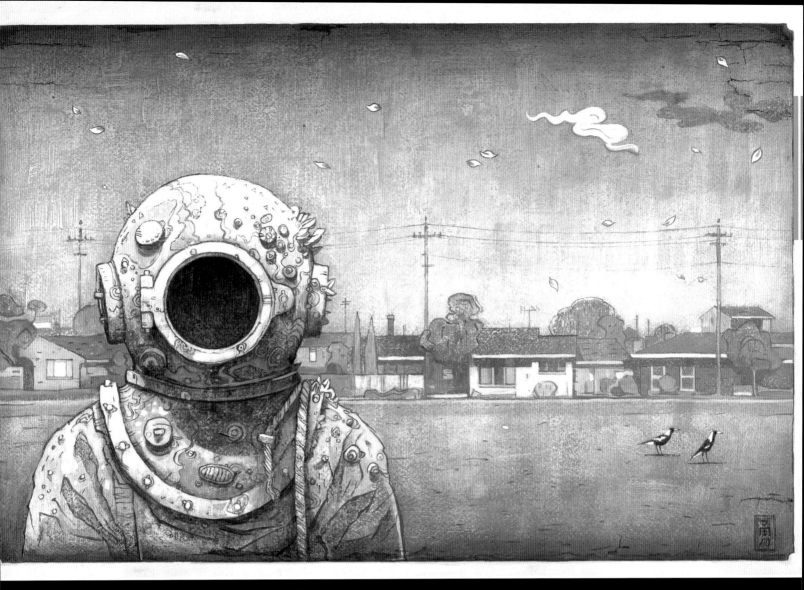

The Visitor. Acrylic/oils/digital. From *Tales from Outer Suburbia.*

Tan designed this illustration for a story about a Japanese pearl diver who returns from the dead—in the middle of an Australian suburbia—to resemble a Japanese woodcut print. The artist knew from experience that sandpapering layers of acrylic on a rough canvas or heavy watercolor paper could approximate the texture of old wood, and "weather" a picture, so he sandpapers frequently after adding each layer of detail in acrylic. A final layer of oil paint using a resin varnish allows him to make subtle color adjustments while still allowing the rougher acrylic underpainting to show through. Final, tiny effects were added to edges using Photoshop, by scanning in the cracks on a piece of old wood from his backyard.

Sunday Afternoon. Acrylic/oil. From *Tales from Outer Suburbia.*

Our Tuesday Afternoon Reading Group. Acrylic/oils.

Rather than tell his stories in narrative text, Tan prefers to tell them by narrative image. "I have to say that illustrations are for me the main 'texts' in my books," he explains. "Writing—though often the starting point—acts as a kind of scaffolding, a premise that stitches everything together."

The artist says that humor helps ease readers into his stories. "Playing games with readers' assumptions—rupturing the usual process of recognition—naturally lends itself to humor, particularly of an absurd kind," he says. "Whimsy can bring a reader along for the ride, and arrive at certain serious insights without being pretentious about it."

He adds, "Humor is also an excellent way to cross over between child and adult audiences because it can work on so many levels—I always think of *The Simpsons* as a great example of this."

"I don't really write or illustrate for children, yet the publication of picture books is contingent on being marketed as children's literature, so it helps to have some appeal for younger readers. *The Lost Thing*, for example, is acceptable to many teenagers, especially boys, because it's amusing, weird, and cool, not didactic."

Tan takes humor seriously. "I think whimsy is really a serious way of testing our understanding of the world," he says. "It pokes our brains in novel directions, which is why kids love it so much. And what is art if it isn't a continuation of childish playfulness well into adulthood?"

EVERYTHING IS HYPOTHETICAL

"A picture book takes me about a year to complete, in between other tasks that help pay the bills, such as painting book covers," Tan says. "Most of the time spent 'working' on a book project isn't very productive. It involves a lot of thinking while cleaning the house or walking to the shops, browsing through my local library, and making scribbly notes and doodles in my sketchbook."

I'm always trying to create some kind of parallel equivalent, in some way a serious caricature that emphasizes a particular idea or feeling about the subject. All drawing and writing is, after all, one kind of abstraction or another, " he says.

"I want to do something that makes people do a double take. I'm interested in showing people where the strangeness comes in. I want them to *have* to look more."

Tan explains, "When I was about eleven I discovered reruns of *The Twilight Zone* and became hooked. I also wanted to read these sorts of stories, and found about two dozen writers I really liked, with Ray Bradbury at the top. I loved his intriguing fairy-tale places, at once sensual and sinister, as convincing and unbelievable as dreams. Eventually, I read a lot of other writers and realized that I wanted to tell my own stories."

"With a blank piece of paper in front of me, my imagination is quite impotent," Tan admits. "I could start drawing, but everything would end up looking the same. So I actively look to absorb foreign ideas and influences—another lesson learned from years of illustrating different science fiction stories, where some of my best work came out of having to illustrate texts that were very different from anything I would have thought of myself."

It might be difficult for such a protean artist to name his favorite tools. Tan's choice is a bit surprising. "Aside from my laptop, which is pretty indispensible, my favorite tool is probably a cheap, fine-tip ballpoint pen," he says. "Most of my initial concept sketches originate from very small pen doodles in a sketchbook: the low-quality media removes any concerns of producing 'Art,' and I find my best ideas emerge when working quite carelessly, with a sense that everything is hypothetical."

Tan has a couple of observations to share with students looking for advice. "I remember a librarian saying that I should not just read books that I think I'll like, but also ones that I wouldn't ordinarily read. Similarly, I had an art teacher who emphasized the need to experiment with different media and styles, rather than clinging to something I was good at. Both of these are valuable pieces of advice, I think, and illustrate the need to challenge a talent or an interest in order to make it grow," he explains.

He also recommends that all artists "learn to communicate well with people. And be articulate about your own work and ideas."

"If I could squeeze in one extra tip," he says, "I would assure young artists that it's perfectly normal to feel depressed about your own work from time to time: I don't think you can create really good work without some degree of doubt and anxiety."

When it comes to inspiration and influences, the artist takes it where he finds it, and he seems to find it everywhere. "I'm pretty omnivorous when it comes to influences in my work, and I like to admit this openly," he notes. "Readers of *The Lost Thing* often notice my parodies of famous paintings by artists like Edward Hopper, or slight references to the medieval artist Hieronymus Bosch. I could list hundreds of illustrators, writers, cartoonists, photographers, filmmakers, and artists (both ancient and modern) who influence me, but it changes from time to time."

Tan adds, "I keep a sketchbook filled with drawings—both imaginary and from life—and clippings from newspapers or magazines, bits of story ideas, or whatever. It's really a memory aid—keeping a disordered archive of interesting material in case I need it later. The random way in which they end up being juxtaposed can be quite interesting, too."

He notes, "I would also have to include equally important influences like streets, clouds, jokes, times of the day, people, animals, the way paint runs down a canvas or colors go together—all this sort of stuff is useful in trying to find new ways to look at things. And there's always something to discover, usually in the same old stuff you've been looking at every day. Everything is fundamentally mysterious."

To learn more about Shaun Tan and his artwork, check out his website at www.shauntan.net.

All images © Shaun Tan and used by permission of the artist. All images from *Tales from Outer Suburbia* reproduced by permission of Allen & Unwin, Australia, and Scholastic Inc./Arthur A. Levine Books. Images reproduced with permission from *The Lost Thing* (2000), *The Red Tree* (2001), *The Arrival* (2006) by Shaun Tan, Lothian Children's Books, an imprint of Hachette Australia, and Scholastic Inc./Arthur A. Levine Books.

Never Leave a Red Sock on the Clothesline. Pastel/crayon/pencil/digital. From *Tales from Outer Suburbia.*

Sometimes You Just Don't Know what You are Supposed to Do. Acrylic/collage/oil. From *The Red Tree.*

Tender Morsels. Oil. Cover art for *Tender Morsels* by Margo Lanagan (Allen & Unwin).

Departure. Pencil/digital. From *The Arrival.*

The Night of the Giants. Pencil/digital. From *The Arrival.*

Inspired by stories of refugee immigrants, Tan begins with a series of very small, rough drawings, developing the concept of a quasi-European city overrun by powerful threatening figures, giants who are symbols of repressive regimes engaged in the elimination of people they consider undesirable. He then sets up a rough model of the scene—using small cardboard boxes for the city, and wearing overalls and his father's garden fungicide sprayer—and films himself for later photo reference in video stills. Next he sketches the scene a few more times before carefully rendering it by hand on paper approximately 15¾ x 23½ in (40 x 60 cm), using pencils from F to 3B, and a putty eraser. The buildings of the city are based on photos of Florence, Italy. Finally, the artist subtly edits his pencil drawing on graphite paper by digitally adding sepia color tones to the black-and-white image. The whole process, from concept to finished art, takes about two weeks.

DAVE SEELEY

"Even if I bury the entire photo collage with oil paint, it would never look the way it does without the digital exploration that's at the core of how I approach image-making. The computer allows me to experiment and 'happen into' things that are then preserved and incorporated in the finish."

Virga 1.2. Oil on digital underpainting.

Dave Seeley was a decade into an architectural career when he won a traveling scholarship that changed his life. "Suddenly I was seeing all this incredible historic art mingled with architecture," he recalls. "At the same time, I was also seeking out the phenomenal art of European graphic novels because I was a comics fan. That infusion of art within the big-picture context of a four-month 'walkabout' ultimately inspired me to move from art-fan architect to artist." He adds, "By the way, Michelangelo was an amazing fantasy artist!"

Shortly after his return to the United States, Seeley gave up his career as an award-winning architect in order to become an illustrator. Since then he's won accolades from art directors and fans for his textured, painterly mixed-media images used as covers, posters, and *Star Wars* tie-in book covers.

Seeley has been making art for as long as he can remember. Born in Boston, he earned a degree in architecture and fine art from Rice University in Houston, then returned to his hometown to practice architecture. In his spare time

Unincorporated Man. Digital.

Seeley begins by working up a digital image from as many as fifty or sixty photographic elements. He sketches over these in Photoshop until he's about 75 percent finished. Next he prints it out and begins to overpaint in oils.

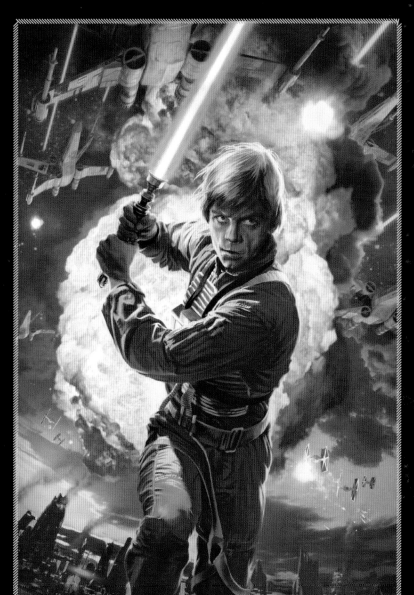

Star Wars: Rogue Leader. Oil on digital underpainting. Collection of George Lucas © Lucasfilm, Ltd. All Rights Reserved.

Seeley takes photos of himself in an orange flightsuit, holding a light-saber toy. In Photoshop, he merges several shots to get an exaggerated dynamic pose. Next, he adds photos he's taken of an X-wing model kit and creates a background using National Aeronautics and Space Administration (NASA) starscapes and Lucasfilm archive photos to craft the dogfights. To bring more attention to the main figure, Seeley brings in explosions from U.S. Department of Defense photos, then refines Luke's likeness using Lucasfilm reference photos. When the digital underpainting is done, the artist makes an archival paper print, mounts it on a panel, seals it with acrylic medium, and paints in oils the figure of Luke Skywalker and the X-wing spacecrafts.

Marque and Reprisal: The Vatta War. Oil on digital underpainting.

MARQUE DEVELOPMENT SEQUENCE: ❶ Seeley photographs a model for reference but only uses her face in the final image. He also shoots—and then warps—photos of a motorcycle in Photoshop to use for armor. ❷ For spaceship wreckage in orbit, he samples royalty-free photos of NASA spacescapes and U.S. Department of Defense aircrafts. For the ship's interior he sources an industrial stock photo and warps it. ❸ He also photographs his own gloved hands and a metal clip for the final elements of his underpainting. He next makes an archival paper print, mounts it on a panel, seals it with acrylic medium, and oil-paints the figure and ship interior.

CryoBurn. Digital.

Star Trader: David Falkayn. Oil on digital underpainting.

Star Wars: Healer. Oil on digital underpainting. Collection of George Lucas.
© Lucasfilm, Ltd. All Rights Reserved.

It was at this point that Seeley began using the computer as an art tool, scanning detailed pencil drawings or oil underpaintings into Photoshop to digitally color and enhance his pictures. He also began to abstract photographs in order to lay in digital backgrounds for subjects that he would then take "outside the box" and render by hand. As he sought to expand his client base and move into the publishing market, Seeley kept hearing that art directors were looking for more photorealistic work. However, he was wary of overtightening his painting style. "Though I loved oil painting, I didn't have a genuine interest in honing my painting skills toward photorealistic results," he notes. "I love to see the medium in paintings. I did, however, have a strong curiosity about building images directly from the photo sources."

A technical breakthrough came while Seeley was doing images of giant mechanized robots—in mixed media—for a trading card game. He became so inspired by the machinery he saw being used in Boston's Big Dig construction project that he began to cobble together bits of heavy-machinery photos in order to build his own big robot. That image, published in *Spectrum: The Best in Contemporary Fantastic Art*, got him the attention and services of a professional artist representative. It was also the beginning of his digital photo-collage style, in which he utilizes anywhere from a few dozen to a few hundred photographic sources to build complex images. Seeley notes that photo collage is a common stage in working preliminaries of many digital artists. "The basis of my figures comes from so many different photographs that it's a total Frankenstein project," he says. He samples images from his own photographs and from a searchable database of royalty-free stock images from Corbis, Metaphotos, NASA, and other sources.

In putting together an image by mixing and warping photographic bits, Seeley fundamentally changed the way he went about conceiving images. Where he formerly

he collected comics and science fiction art. "I think the collecting bug was largely a subverted desire to make art, because the yen waned after I began illustrating," he says.

Seeley tracked down fellow artist Rick Berry in Arlington, Massachusetts, struck up an art-collaborative friendship, and dived into art-making. His friendship with Berry led to his first art gig: painting collectible cards for Last Unicorn Games. More work in the card business beckoned, but Seeley realized that he was interested in a bigger canvas. "I like to make incredibly complex imagery," he says. "That doesn't work very well in a two-inch (5 cm) format."

had developed a picture through exploratory sketches, he discovered that the flexibility of a digital preliminary stage was inherently superior for his purposes, and that a digital process expanded his options to explore and modify a piece at all stages of development.

This digital approach blurred together what were formerly distinct sketch and finish phases. The artist explains: "Though I didn't find that digital work was notably faster, the computer gave me the ability to experiment at very little risk, because I could 'undo' anything I didn't like, and I found this wonderfully liberating. Of course, an obvious danger of this approach is that you can become overreliant on the photo," he notes. "You have to know when to break away from it."

To avoid overreliance on the photograph, and to reconnect with what Seeley calls "that sweet toxic oil paint," he began to print out his collages, and paint over them in oil. The result was a more expressive, painterly effect that added a dimension. "A lot of my process is about wiping out details and abstracting back," he notes.

The artist says he restricts his oil painting to figures, saving the digital effects for the background of his images. "I love crazy, complex backgrounds, but I have little desire to oil-paint them," he says. "It's the figures that I feel compelled to bury in the paint."

"Something in the searching nature of paint strokes adds depth and wisdom to a face," he explains. "Perhaps it lets us project ourselves into a character, and complete them, much like we become the protagonists while reading a good story."

Seeley states that as much as he loves oil paint, digital tools are integral to his artistic process. "Even if I bury the entire photo collage with oil paint, it would never

Engaging the Enemy: The Vatta War. Oil on digital underpainting.

look the way it does without the digital exploration that's at the core of how I approach image-making," he says. "The computer allows me to experiment and 'happen into' things that are then preserved and incorporated in the finish. I like to let at least some of that show through in the final image, as a map to how it was conceived."

Seeley says it takes him roughly two weeks to finish an image. The architectural and spatial depth in his works show that he approaches image-making in a three-dimensional way. He's also hyperconscious of the materials and construction he's depicting. "I've always been fascinated with how things are made, so I have a subconscious understanding of structure and an eye for industrial design cohesiveness," he notes. "It's a holdover from the architectural side of the force."

COHESIVE COLLABORATION

Another carryover from his former career is Seeley's attitude toward his clients. He sees himself as the agent of his client, building an image to suit his client's needs. "The essence of significant architecture is solving the mundane aspects of buildings, while aspiring to enhance the spirit of the user by the manipulation of built form, space, and light. I approach illustration in the same way. The assignment is the vehicle," he says.

Many artists may feel boxed in by tight art direction, but not Seeley. He works well with others, enjoys problem solving, and finds the illustration process to be inherently collaborative. "The client has editorial control," he says. "For me, there is a sliding scale with creative freedom/high risk on one side, and specific direction/low risk on the other. The trade-off of risk always balances the level of creative freedom. I love letting an image 'find itself,' but there are times when I relish the challenge of tight constraints."

When Seeley has time between commissions, he jumps at the opportunity to make images for himself, then adds them to his portfolio as "ideal commissions" in order to attract similar assignments. *Image Junkie—A Self-Portrait* was one of those paintings. "It's so important that an artist's folio is not just full of the images he's done, but contains images that he wants to do," he notes.

Seeley cites a wide range of influences in his work. "I tend to think of the art world as the primordial soup of collective consciousness, and various artists as crawling out onto the swampy embankment in different directions. They invariably evolve during their lifetimes and spawn other artists (via influence) to continue evolution." Like many in the field, Seeley feels he owes an enormous debt to the pantheon of historical artists from his education. He especially admires the work of John Singer Sargent and Odd Nerdrum. He also cites the films *Blade Runner*,

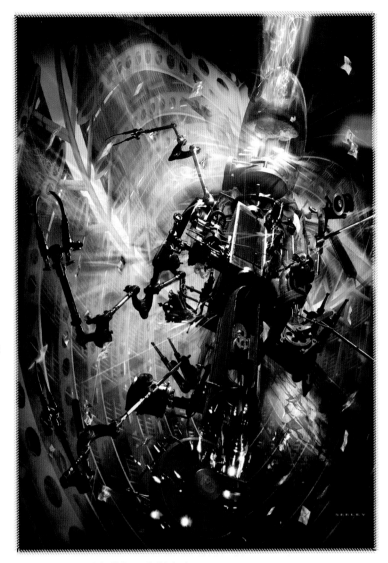

Image Junkie—A Self-Portrait. Digital.

Star Wars, *Alien*, and *2001: A Space Odyssey* as primary early influences. The imagery that lured him into the field was by contemporary comics artists Dave McKean, Rick Berry, Kent Williams, Phil Hale, George Pratt, John Van Fleet, and European comics icons Moebius, Tanino Liberatore, Milo Manara, and Paolo E. Serpieri.

Seeley shares works in progress with a distinguished group of artists via the Internet. "This is a fantastic way to grow as artists, and to stay connected to trusted peers in a 'virtual studio' environment. It's really been a tremendous enhancement to a profession where most of us sit home alone all day."

Seeley also feels that coming from a different profession, and continuing to work in other genres of illustration, engenders a cross-fertilization of influence that strengthens

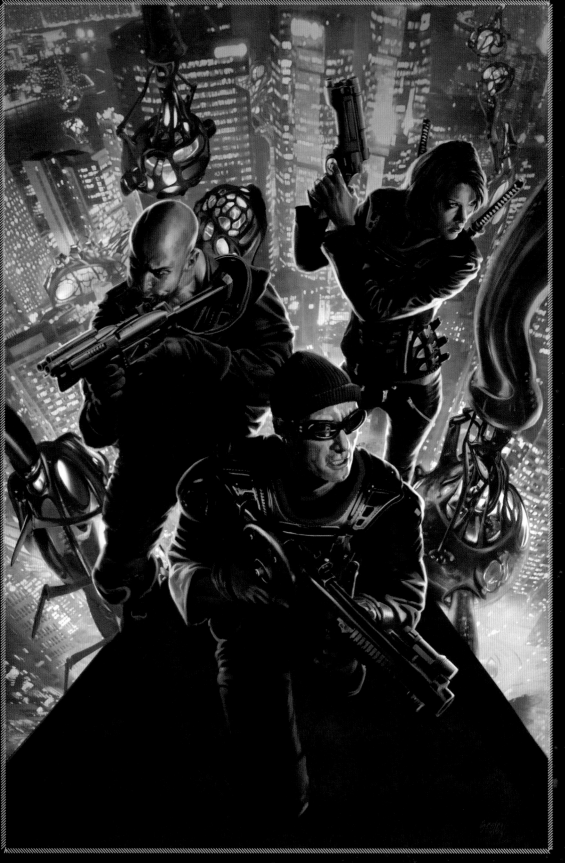

War Machine. Oil on digital underpainting.

Using Photoshop, Seeley divides an aerial photo of Hong Kong into vertical strips. He warps each strip into a keystone shape, reconnects them into a fan to establish exaggerated vertigo, and adds the far background from a different landscape photo.

He then photographs himself for all poses to suit the wide-angle perspective, and selectively modifies the characters using stock pictures and digital underpaint, leaving his own face on the team leader. To finish, Seeley makes an archival paper print, mounts it on a panel, seals it with acrylic medium, and paints in oil over the figures, rooftop, and alien structures.

Pirates of the Caribbean. Digital. © The Walt Disney Company.

his work. "Each genre has its own paradigm," he remarks. "Working outside your paradigm makes you aware of its boundaries, and provokes you to push them when you return."

Seeley advises beginning artists to put their work out there. "Submit to juried annuals and develop a thick skin. Remember: Everybody—even the best—get rejected. Get out to the conventions and exhibitions and meet fans and people in the industry. And don't forget to back up your work. I keep mirrored drives of everything, and use Carbon Copy Cloner at the end of most days."

To see more of Dave Seeley's work, visit his website at www.daveseeley.com.

All images © Dave Seeley unless otherwise noted.

AVI KATZ

"Once you've become used to all the luxuries of digital painting, it's hard to imagine giving them up."

Captive. Watercolor/airbrush/colored pencil.

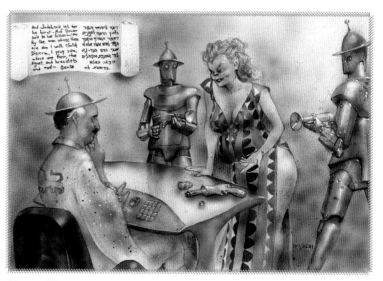

Tamara. Watercolor/airbrush/colored pencil. The artist created a series of portraits of biblical heroines based upon the Hebrew word for a female foreigner or alien, *nochria*. He depicted them literally as aliens from outer space. Katz called the series *Alien Corn*, a reference to Keats's *Ode to a Nightingale*.

Avi Katz showed his promise early as a fantasy artist. When he was still a teenager in Philadelphia, Pennsylvania, two families on his street paid top dollar for his babysitting services because he could draw images for the kids from *The Hobbit* by J. R. R. Tolkien. After a while, Katz sent a stack of the drawings off to Tolkien. He received an enthusiastic response from the author, who told him he was the first illustrator to portray the dwarves as Tolkien had intended. However, Tolkien also told him that his elves were *all* wrong.

Undaunted, Katz continued the art studies he'd begun at age twelve when, encouraged by a mother who had attended art school, he applied for a model-drawing class at the Fleisher Art Memorial school, and overcame the teacher's reser-

vations that he was too young to draw nudes. In 1967, he enrolled at the University of California at Berkeley and studied painting with photorealist Paul Sarkisian. As Katz puts it, "I was swept up in the sex-drugs-treason-rock music excitement of that unique time and place."

To avoid the U.S. draft and Vietnam War, he transferred to the Bezalel Academy of Arts and Design in Jerusalem— where his sister was studying—to finish his art degree. But he encountered opposition there to his interest in doing traditional figurative artwork. While some of his teachers, including Joseph Hirsch, Avraham Ofek, and John Byle, encouraged him, abstract art was in vogue, and most of the school's professors were unsympathetic to his goals.

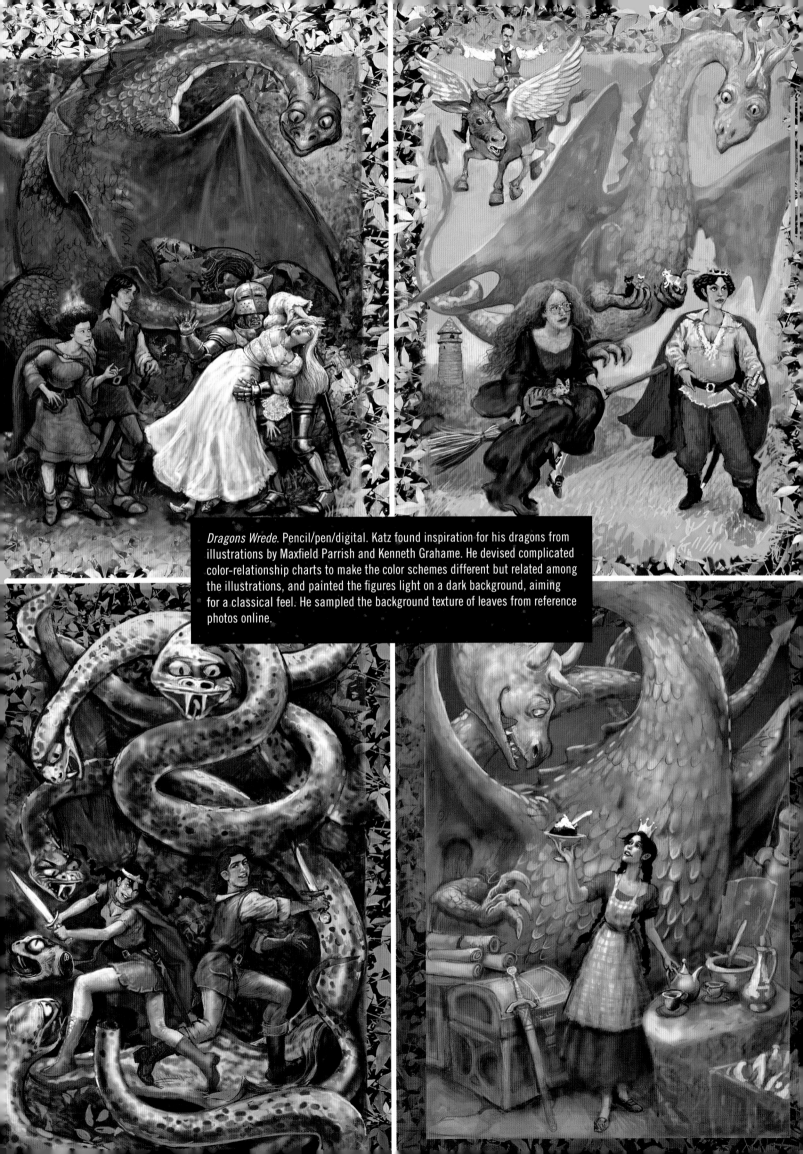

Dragons Wrede. Pencil/pen/digital. Katz found inspiration for his dragons from illustrations by Maxfield Parrish and Kenneth Grahame. He devised complicated color-relationship charts to make the color schemes different but related among the illustrations, and painted the figures light on a dark background, aiming for a classical feel. He sampled the background texture of leaves from reference photos online.

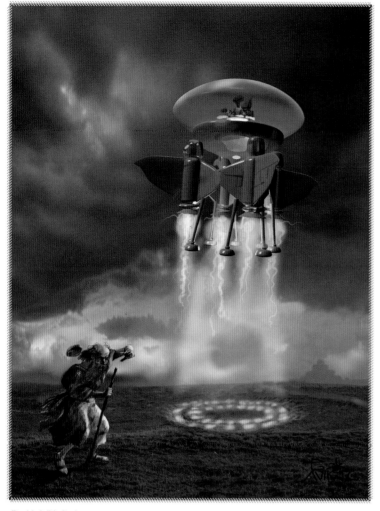

Ezekiel. Digital.

Katz regularly provides cover art for science fiction and fantasy novels published by Oddysea, among them *Tales of the Dying Earth* by Jack Vance (2005), *The Gods Themselves* by Isaac Asimov (2005), *The Fountains of Paradise* by Arthur C. Clarke (2006), and the Beggars series by Nancy Kress (2005). In addition, he's provided covers for *The Hitchhiker's Guide to the Galaxy* by Douglas Adams (Keter, 1985 and 1986) and The Enchanted Forest series by Patricia Wrede (Opus Publishing, 2006 and 2007).

JOINING THE DIGITAL AGE

In the 1990s, Katz bid farewell to his reliance on the airbrush, gouache, colored pencil, and white acrylic. He recalls: "When Photoshop, Painter, and the Wacom stylus came along, the computer became a serious option for illustration." Katz created his first entirely digital piece, *King Solomon and the Queen of Sheba*, in the mid-1990s, illustrated entirely in Painter on a Wacom. "My work now would be impossible without modern digital technology," he says. "I combine traditional drawing with computer tools."

He adds, "Sometimes the work is nearly finished on paper, scanned, and just toned or touched up in the computer. Sometimes the paper stage is just a sketch at the beginning and most of the painting is done in Photoshop and Painter with the Wacom. It varies."

Most of his illustrations begin as a pencil or pen-and-ink drawing on paper, which is then scanned. "I might also choose to do the drawing piecemeal, as separate elements which, once scanned, I manipulate and combine until they fit together. This approach saves a lot of time," he explains. "If I were doing this on paper I'd have to begin afresh or erase and redraw to move the pieces around.

"Once the drawing is in the computer, I can refine it and add color," Katz says. "Digital tools are especially convenient for mixing different techniques and elements. For example, it's simple to take pieces of photographs, stretch and cut

Disillusioned, Katz dropped out and bounced around, landing back in Northern California, where he made some money painting portraits of children of well-to-do Bay Area parents. When he got tired of that, he went to the East Coast, where he showed his portfolio to the legendary science fiction editor John W. Campbell at *Analog* magazine. Although Campbell offered to try out the young artist on spot illustrations, Katz declined, hoisted his backpack, and continued his eastward travels, landing in Europe, and, finally back in Israel, where he settled and has lived ever since.

In the 1970s, Katz taught realistic painting and exhibited his work, which wasn't very fashionable at the time. "The critics wanted minimalism and conceptual art, but I wanted to tell stories with my art, as my favorite artists had. This was looked at with scorn in fine arts circles, but in illustration it was the name of the game. So I became a full-time illustrator."

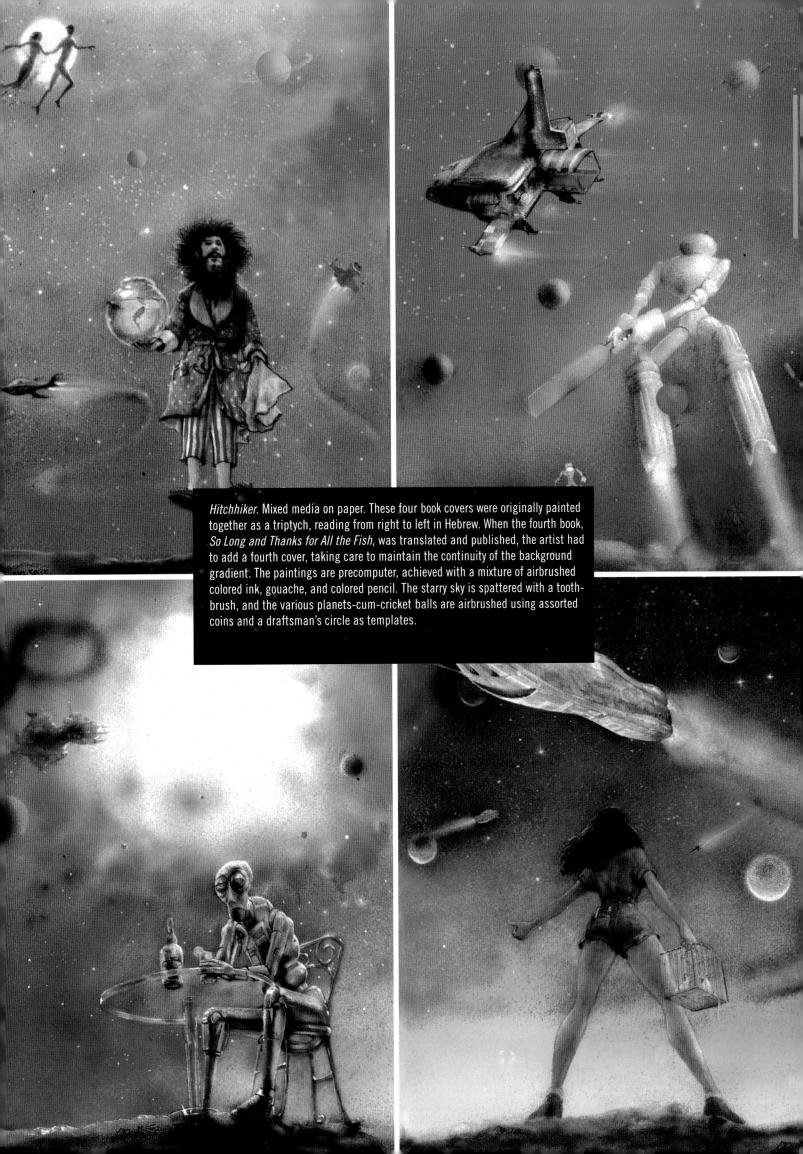

Hitchhiker. Mixed media on paper. These four book covers were originally painted together as a triptych, reading from right to left in Hebrew. When the fourth book, *So Long and Thanks for All the Fish*, was translated and published, the artist had to add a fourth cover, taking care to maintain the continuity of the background gradient. The paintings are precomputer, achieved with a mixture of airbrushed colored ink, gouache, and colored pencil. The starry sky is spattered with a toothbrush, and the various planets-cum-cricket balls are airbrushed using assorted coins and a draftsman's circle as templates.

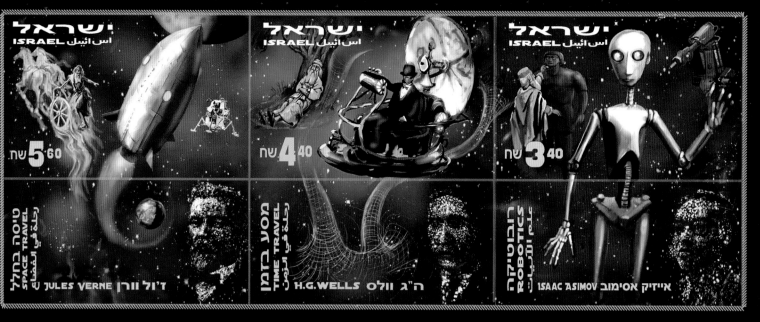

Sci-Fi Stamps. Digital.

Created with Science Fiction Society president Dr. Emanuel Lottem, this series of postage stamps celebrates the millennium and science fiction in Israel. Each stamp shows a sequence of subjects ranging from legend to science fiction to technology, and the associated science fiction writer. In addition, Katz designed a first-day cover envelope design: a group of alien visitors landing at a science fiction convention in Israel, staring at a stone monolith inscribed "2001: Science Fiction and Fantasy in Israel" in Hebrew, Arabic, English, Klingon, and Tengwar.

Sad Toaster. Pencil/digital.

Snow. Pencil/digital.

Ruth. Watercolor/airbrush/colored pencil/acrylics. The watercolor pencils used here allow the artist to build details such as hair, clothing, and machinery quickly and soften them with water. The airbrush is used with a piece of scrap cardboard as a guiding edge, and allows him to define shapes and effects such as metallic sheen and transparency.

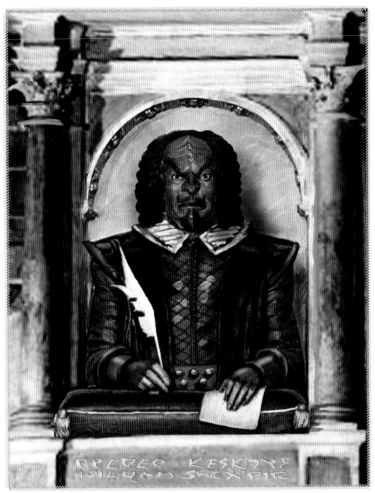

Shakespeare/Shex'pir. Digitally retouched photograph. "Every *Star Trek* aficionado knows the line from the sixth film in which Chancellor Gorkon says, 'You have not experienced Shakespeare until you have read it in the original Klingon.' For this magazine cover I took a portrait bust of Shakespeare and tweaked it in Photoshop until the face and dress became Klingon." The artist also notes the resemblance of the Bard's plumed pen to a *bat'leth*, the Klingon dueling weapon.

them to fit, and combine them with the drawing, whether as a collage or a seamless trompe l'oeil."

He admits to occasionally missing his old painting media and techniques. "I do make an effort to get back to traditional art media as much as I can," the artist says. "I long for the time when I'll be able to stop working twelve hours a day on commissions to make a living, and can go out with my folding easel, canvas, and box of acrylics like I used to. But once you've become used to moveable layers, copy and paste, scaling and warping, color-tuning, brush definition, and all the other luxuries of digital painting, it's hard to imagine giving them up."

In today's competitive art market, Katz wears many artistic hats: science fiction and fantasy cover artist, children's illustrator, editorial illustrator, and fine arts

portraitist. In his "day job," he illustrates the *Jerusalem Report*, a biweekly magazine of news and commentary. His work for the *Jerusalem Post* has been exhibited and republished around the world. Katz has also illustrated almost 200 children's books over the years. In 2010, he won the National Jewish Book Award for the *JPS Children's Illustrated Bible. The Adventures of Simon*, a comic book he wrote and drew, has been adopted by the U.N. and is being distributed throughout Africa.

To see more artwork by Avi Katz, please visit his website at www.avikatz.net.

All images © Avi Katz unless otherwise noted.

JOHN PICACIO

//

"I like drawing and painting the elements of a final picture in the real world and then use Photoshop to combine them into the finished picture. I keep my hands dirty via pencils and paints, while allowing room for surprise and spontaneity when combining them via digital means."

//

Gateway. Oil on illustration board/mixed media/digital. Cover illustration for *Gateway* by Fredrik Pohl (Random House/Del Rey, 2004).

John Picacio is a World Fantasy Award–winning illustrator of science fiction, fantasy, and horror. His artwork is noted for its dramatic composition and bold use of color as well as its diversity and range, often combining traditional drawing and painting with dynamic digital effects and/or unique handmade assemblages.

"I use different working methods for different assignments," says Picacio. "My work is often a blend of traditional and digital means. Sometimes it's 100 percent traditional but never 100 percent digital. I've always tried to stay open to new media, as tasks call for them." He adds, "I think the pencil is still my favorite tool, because I love to draw. Everything I do starts with pencil drawing. I sketch with Ebony pencils and I like building up value with Faber-Castells for a final drawing."

Picacio has painted covers for a pantheon of writers, including Dan Simmons, James Tiptree Jr., Fredrik Pohl, Robert Silverberg, Jeffrey Ford, and Joe R. Lansdale. He has also provided cover artwork for franchises such as Star Trek and the X-Men.

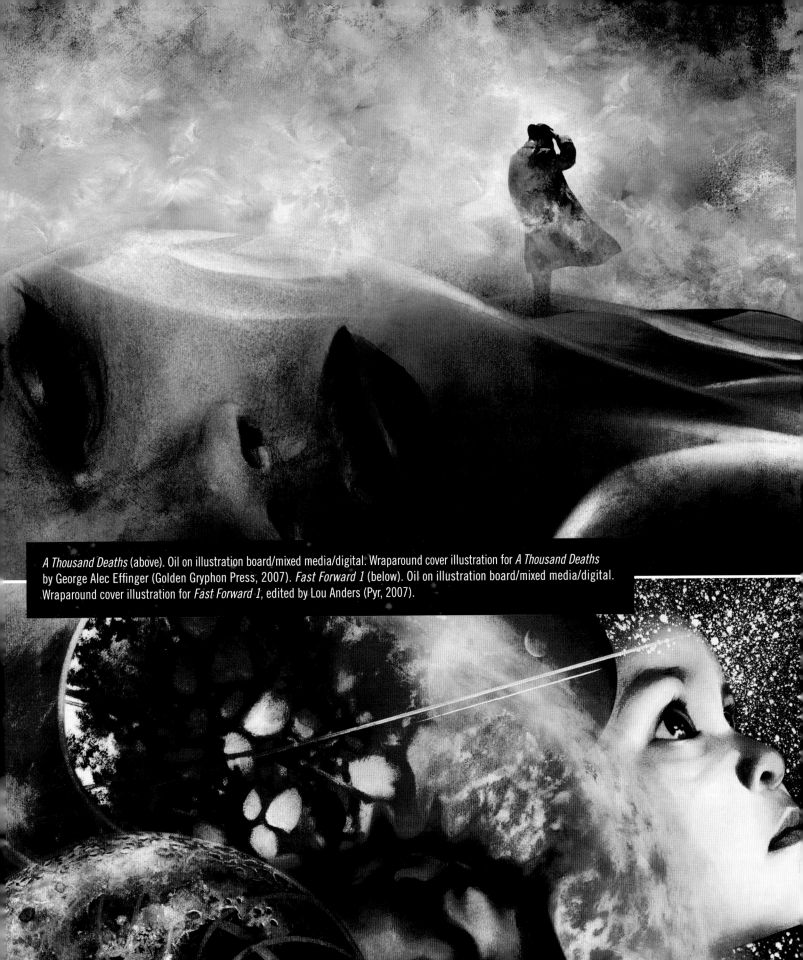

A Thousand Deaths (above). Oil on illustration board/mixed media/digital. Wraparound cover illustration for *A Thousand Deaths* by George Alec Effinger (Golden Gryphon Press, 2007). *Fast Forward 1* (below). Oil on illustration board/mixed media/digital. Wraparound cover illustration for *Fast Forward 1*, edited by Lou Anders (Pyr, 2007).

Fast Forward 2. Oil on illustration board/mixed media/digital. Cover illustration for *Fast Forward 2*, edited by Lou Anders (Pyr, 2008).

The artist creates a preliminary grayscale painting and scans it into the computer. Next he paints big abstract swatches of color on separate boards and scans them, then composites the color swatches over the grayscale painting to build up layers and juxtapositions.

This mixed media/digital illustration won the 2009 Chesley Award for best paperback cover illustration.

Drood. Oil on illustration board/mixed media/digital. Cover illustration for the limited edition of *Drood* by Dan Simmons (Subterranean Press, 2009).

"*Drood* is an amazing novel about madness, murder, and Charles Dickens's final years," says Picacio. "I wanted to put a portrait of Charles Dickens on the cover unlike any other. Illustrating his inside became as important as illustrating his outside."

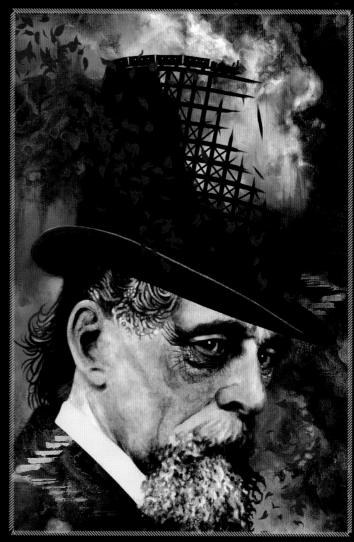

Elric the Damned. Pencil on illustration board. Interior illustration for *Elric: The Stealer of Souls* by Michael Moorcock (Ballantine/Del Rey, 2008). Elric of Melniboné © & ™ Michael Moorcock.

Picacio's accolades include the Locus Award, three Chesley awards, and two International Horror Guild awards. He is a frequent Hugo nominee for best artist and his illustrations have often been featured in the pages of *Spectrum: The Best of Contemporary Fantastic Art*. His clients include Ballantine/Del Rey, Bantam, HarperCollins, Simon & Schuster, Tor Books, Pyr, Golden Gryphon Press, Subterranean Press, Angry Robot, and many more. Recent works include covers and interiors for new Del Rey editions of Michael Moorcock's legendary fantasy icon Elric as well as the 2011 calendar for George R. R. Martin's *A Song of Ice and Fire*.

Affable and enthusiastic, the artist enjoys visiting with fans and peers at science fiction and fantasy conventions. But when he's at work, he definitely wants to be alone. "I'm very private when working," he notes. "I'd rather fall on my face on my own rather than get confused by input."

Picacio begins by reading the manuscript. "I can't just blindly follow marching orders," he says. "The only way I can make myself happy and provide the maximum value is by reading the book and filtering it through my own sensibilities."

READ, THEN DRAW

"It's best to remember that my process always varies," cautions the artist. "Every painting is a new journey. But they all begin the same way: reading the book. I do my best to understand it on its own terms, although it's going to filter through my brain."

"I make pencil marks and little notes and sketches to myself as I read the work for the first time. That's when interesting connections happen," he explains.

"Eventually, an image bubbles to the surface. Then I create a design brief, a two-to-four sentence statement encapsulating what I think the book is trying to do, and maybe a nugget of truth that I can serve in the process."

"Once that image is approved by the art director, I'll do a full pencil drawing of the idea, and then I'll seal the drawing with spray fixative," says Picacio. "Next I paint all of the darkest areas with black acrylic."

"When that's dry, I'll do a full grayscale oil painting of the entire composition. This is where all of the values of the painting happen," he says. "Then I seal this painting and wait for it to dry. After that, I'll build up my final color glazes directly onto this painting, or, if I'm doing a digital route, I can scan the grayscale painting into the computer."

He adds, "If I do the latter, I can paint big abstract swatches of color on separate boards and scan those in, and then composite these color swatches over the grayscale painting. In this way, the layerings and juxtapositions create interesting, powerful results that are often unexpected."

A Canticle for Leibowitz. Oil on illustration board/mixed media/digital. Cover illustration for *A Canticle for Leibowitz* by Walter M. Miller Jr. (HarperCollins/Eos, 2006).

Says Picacio, "I've been known to do shadowbox assemblages, collages, and many other mixed-media approaches. I don't limit myself. I try to do what I think best communicates the idea."

He adds, "I would say that I consistently enjoy drawing and painting with traditional media. The computer is most fun to me when I use it to composite and layer things that I've done with my hands."

A DREAM BLOOMING

"Back in 1995, I was working in architecture by day while writing and drawing self-published comics by night, experimenting and finding a voice. At the time, I would've been content working toward a full-time career in comics, writing and drawing my own stories. That was the dream at the time." He notes, "That all changed after Mojo Press tapped me to illustrate Michael Moorcock's *Behold the Man.*

That job changed my life. I ended up doing not only the cover, but interior illustrations and design, too. The more I worked on that book, the more I fell in love with being a book illustrator and learning the craft. It was like a self-taught crash course in book illustration and design."

Says Picacio, "The dream of being a full-time professional illustrator bloomed in my head and took root very deep, very quickly. My spare time was spent eating, drinking, and breathing, drawing, painting, and [working with] photography, illustration, and genre literature. So my architecture days were numbered at that point, and in April 2001, I left behind architecture for good and plunged full-time into the illustration life. I've never looked back."

"Sometimes I wonder if being an artist is even a choice," he muses. "I think this is the path I've wanted since I was a kid. It just took me a few detours to find it full time. That said, I think an artist is more than just someone who draws and paints well. Those are essential skills that can be hard-won through ceaseless hard work."

Picacio admits that almost everything influences his work, but he recalls one artist who changed the way he thought about art and illustration. "When I was a kid I was initially repulsed by Bill Sienkiewicz's work. He was mixing media and illustrating comics with scratchy lines, doing collage, and other bits of stuff."

"Before, I had always been attracted to artists who were about clean lines and easy language. That changed with Sienkiewicz. He was the first one who made me see a larger world of ideas and possibilities. He was a hybrid artist, and that 'both/and' impression stuck with me."

For Picacio, it was a watershed moment. "From there, I started looking beyond comics and genre art toward the larger art world and the world around me."

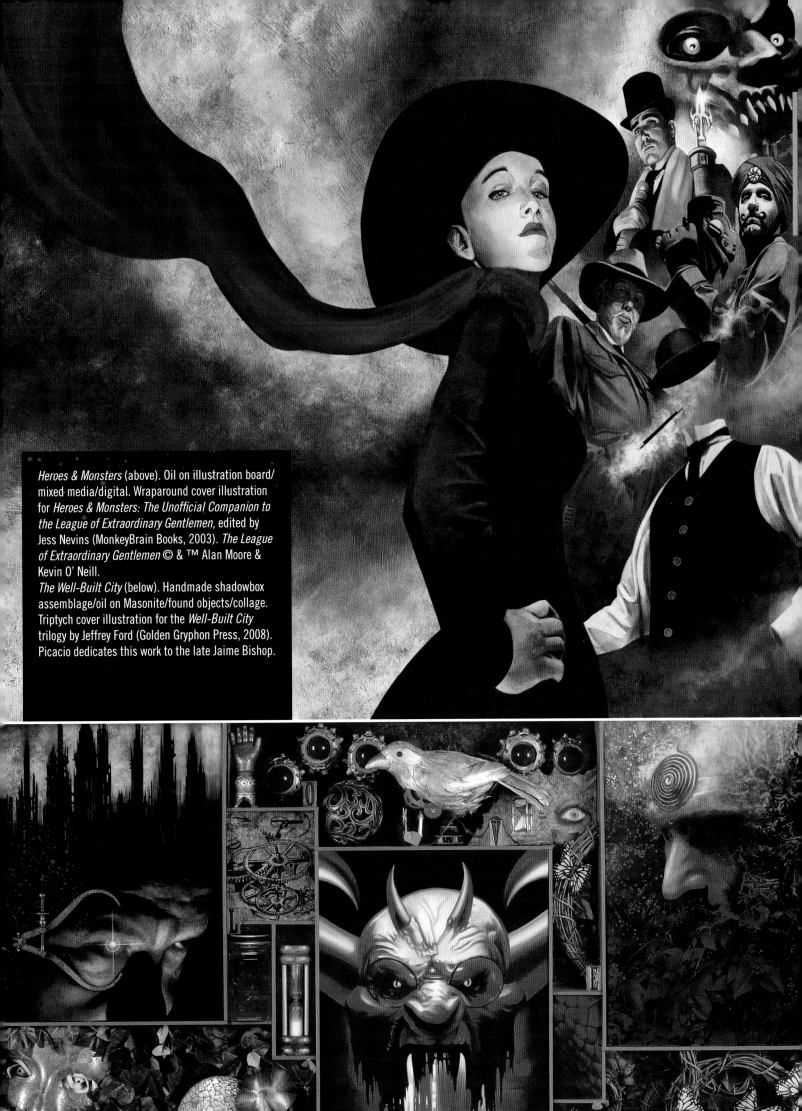

Heroes & Monsters (above). Oil on illustration board/ mixed media/digital. Wraparound cover illustration for *Heroes & Monsters: The Unofficial Companion to the League of Extraordinary Gentlemen*, edited by Jess Nevins (MonkeyBrain Books, 2003). *The League of Extraordinary Gentlemen* © & ™ Alan Moore & Kevin O' Neill.

The Well-Built City (below). Handmade shadowbox assemblage/oil on Masonite/found objects/collage. Triptych cover illustration for the *Well-Built City* trilogy by Jeffrey Ford (Golden Gryphon Press, 2008). Picacio dedicates this work to the late Jaime Bishop.

Elric: The Stealer of Souls. Oil on illustration board/mixed media/digital. Cover illustration for Michael Moorcock's *Elric: The Stealer of Souls* (Ballantine/Del Rey, 2008). Elric of Melniboné © & ™ Michael Moorcock.

Picacio uses one of his favorite working methods here: a hybrid of traditional and digital media, pencil drawing, acrylic, and oil paints, composited digitally.

Age of Misrule: World's End. Pencil on illustration board/mixed media/digital. Cover illustration for *Age of Misrule: Book 1—World's End* by Mark Chadbourn (Pyr, 2009).

Are You There, Pencil and oil on illustration board/mixed media/digital. Cover illustration for Jack Skillingstead's *Are You There and Other Stories* (Golden Gryphon Press, 2007).

He adds, "There's so much amazing art being created in the science fiction and fantasy illustration field, in books, comics, and concept art for films. There's so much to admire, whether it's traditional or digital, but when I see artists who combine multiple media or work in them simultaneously, those are the ones who really turn my head. I love hybrids."

Picacio draws on his experiences and environment when beginning an illustration. "Drawing from life helps me keep my imagination fresh. I don't actually paint from live models in my studio, but I'll photograph friends or relatives to provide a starting point. Sometimes I'll make my own costumes and props to provide more information when I paint," he explains. "No matter how much or how little reference material I use, my imagination always adds or subtracts elements.

"I admire anyone who can create a piece of transcendent art under any conditions," Picacio says. "But to do it within commercial constraints, and still blow people's minds, is especially admirable. Those are great victories. That's my aim, and my job."

Picacio's advice to beginning artists is simple: keep at it. "If there's one quote I live by," he says, "it's this one by Jacob Riis: 'When nothing seems to help, I go look at a stonecutter hammering away at his rock perhaps a hundred times without as much as a crack showing in it. Yet at the hundred and first blow it will split in two, and I know it was not that blow that did it, but all that had gone before.'"

Muse of Fire. Pencil and oil on illustration board/mixed media/digital. Cover illustration for *Muse of Fire* by Dan Simmons (Subterranean Press, 2008).

He notes, "I think that quote applies not only to trying to improve technically but also being a better problem solver. It's not good enough to just be a hired hand. The best work happens when I'm solving a problem for a client, creating ideas, executing them, and engaging heart and soul in my work. My advice is to do that with every assignment, every time, and keep chopping that rock."

To see more of John Picacio's work, check out his website at www.johnpicacio.com and his blog at http://picacio.blogspot.com.

PAVEL MIKHAILENKO

"Learn everything that interests you. It will not only improve your skill but your self-confidence as well. And, of course, be patient. Nothing comes at once."

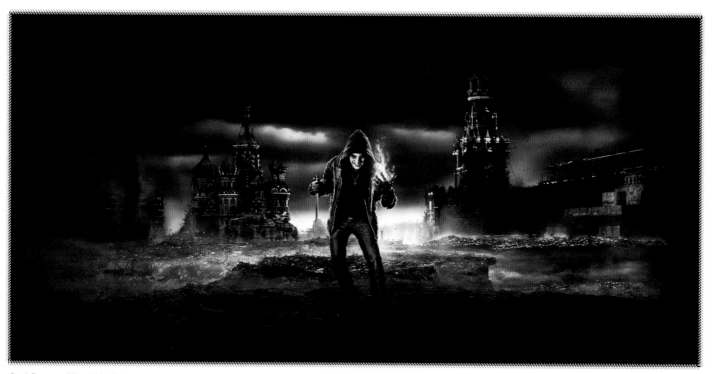

Red Square. Mixed/digital.

The best piece of advice Pavel Mikhailenko ever received was when a good friend told him to stop freelancing and go find a job in film post-production or a game-developing studio. He moved from his small Russian hometown to Moscow, where he quickly found employment as a 3D artist and composer at CLR-Films, one of the leading post-production facilities in Moscow.

"I do enjoy working here," he says. "I didn't expect to be working as an artist when I was in school, but surprising things happen."

For several years, Mikhailenko worked as a freelance artist with an international clientele. In 2006, he worked in Göteborg, Sweden, at Edithouse Film, a post-production

Garbage Masters. Mixed/digital. The artist says that this image came to him in his sleep. When he woke up, he did a quick sketch to save the overall shape. Then he began to develop it into a more detailed vehicle. The first sketch is done in pencil on paper. Next he scans it and, using Photoshop's simple brushes tool, begins blocking in shapes and creating a light scheme using gray tones. After he's roughed out the image, he adds details and cleans up the drawing. Finally, he adds a greenish tint to enhance the sickly polluted feel of the piece.

facility that mostly produces art and film for Volvo. While there, he made movies and DVDs for car advertising. "It was a great experience to work in a European studio," he says. "I also worked with a German advertising company for whom I did a lot of interesting projects for companies such as Porsche, Heinz, and Sennheiser."

Mikhailenko's artwork has been featured in *Exposé 7*, *Matte Painting 2*, *Elemental 2*, *Exposé 5*, *Point 1*, and *Point 2* annuals. He says that he has always been interested in art and is, essentially, self-taught. "I think I was born with some artistic gift," he comments. "I didn't get a degree from any art school, but I can feel how to make something beautiful—in my opinion, of course!"

He adds, "I've been drawing since I was very little, maybe since the age of ten. All my school copybooks are filled with drawings, mostly of sci-fi starships."

When Mikhailenko first saw *Star Wars* in 1991, it changed his life. "I was deeply impressed. I didn't have a clue how it was done, but I badly wanted to learn! That's when I started drawing all kinds of sci-fi stuff like starships and robots," he recalls.

"Later on, movies like *Aliens* and *Terminator* made my expectations even stronger. And I still remember how the cartoon serial *The Real Ghostbusters* influenced me. I redrew almost half of all its episodes. It was really funny: I would just push the pause button on my TV/VCR and draw what was in the frame. I did tons of sketches. It was good practice."

When the artist got his first computer, again, the world changed for him. "In 1997 I moved to 3D graphics. With the enormous help of the Internet I was soon learning *everything* available concerning computer-generated (CG) art.

"My first package was 3DS Max 2. After three to four years of studying it I got some good results. But all that time, it was more like a hobby; I didn't realize it could become my main job. I was studying at Rostov State University, trying to become an economist, and actually I got a magister (masters) degree in economy. But right after graduation, my hobby became my job."

Mikhailenko explains, "After a couple of years of learning the basics of the software, I got into modeling hi-res vehicles. I've been modeling in Rhino and Alias Studio Tools for about three years now. I also have strong skills in two-dimensional work like matte painting, and compositing in Nuke and After Effects. I did a lot of work as a freelance 3D artist." He adds, "But more and more, as I worked in 3D, I realized that it was bringing me back to 2D. Mostly I was doing texture paintings. And one sunny day, I thought of a better use for my tablet."

Mikhailenko decided to pursue his interest in traditional painting. "I got back to concept painting," he notes. "I watched tons of tutorials on painting and sketching and now I'm on my way to being as skilled in 2D as I am in 3D."

Photoshop is his favorite digital tool. "Photoshop gives me everything I need in all aspects of drawing," he remarks. "You customize it the way you want it and nothing can stop you from creating great pieces of art . . . except lack of skill."

FROM NATURE TO HI-TECH

When describing *Dragonfly*, his concept sketch of a near-future helicopter and landing pad, Mikhailenko says, "I took my inspiration from nature. I often do. It's amazing how many unbelievable creatures with fantastic shapes you can find in nature. If you want to come up with some really fresh design ideas, look at nature for inspiration."

He adds, "Here I tried to do a 'biological' design, similar to the kind I had seen in movies like *The Matrix*. I took some pictures of a dragonfly and studied them until I had deduced their main features, which I put on my helicopter. I designed not only the main rotor but also a set of engines to provide more maneuverability, speed, and overall dynamic characteristics."

Mikhailenko makes the point that he is not a pure digital artist. "I don't do *all* my work in Photoshop. I try to draw on paper first. The tablet doesn't give me that feel of comfort and freedom that I find in the drawing process. I got used to drawing with pencil, and that's the way I like to work." But, he adds, "in some cases I use 3DS Max when I have

Dragonfly. Mixed/digital. The artist first sketches his idea on paper, then scans it and paints it in Photoshop with simple brushes. After finishing the image of the helicopter he decides to add some background interest and paints in the deck of the aircraft carrier with the figures of the pilots and engineers to provide scale.

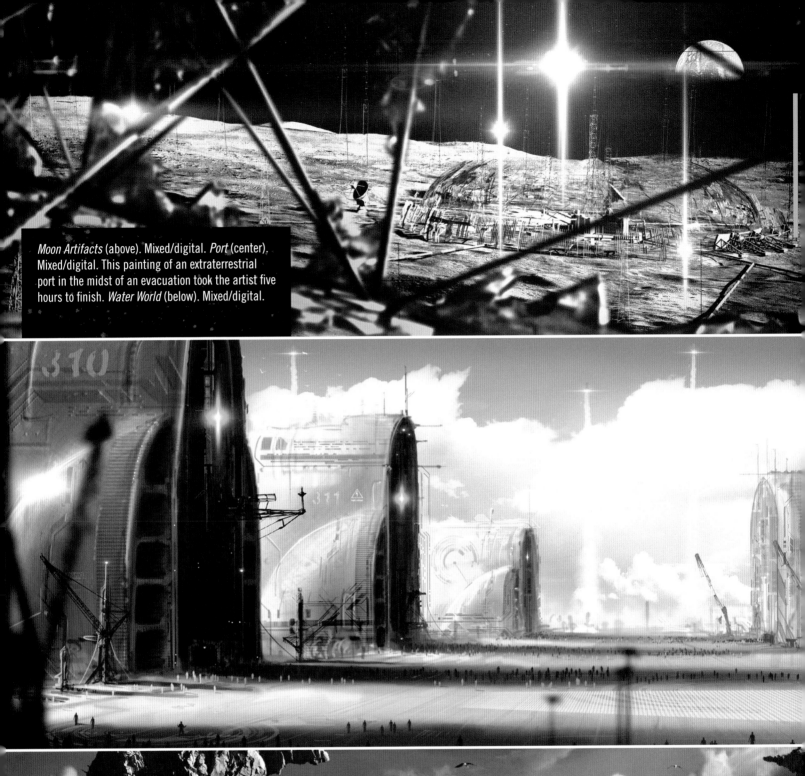

Moon Artifacts (above). Mixed/digital. *Port* (center). Mixed/digital. This painting of an extraterrestrial port in the midst of an evacuation took the artist five hours to finish. *Water World* (below). Mixed/digital.

Black Lightning. Mixed/digital.

The artist painted what he calls a "flight of fantasy" inspired by concept work he had done on the popular Russian movie Black Lightning, produced by Timur Bekmambetov. The artist made a simple sketch on paper and scanned it, then overpainted it in Photoshop.

Lake in the Deep. Mixed/digital.

some problems with building weird perspective that I just can't fix by hand. I recreate the main parts of my concept in 3D and set its dimensions and position in space. There can be no mistakes if you do it in 3D."

His greatest frustration in his line of work is compromising his artistic vision. "You try to be creative, you offer many variants of whatever you work on, but a supervisor or producer picks the worst choice of all—and adds his own variations, and you just can't do anything about it. You have to accept it with no questions. It's not always like that, of course, but it can happen," he says.

The artist enjoys knowing that his work is appreciated. "The greatest pleasure to me is when I hear words like 'Wow, that's cool!' You feel like your work is not just a waste of time, that people like what you do, and it's really inspiring!"

Asked for his best tip for beginning artists, he encourages intellectual exploration. "Be curious. If you are interested, you're already halfway to success. Learn everything that interests you. It will not only improve your skill but your self-confidence as well. And, of course, be patient. Nothing comes at once. You have to work hard in your quest for perfection. That's it: curiosity and patience and there will be no limits."

To see more of Pavel Mikhailenko's art, visit his website at www.mpavelart.com.

KEN WONG

///

"There are many budding artists who have all the enthusiasm and imagination to make it big, but they are getting wrapped up in fine details, and color, and Photoshop brushes without having put enough work into studying drawing, anatomy, and storytelling."

///

Fly by Night. Photoshop.

Ken Wong is an artist, an illustrator, and a designer whose work is frequently haunted by paradoxical aquatic and undersea symbolism and references. Fish float in midair, tortoises bear unusual passengers, and even an occasional octopus gets into the act. He combines lo-fi and hi-tech tools freely, depending upon his artistic goals.

Wong works as an art director at Spicy Horse Games in Shanghai, China. Born and raised in Adelaide, South Australia, he studied multimedia at the University of South Australia. During this time he says that he began teaching himself digital art, "largely by hanging out at a seedy digital art forum called Eatpoo." At the same time he also started freelancing for a range of clients over the Internet.

Wong was art director on the games Bad Day LA and Grimm. Currently, he's art-directing American McGee's Alice 2, based on the Lewis Carroll classic, *Alice in Wonderland.*

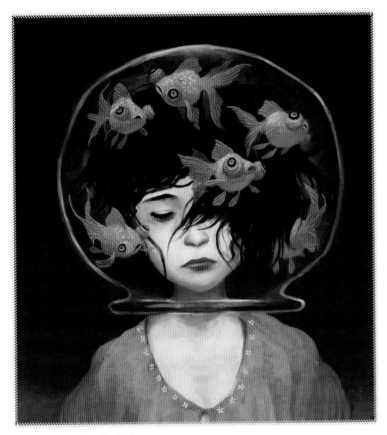

Mistaken Identity. Photoshop.

The Mock Turtle's Story. Photoshop.

Apart from serving as concept artist and art director on computer games, his work pops up on book covers and in magazines. He has been a featured speaker at the Animex Festival of Animation and Computer Games in the United Kingdom and the Red Stick Animation Festival in Baton Rouge. His work has appeared in the *Spectrum* and *Exposé* art annuals.

Whimsy and mystery attract Wong in equal measure. "I love the art of Gustav Klimt, Mike Mignola, Shaun Tan, Moebius, Zdzislaw Beksinski, and James Jean," he says. But the influences don't stop at his eyes. "I listen to the Smashing Pumpkins (which has a huge influence on my work), Sparklehorse, and various movie scores. Films I like include *The Life Aquatic*, *The Thin Red Line*, *Blade Runner*, *Children of Men*, *Leon*, *Porco Rosso*, *Lost in Translation*, and the original *Star Wars* trilogy.

"I also like retro game culture—playing video games on vintage computers or vintage game consoles—as well as traveling, urban decay, pasta, and avoiding my inbox." Despite his computer-savvy art skills, Wong admits that he loathes checking his email. He employs a combination of traditional and digital techniques, but at the end of the day, he utilizes digital to finish his work. "Photoshop was designed for photoediting, but can be used for graphic design and painting, too. It really becomes interesting when you take advantage of all these techniques and put them together to make something unique."

Wong relies heavily on the layer mask tools in Photoshop. "They are very powerful for applying an effect, a color, or a modification to only part of an image. For example, I might create a mask for only the light part of an image, then blur it. Using this technique I can experiment, finding lots of variations as I'm working," he notes.

Dabbling in digital art, as it turned out, led to a career path. "While I was studying multimedia at university I did some fan art for a computer game and the game designer saw it on the Web. He emailed me and asked if I'd like to do some paid work. I've been working with him ever since."

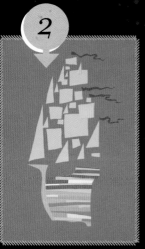

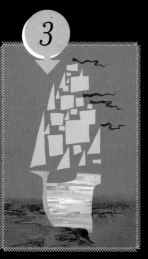

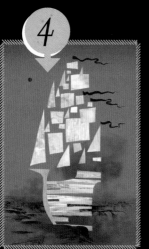

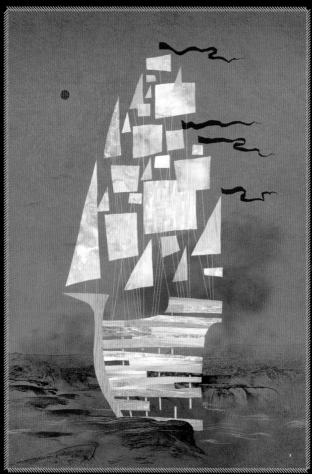

White Empress. Digital.

WHITE EMPRESS DEVELOPMENT SEQUENCE ❶ This picture began as a group of small, quick sketches of ships with sails and rigging, but no masts. Once the artist has a sketch he likes, he scans it, prints it big on two A4 sheets, and redoes the linework in pencil. What appears here is a scan of those pencils, cleaned up. This is the artist's second version, to which he's added in more sails. ❷ To create the style he's after, Wong uses the clean flat cells of color in Photoshop. He usually traces his lines with the polygonal lasso with anti-alias off to get a clean edge. Notice that the wood is different colors so he can select them individually. He chooses bright colors at this stage because they're easier to see. ❸ At this stage the artist isn't precisely sure what colors to use or what the story is behind the ship. He toys with a black ship, and decides to set the ship in the desert instead of the sea. To expand on that idea, he removes a few of the wooden planks to create the look of a shipwreck. Wong's idea now is that it's a shipwreck still dreaming of being at sea, longing for home. ❹ Wong uses several different photos for a variety of colors and texture. One image in particular, the one of rocks, he uses as is instead of drawing a representation of it. Wong uses Photoshop's find edges tool to emphasize the contrast of the rocks. Next he inserts photos of paint streaks into the different sections of wood by selecting the cell and using the paste into command. He then resizes and rotates the texture to the desired position and adjusts the color. Aiming for a lightly colored tinted sky, as in a Japanese print, Wong tries many color combinations before he's satisfied, and adds some dark clouds behind the ship for extra contrast. Finally, he gives the sails the same textural treatment as the wood, using different photo references. In the final stage, the artist reveals the rope lines, drawn at the beginning of his process, but kept hidden so he could more easily work on the layers below. He adds clouds and waves to indicate that the ship is dreaming as well as ribs inside the ship. Throughout the process, and even at this final point, he experiments with different colors for different elements.

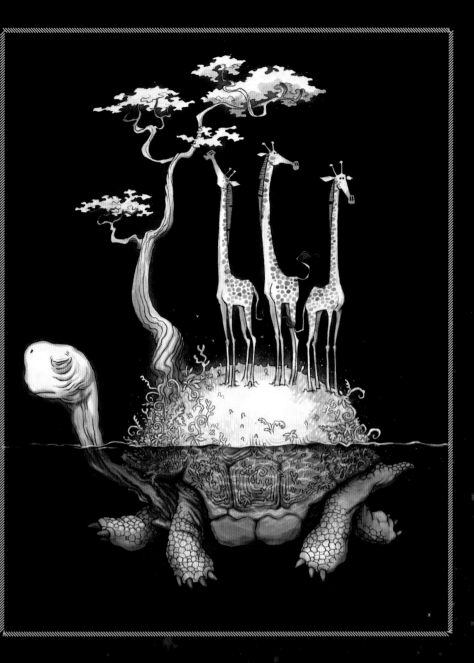

Three Wishes. Digital.

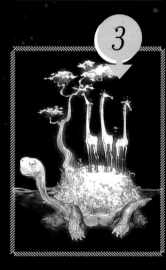

THREE WISHES DEVELOPMENT SEQUENCE ❶ Wong takes a lo-fi approach at first: the scan of his original linework features two A4 pages taped together. He draws the tortoise separately from the giraffes and tree, then uses Photoshop to erase the seams. When cleaning up the lines he also enhances the cool and warm tones from the scan to emphasize contrast. ❷ Wong creates a mask for the background, in order to paint separately on the background or foreground. He enhances the linework even more using curves, but at this stage still hasn't added any of his own brushwork or color. ❸ He lays down a lot of rough brushwork, sampling colors by holding CTRL as he paints, using the colors that already exist on the canvas. He's not concerned about hue here, just light and dark. The feeling he wants to achieve with the water is of a dark cave, with only the edge of the water visible, and mysterious quiet depths below. For the finished image, Wong refines the brushwork to bring out the shape of the shell texture and wrinkles, and to add shadows. He also adds caustics from the light, and added "glowy things" in the air. Finally, he processes the colors a bit, and it's done.

Imogen. Photoshop.

Stay. Photoshop.

Wong enjoys the daily challenges and opportunities for artistic expression that working in gaming design provides. "My biggest pleasure is in the day-to-day of spinning ideas," he says. "Letting our imaginations run wild. When we're doing that, it reminds me of why I'm doing this job."

What he doesn't love are the long development periods required by complex games. "Big-budget computer games take around two years to make. Some projects run even longer. So by the time I'm finishing a project I have so many ideas in retrospect about how I could have done it better," he confesses.

Wong advises beginning artists to "study foundation skills. There are many budding artists who have all the enthusiasm and imagination to make it big, but they are getting wrapped up in fine details, and color, and Photoshop brushes without having put enough work into studying drawing, anatomy, and storytelling."

To see more of Ken Wong's artwork, visit his website at www.kenart.net.

All images © Ken Wong unless otherwise noted.

BROM

"I usually try to paint characters that I would want to be if I had to be that person. I aim for some integrity behind the monster, the woman, or the guy, regardless of who they are in the story. I'm always trying to get emotion in there."

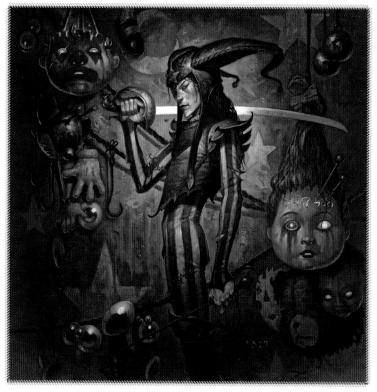

Jack. Oil on board. From *The Plucker.*

Brom paints some of the most beautiful and challenging fantasy images in the science fiction and fantasy field. The artist's mastery of line, texture, contrast, and in-your-face composition takes viewers on an often-disturbing journey to the darker side of fantastic art, a place populated by leather-clad fiends, tattooed ladies,

depraved toys, and fallen angels. What might be merely creepy and maybe even cartoonish in the hands of a lesser artist makes a profound impression in Brom's work. The author/illustrator of three novels, Brom finds writing and illustrating to be his own personal nirvana.

"Writing and illustrating my own work is almost as far as you can go in an individual project and maintain control," Brom notes. "I really enjoy it and it's what I've always wanted to do. Variety in subject matter and medium are what keep things interesting."

"*Gunslinger* is one of my favorite paintings," he says. "It inspired my novel *The Devil's Rose*. I did it for the Deadlands role-playing campaign. I love horror and historical Americana, so I was very happy to receive an assignment that combined both."

He adds, "For me, painting is all about character as I strive to create a connection with the viewer. I feel that the humanity in the subject's eyes—in contrast to the horror he has become—somehow—makes him tragic."

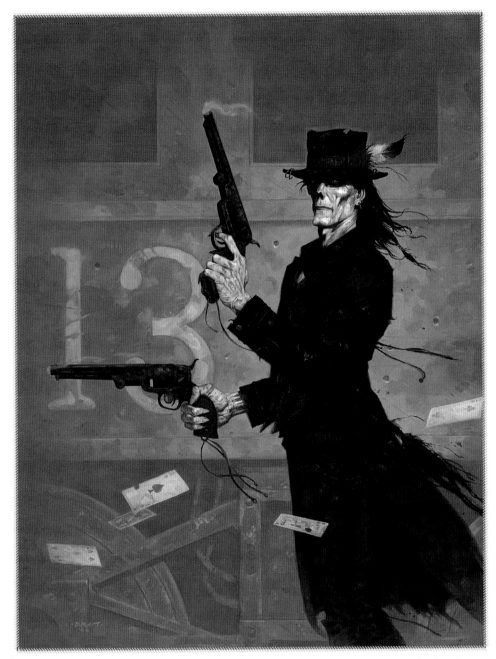

Gunslinger. Oil on board. Brom begins by transferring his finished drawing to the illustration board. From there he puts down an acrylic underpainting, working up the darks and lights and basic colors. He finishes with oils to achieve the rich look of classical paintings.

ated from high school in Frankfurt, Germany. He began to draw as a hobby. By age twenty, he was a commercial illustrator and soon acquired national art representation. Among his clients were Coca-Cola, IBM, and CNN. In 1989 he came into the fantasy field, working for legendary gaming design company TSR and contributing his particular artwork to Dungeons & Dragons and book lines as well as putting his mark upon the best-selling Dungeons & Dragons Dark Sun World campaign. Since that time he has become known in the art and publishing worlds by his last name, Brom.

In 1993, after four years at TSR, Brom returned to the freelance market. In addition to producing cover art for novels, comics, and games, he has been a concept and character designer for movies, computer games, and toys. Among the games he has worked on are World of Warcraft, Magic: the Gathering, Diablo, and Doom. Movies he has worked on include *Batman*, *Galaxy Quest*, and Tim Burton's *Sleepy Hollow*.

Brom's art has won several awards, including medals from *Spectrum: The Best in Contemporary Fantastic Art*. His imagery has been collected in *Darkwërks* (Paper Tiger, 1997) and *Offerings* (Paper Tiger, 2003). Most recently he's created a series of award-winning horror novels that he both writes and illustrates: *The Plucker* (Abrams, 2005), *The Devil's Rose* (Abrams, 2005), and *The Child Thief* (Eos, 2009).

Brom uses old-world techniques in a combination of new and old media, putting an acrylic underpainting beneath his oils. "I really like the feel of paint on board," he says. "I may reach a point where after a painting's finished I scan it into a computer, touch it up, and send it on its way. But a computer's like any other tool: It's got its pros and cons."

The artist was born Gerald Brom, in Albany, Georgia, in 1965. An Army brat, he lived in many different places, including Alabama, Hawaii, and Japan, and he gradu-

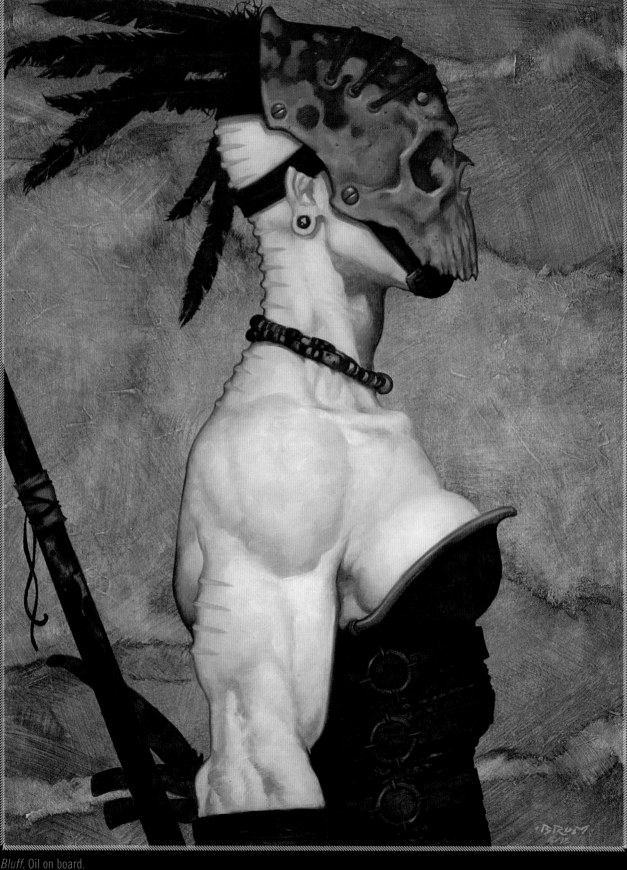

Bluff. Oil on board.

Brom's punk-influenced portraits and morbid paintings have decorated book covers, trading cards, and role-playing games, breeding an equally morbid enthusiasm in his fans, some of whom have gone so far as to tattoo his imagery onto their own flesh.

Unlike many fantasy illustrators, he doesn't rely on melo-dramatic color to make his effects. Using monochromatic color harmonies and strong contrast, he achieves powerful impact. Strong color, when it's employed at all, is used as an accent: a splash of tomato-red blood against pale skin.

The artist admits to being superstitious and easily scared. It's oddly reassuring to learn that when Brom turns off the lights in the basement of his home he races up the stairs. And who would blame him? If anyone knows what lies in wait in the darkness, it's Brom. "I've always enjoyed scary movies," he says. "Even as a kid, watching from behind the couch with my fingers over my eyes. It's that morbid fascination. I've just always liked things that are creepy and monster-oriented."

About the only blood involved in his artistic process is the metaphorical amount he sweats over his work. Not that every painting comes the hard way: "Some just fall into place," he admits. "Some you have to beat with a stick."

Becoming an artist was never a conscious decision for Brom. "I was drawing and creating as far back as I can remember. I believe such things are in the blood. My career path has been driven by my obsessive nature."

His brother opened the gate to the world of fantastic literature. "When I was a kid, my older brother first introduced me to Edgar Rice Burroughs, J. R. R. Tolkien, and Robert E. Howard," he says.

Brom became convinced that mainstream art was not his intended path. "I'd read all the fantasies and loved Frank Frazetta's artwork. I knew that that was the kind of work I really wanted to be doing. So, in my not-copious free time, I put together a portfolio, sent it out, and that's how I hooked up with TSR."

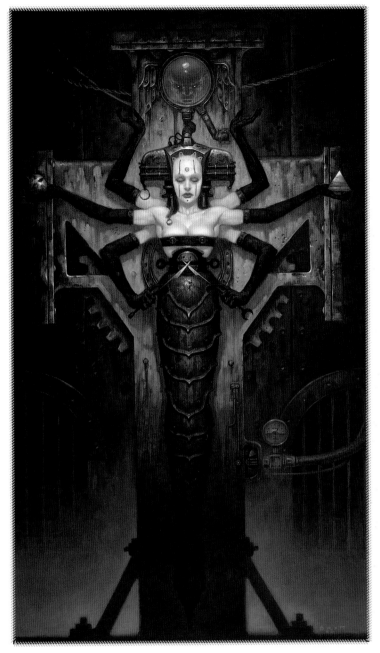

Soul Forge. Oil on board.

Brom has also found inspiration in the work of Richard Corbin, Michael Whelan, Greg and Tim Hildebrandt, Jeffrey Jones, Norman Rockwell, N. C. Wyeth, Howard Pyle, and even the pre-Raphaelites. "On top of that, add photography, music, and film," the artist says. "I think when you're a creative person in general, it's all about input. Everything goes into your own little machine and comes out with your own stamp on it."

One departure from earlier fantastic art traditions can be seen in the treatment of women in his work. Never mere displays of female pulchritude, Brom's women look

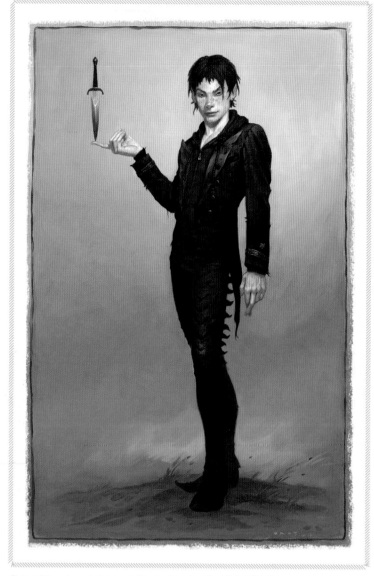

Peter. Oil on board. Internal illustration for *The Child Thief*.

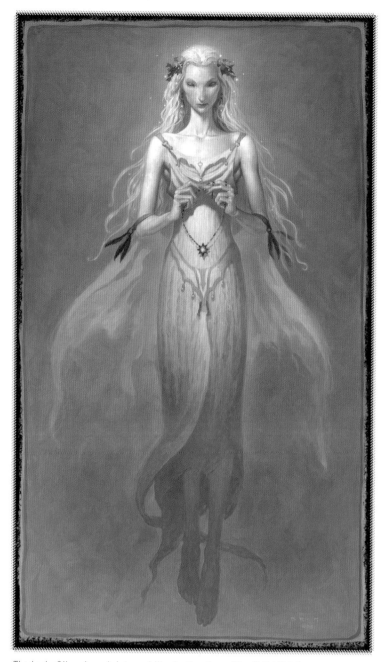

The Lady. Oil on board. Internal illustration from *The Child Thief*.

like they mean business. "I don't want to do just standard babe painting," he says. "I really like the idea of combining something beautiful or sexy with something disturbing or strong. I like to create that tension."

Brom's sympathy for his devils, monsters, and murderers is apparent in every painting he makes. "I usually try to paint characters that I would want to be if I had to be that person," he says. "I aim for some integrity behind the monster, the woman, or the guy, regardless of who they are in the story. I'm always trying to get emotion in there."

He notes, "Although I prefer painting straight from my imagination, there are areas where having a model—whether live or in photographs—can really help. The key is to go beyond the photo and not become a slave to it. Understand the physical structure of your subject and alter or exaggerate it as needed."

After his time spent as a commercial artist, Brom is definitely interested in artistic freedom. On the painting *Coil*, he says, "As lead artist and art director on the Dark Age collectible card game, it was my job to turn the various card descriptions into scenes and characters. It was one of the first times I had full creative freedom over a project," he recalls. "As a result, I feel I did some of my best work. It was a post-apocalyptic world returned to a feudal state, so I tried to bring a medieval theme to the futuristic elements."

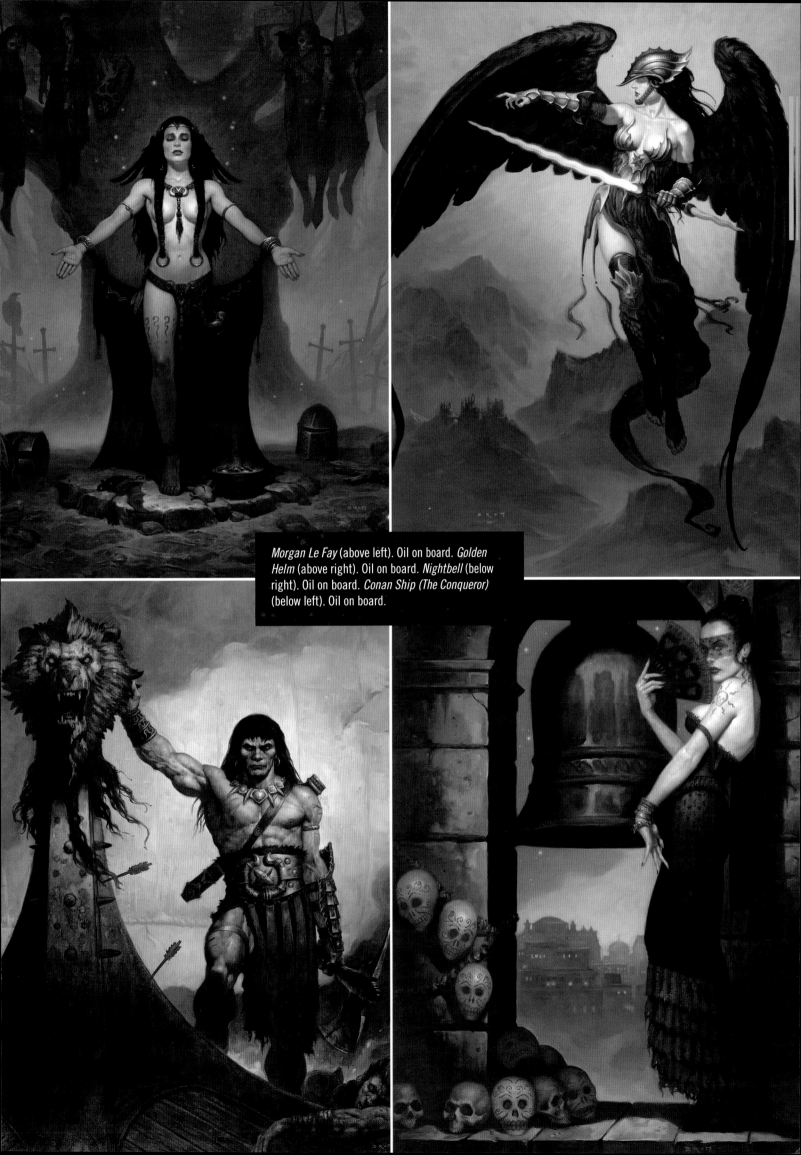

Morgan Le Fay (above left). Oil on board. *Golden Helm* (above right). Oil on board. *Nightbell* (below right). Oil on board. *Conan Ship (The Conqueror)* (below left). Oil on board.

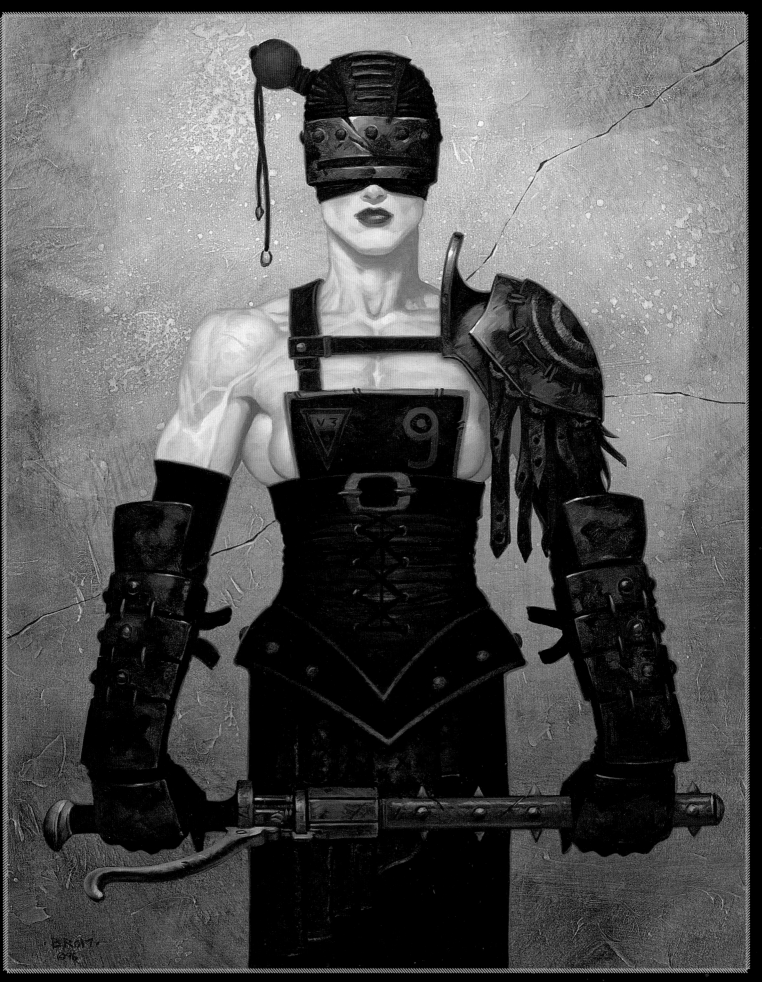

Coil. Oil on board.

In a simple composition such as this one, the artist likes to skip any preliminary drawing and instead draw the image with paint. This allows him more opportunity for discovery and happy accidents.

Stickmen. Oil on board.

Brom's creative process begins with ten or fifteen loose thumbnail sketches that allow him to experiment with gesture and composition. From there he often moves into the actual painting. His supports and textures may vary, depending upon his mood: He's used Masonite, illustration board, and canvas. What doesn't vary is his next step: a quick-drying acrylic underpainting to establish the darks and tones. Next, he goes in with oils to achieve subtle soft blending and pull out all the details. Varnish finishes the piece.

"I want to achieve an antique look that recalls the great illustrators of yesteryear and gives a sense of darkened varnish and accumulated years," he explains. Brom found his way to his true medium by hit and miss. "When I first left art school I was using straight airbrush," he recalls. "And then I tried acrylic. But oils are wonderful to me because they're very forgiving. I can scrub them out, change things, and the oils sit on top of the acrylics without any problem, although you can't do the reverse." Fans of his dark imagery might be disappointed to learn of his artistic versatility. "I really can enjoy painting any subject," he admits. "I wouldn't turn down an assignment just because it wasn't horrific."

FUN WITH MONSTERS

"I try to draw and paint out of my head as much as possible," he notes. "But if the subject is very realistically human, it helps to have really good references." He adds, "it's with the monsters that I can really have fun and exaggerate."

His favorite tool is an old beat-up brush. "I have dozens of mangy brushes in various states of decay," he says. "They're great for scrubbing in unique textures."

"My greatest pleasure is creating for myself and bringing my own visions to life with pictures and words," Brom says. His advice to beginning artists is to "fill your portfolio with the type of work you want to do. You get work based on what is in your portfolio. If you want to paint apples, don't put oranges in your portfolio."

To see more of Brom's work, check out his website at www.bromart.com.

All images © Brom unless otherwise noted.

GREG SPALENKA

"I work very hard at conceptualizing. In this day and age of visual bombardment I want to create something new and not use so much borrowed interest. The norm in this business is the obvious, the literal, and the cliché. There are too many editors and marketing people making decisions about art."

Hypnotised. Mixed media/digital. Concept design for *Prince Caspian: Voyage of the Dawn Treader*. Image © Walden Media, Fox.

As artists go, Greg Spalenka is a bit of a paradox. He uses such low-tech materials as packing tape, found objects, and scratches in paint, then reworks them using sophisticated digital effects. He creates images of both sublime spiritual beauty and hard-edged science fiction machinery. The artist, a spiritually engaged transcendentalist, is also a business professional who keeps a sharp eye on the bottom line when it comes to financial compensation and artistic freedom.

Spalenka began his award-winning career in 1982, after graduating from Art Center College of Design in Pasadena, California, with a BFA. He moved to New York City and began a twenty-six-year journey illustrating for the United States' most prominent publishers of books, magazines, and newspapers before turning his professional attention to films, music, lecturing, and fantastic art. Spalenka's print clients include the *New York Times*, *Wall Street Journal*, *Rolling Stone*, *Time*, *Newsweek*, *Ms.*, *Psychology Today*, *The Atlantic*, *Sports Illustrated*, *Harpers*, *Fortune*, *Business Week*, *Mother Jones*, and *Playboy* magazines. His artwork has appeared on the covers of books published by HarperCollins, Scholastic, Viking Penguin, Random House, Simon & Schuster, Holiday House, Tor Avon, and Farrar, Straus and Giroux.

The recipient of gold and silver Society of Illustrator medals, gold and silver awards from *Spectrum: The Best in Contemporary Fantastic Art*, as well as recognition in *Communications Art Annual*, *American Illustration Annual*, and *Print Magazine Regional Design Annual*, Spalenka has extensively exhibited his work in the United States and

Big Gun. Digital. Concept design in collaboration with Ian Miller for the animated film *Escape from Planet Earth*. Image © Rainmaker Entertainment.

Japan. He has also lectured and run workshops throughout the country. Much of his deeply textured artwork is drenched with light that emanates a palpable spirituality and lingers long in the mind's eye. "I attempt to attain a sense of the sacred in all my art," Spalenka says. "Even if the subject is dark, there is always a little light to balance it."

As a concept designer he's worked on five feature CG animated and live action films, including *The Ant Bully*, *The Golden Compass*, *Escape from Planet Earth*, *Kamlu*, and most recently the third Narnia film, *The Voyage of the Dawn Treader*. He has also provided art and design for the game Warcraft.

Spalenka's work combines traditional hand skills and digital effects while building layers of imagery, texture, and meaning. He is guided by both concept and intuition. The artist begins his process with photos, images drawn on illustration board, and collaged elements. After these are assembled and sealed with an acrylic medium, he paints on top of them with acrylics, sometimes applying the paint by hand and moving it around. Next he distresses the paint with sandpaper and metal scrapers and again uses acrylics to seal the final results.

Dufflepod. Mixed media/digital. Concept design for the film *The Voyage of the Dawn Treader*. Image © Walden Media, Fox.

THE ANT BULLY DEVELOPMENT SEQUENCE "In the film *The Ant Bully*, the ants have created their own creation mythology," Spalenka explains. "The Ant Mother was their goddess and she was depicted in a mural inside a drainage pipe. Barry Jackson was the production designer for this film and he had his concept design team working in black and white at the beginning of the production to speed things up and so that we could focus on design solutions. I worked on many designs for this environment, but these images will give a sense of how this concept evolved." He adds, "All work here was created in Photoshop." ❶ Spalenka wants to communicate a feeling of reverence despite the scene's location inside a drainage pipe. After researching different cultures' sacred sites, he selects patterns, effigies, and sacred symbols as elements to embellish and decorate the scene, establishing the drainpipe as a spiritual sanctuary. ❷ The artist makes the Ant Mother more representational. He places lost human objects—a key and tweezers—in the ground before the Ant Mother to bring some perspective to the space and provide a sense of scale. He also adds rays of light, coming through the broken pipe, to provide some drama to the scene. ❸ Spalenka takes a new viewpoint, and adds some color to the art and ant statues on the pipe's walls. In this final image used in the film, Spalenka refines the Ant Mother for a quicker "read" by viewers, reinserts the iconic images of key and tweezers, and places some golden rays behind the Ant Mother image to further emphasize her sacred importance.

The Seer. Mixed media/digital.

His interest in distressed surfaces emerged literally by accident. During his student days, Spalenka asked a friend—fellow artist Matt Mahurin—to give him some objective criticism of a piece he was working on. Mahurin's response was startling, Spalenka recalls. "Matt said, 'Sometimes you just have to know when to let a piece go.'" With that, he tossed the painting into the street, where it was run over by several cars before Spalenka could retrieve it. As the artist recalls, "Deep gashes covered part of the surface, new textures came to light, and I realized that this treatment had actually improved the piece! After that, texture became increasingly important to me." He notes, "I rely on what I call 'happy accidents' rather than attempt to guide it. The collage aspect of my work is very intuitive. Whatever ends up in much of the collage disappears beneath the paint. Little bits and pieces may show through in some places, turning it into texture."

IN AND OUT OF THE BOX

As Spalenka develops each work, the process of building and destroying continues until he's achieved what he calls "a balance of refinement and rawness." At this point, the artist begins to refine certain elements and images with oils. Next he scans the art and continues the process with Photoshop. "Adding images, textures, and paint in the digital realm brings the art into another world," he notes. "After working in cyberspace for a while, I may print the image out on my Epson and work again in paint."

Spalenka usually scans the work once again and finishes it in the computer. This in-and-out-of-the-box process takes him roughly three days to complete. The effect can give an "archeological" aspect to his work as the viewer literally uncovers layers of imagery and meaning. "I work very hard at conceptualizing. In this day and age of visual

Green Witch. Mixed media/digital. Concept design for the film *The Voyage of the Dawn Treader*. Image © Walden Media, Fox.

bombardment I want to create something new and not use so much borrowed interest. The norm in this business is the obvious, the literal, and the cliché. There are too many editors and marketing people making decisions about art." He adds, "That said, there's a point in my process where intuition takes over."

The artist lives in the Santa Monica mountains with his wife, artist/botanical perfumer Roxana Villa, and her daughter, Eve. He is currently focused on presenting

Artist as Brand workshops, finishing his first written and illustrated novel, and releasing a second musical CD, *Moonsaba* (2010). His first is called *The Visions of Vespertina* and is a musical/artistic collaboration with songwriter Michelle Barnes.

To see more of his work, visit his websites at www.spalenka.com and ArtistAsBrand.com.

All images © Greg Spalenka unless otherwise noted.

New Dimensions. Digital. Concept designs for the film *The Golden Compass*. Image © New Line Pictures.

Lotus Love. Mixed media/digital.

DEEP BLUE SEE DEVELOPMENT SEQUENCE The poster *Deep Blue See* was created for portfolio day at the Laguna College of Art and Design. Spalenka explains: "My concept for this art focused on the depth of our imagination, how ideas swim to the surface of our consciousness to break into the conscious mind. The subconscious is associated with water, liquid, and fluid, so turning the body into an ocean of possibility seemed to work here."

LAGUNA COLLEGE OF ART & DESIGN

Laguna College of Art & Design
2222 Laguna Canyon Road
Laguna Beach, California 92651
949.376.6000
www.lagunacollege.edu
admissions@lagunacollege.edu

BFA & Hybrid Programs
Graphic Design
Illustration
Feature Animation
Drawing & Painting
Sculpture

Deep Blue See. Collaboration with Brad Weinman. Jeff Burne Design.

❶ Spalenka works up some preliminary color sketches in Photoshop. ❷ He uses sketches as a springboard into the final art to keep his sense of spontaneity. ❸ Next, Spalenka takes photos of his stepdaughter Eve and a glass pitcher filled with water. ❹ He begins weaving bits and pieces of these photos together in Photoshop ❺ Spalenka wants to get a sense of depth and transparency in his concept of an ocean inside the body. ❻ "Occasionally I like to collaborate with artist friends. In this case I asked Brad Weinman if he would whip up some creatures that I could place inside this figurative ocean," Spalenka says. He takes Weinman's pencil drawings of different sea creatures and places them inside the waters, tweaking here and there to make them more fantastical and mysterious. ❼ For the background he uses a chaos generator program and creates some mysterious smokelike effects. ❽ Friend and graphic designer Jeff Burne provides possible type approaches. Spalenka suggests the arching title over and around the head, which is used in the final version.

BRUCE JENSEN

"Digitalized art has gotten kind of familiar. Now people get a software update or new filter from Photoshop and it might be neat, but if everybody gets it, it's almost like a style virus infecting the field. Anything that's overdone loses its impact."

Forever War. Digital.

When you look at a work by Bruce Jensen, don't be surprised if the painting stares right back at you. Jensen is known for confrontational compositions, often dealing with cyberpunk themes. His acrylic paintings are characterized by strong geometrics, trompe l'oeil realism, and a collagelike quality that is often heightened by digitalized manipulation of the imagery. His use of color is bold and his portraiture is edgy and unsettling.

Two of his notable covers have been for *The Diamond Age* by Neal Stephenson (Bantam/Spectra, 1996) and the reissue of *Do Androids Dream of Electric Sheep?* by Philip K. Dick (Ballantine, 1996). "I only do science fiction art," Jensen says. "And there's a natural tendency in science fiction art to paint something realistically. It's sort of a conservative art mode wherein you're realizing fantastic things in realistic ways. But I like to push that, to take a less literal approach. I want to evoke the books' themes without painting a specific scene or situation."

"Commercial art is basically about problem-solving issues," the artist says. "I bought myself a lot of freedom when I realized that there wasn't just one way to interpret."

Maelstrom. Digital. The artist used Photoshop to bring out graphic elements, textures, and paint. In this image there are scans of air bubbles trapped under cellophane tape, flaking paint on cement, thread, and paint drips. The artist also did some filtering to swirl some of the paint and textures as well as the typographic bits. The portrait is painted in Photoshop.

Diamond Age. Mixed media. The cover for the novel by Neal Stephenson is a mixed-media construction. Clockwork gears are evocative of the Victorian period revival, and of the nanotechnology central to the plot. The artist uses them with wires as a framing device for the central digital image.

Jensen has been illustrating covers for science fiction novels since his graduation from the Columbus College of Art and Design in 1984. His clients include Berkley Books, Bantam Spectra, Ballantine Del Rey, Penguin/Roc, Tor Books, the Science Fiction Book Club, Marvel Comics, DC Comics, and various magazines and other publications. His illustrations are on the covers of books by Philip K. Dick, Neal Stephenson, Bruce Sterling, Robert Silverberg, Robert Heinlein, Arthur C. Clark, Joe Haldeman, Pat Cadigan, Frederik Pohl, and A. E. van Vogt, among others.

From 1999 to 2005 Jensen was art director and illustrator for the seven-season run of the CBS newsmagazine *60 Minutes II*. He continues at *60 Minutes* as a designer and an animator. His work can be seen in *Spectrum: The Best*

in *Contemporary Fantastic Art 1–13* and *15*, *Infinite Worlds: The Fantastic Visions of Science Fiction Art* by Vincent Di Fate (Studio, 1997), and *Illustrators 35* and *40*.

Born in Indianapolis in 1962, Jensen knew early on that he wanted to be an artist. Luckily, his parents were unusually supportive. "I guess telling your parents that you want to be an artist is almost as bad as telling them you want to be a rock musician," he says. "But my parents never freaked out. They always tried to figure out how to help me out. My dad even took me to a comic book art convention, grabbed a comic book artist, and asked him to talk to me about the field."

For years, comic books and science fiction competed for Jensen's attention. "In high school I was always bouncing back and forth between comics and painting," he says. "I was also painting my own ideas for science fiction. I would take my paintings to conventions and show them to the pros."

Other Dimensions. Digital.

What Have They Done to Our Food? Digital. Image © CBS News.

When it was time to choose a college, Jensen looked to other artists' bios to see where they had studied. "Robert McCall had attended Columbus College of Art and Design in Ohio, and John Jude Palencar was a recent grad. That convinced me to go there," he says. "After my junior year of college I decided to test the waters, so I went to the Baltimore World Science Fiction Convention, and met David Mattingly, Barclay Shaw, and Michael Whelan, and saw Vincent Di Fate for a second time. Everybody was really supportive." Looking back on it now, Jensen admires his own deliberate approach to finding a career in art. "I was awfully single-minded when I think about it now," he says. "I wanted to get the technical skills down. As soon as I got out of school I moved to New York and took my portfolio around. I was getting book covers—but it was slow at first. So I got into television and learned computer stuff back in the 80s while I freelanced. In 1985 it was all quite new and exciting."

MIXED FEELINGS

Jensen's early immersion in the newborn medium of digital art has left him at ease with computer tools, if a bit ambivalent about the spread of their use. "In principle, I think digitalization is a good thing." he says. "It especially helps people who aren't as technically skilled, although a lot of painting is about technical ability. You can bypass certain learning curves, but I don't think you can bypass creativity. So we're in the midst of a big artistic experiment."

"At the time I started working I was happy to be using a new approach," Jensen recalls. "I would paint from computer sketches, using them as roughs. But digitalized art has gotten kind of familiar. Now people get a software update or new filter from Photoshop and it might be neat, but if everybody gets it, it's almost like a style virus infecting the field. Anything that's overdone loses its impact."

"That said, I do think that many people do digital art really well, especially artists like Dave McKean and Rick Berry." Before he began working regularly in digital mode, Jensen's own airbrush and acrylic paintings frequently combined digital imagery and hardware. Many of his assemblage paintings are trompe l'oeil, as can be seen in his cover for the book *The Diamond Age*, where Jensen literally incorporated watch parts into the work.

Four Frontiers. Digital.

Among his influences, Jensen counts Richard Powers and Michael Whelan, but also cites the assemblages of Joseph Cornell, the juxtapositions of René Magritte, Yves Tanguy, Alberto Giacometti, and the modernists. "Sometimes I'm just doing a science fictional variation on the early twentieth-century modernists and surrealists," he explains. "Publishing—which is where I do my sci-fi illustration work—tends to favor literal and even scene-specific illustrations. I like to insert ambiguity wherever possible." He adds, "Fantasy has become more popular than science fiction, and although I favor the latter, I understand the appeal—and challenge—in making something 'fantastic' look real." Jensen describes his illustration process as collaborative. "It's like improvising on a theme—the author's theme. I read the book, then put it aside for a few days because I've found that I'm always a bit too dazzled by it at first. Then I make some lists of images and ideas. It's a strategizing kind of thing," he notes. "My artistic considerations are separate from the book: color or no color, texture, use of the title, etc. I like to link the title to the image whenever possible." Next come thumbnail pencil sketches. "All of my final sketches are done in digital media to finish the color. The computer's really handy for pushing things a level beyond. You can imagine something and then try to execute it. It allows you to play with certain imagery, experiment without damaging. It's like a painting medium that's always dry, but it's also always wet. You can always move things around."

He adds, "Photoshop is really versatile and powerful, just as the airbrush was a very handy tool when I worked in acrylics. But if I have to imagine a single, favorite tool, then probably that would be the paintbrush. There's something incredibly satisfying in the craft of making an image with brush and paint."

Archangel Protocol. Digital.

This is a Photoshop piece for which the artist used several photos he'd taken of scan lines from a CRT monitor as a primary texture. Previously he had attempted painting some of these same effects with acrylics and occasionally collaging a photo into a mixed-media piece. With Photoshop he can achieve the desired effects, to blend and distort the photos, within the painting itself.

Do Androids Dream. Acrylic on board.

"The coarse textural treatment is drawn from the author's preoccupation with entropic processes," Jensen explains. "The electric sheep of the title is illustrated as a psychedelic 'painting' within the larger painting. The portrait is intended to remain unresolved as either human or android."

Wall Street Prophets. Digital. Image © CBS News.

Jensen aims for evoking a sense of the book's contents in the cover rather than directly stating something in narrative style. "I hope that I can draw from the book a textural impression. This was my goal in illustrating the cover for *Do Androids Dream of Electric Sheep?*"

"That assignment was truly a gift," he notes. "I produced more sketches for it than I ever had for any other job. I'm very fond of constructing ambiguous imagery, and what better reason than when illustrating a Philip K. Dick book?"

Jensen says that his major considerations when painting a cover are what the publisher needs, what the author offers up, and what he can personally bring to the work. "It's a challenging time. Art directors and publishers are so nervous now. They're worried about making the wrong choice."

He adds, "I always like to put something personal in my work. To meet the story halfway but leave something mysterious. My greatest pleasure is making an image that invites and intrigues viewers, making them want to know

Astronomer. Oil on panel. In order to work more with hand skills, the artist has embarked on *Alien Menagerie*, a series of personal oil paintings on panel. These paintings emphasize color and formal qualities, with a touch of whimsy thrown in.

more. Sometimes I pull the cover imagery from other unexpected places. All sorts of things seep back in. I like it when people say, 'It feels like the ambience of the book comes through.' That's when I know I've done my job."

For readers interested in seeing more of Bruce Jensen's work, check out his website at www.brucejensen.com.

SCOTT M. FISCHER

"Every artist has to be able to develop a third eye—to know what you have to do, where, and when. It's an editing process, literally art-directing your own work. So many young illustrators are so crushed by deadlines that they don't have time to let the work cool off and breathe."

Serra Avenger. Mixed media/oil on canvas. © Wizards of the Coast.

Dreams can come true. Just ask Scott M. Fischer. "Back in the fourth grade, I said, 'I want to make the art for Dungeons & Dragons,'" he recalls. "To have grown up and actually done it is just amazing. I've been *so* lucky."

Fischer graduated with honors from the Savannah College of Art and Design in 1994, and since that time his brush has steadily been emblazoning a path through the science fiction and fantasy landscape. He is the illustrator of Geraldine McCaughrean's *New York Times* best seller *Peter Pan in Scarlet* (Simon & Schuster, 2008), and a notable cover artist for Tor Books, HarperCollins, Scholastic, Penguin, Del Rey, and other leading publishers.

Fischer's paintbrush has illustrated The Secrets of Dripping Fang series by Dan Greenburg (Harcourt Children's Books, 2001–2007), Halo, the Harry Potter Trading Card Game, Robert Jordan's Wheel of Time series, Magic: The Gathering, and, of course, Dungeons & Dragons. Fischer recently contributed a painting to *Star Wars Visions* (Abrams, 2010). His client list includes Marvel, Microsoft, Nintendo, Warner Bros., Wizards of the Coast, Lucasfilm, and White Wolf.

Bogardan Hellkite. Mixed media/oil on canvas. © Wizards of the Coast.

Recently the artist added a new title to his resume: children's book author and illustrator. His first children's book, *Twinkle* (Simon & Schuster, 2007), is a personal take on a famous childhood nursery rhyme. "It was so exciting to see my first children's book hit the shelves," Fischer says. "Stylistically, my illustrations for my children's books are a real departure from my fantasy work. I keep them very simple, and I felt they had to be more immediate, more basic, and fresh. I wanted the reader to see the smudges, to see that there was a human hand involved."

Twinkle was soon followed by *Animals Anonymous* (written by Richard Michelson, Simon & Schuster, 2008). Fischer's latest book, *JUMP!* (Simon & Schuster), was published in 2010.

Fischer has also been busy as a conceptual designer in the gaming industry and Hollywood. He's helped create worlds for gaming producers Microsoft and Sony, and recently finished working with Disney Interactive on a new game, Tron-Evolution.

Luck may have had something to do with his success, but it doesn't hurt that Fischer is incredibly positive and enthusiastic, not to mention talented and hardworking. His "no-problem" attitude makes every challenge he's encountered sound like a pleasure.

Many artists might have been a bit nervous to take on the challenge of illustrating a fairy-tale legend, especially when the gig was art for the first authorized sequel to J. M. Barrie's hundred-year-old classic, *Peter Pan in Kensington Garden*. The original illustrator, art legend Arthur Rackham, casts a long, intimidating shadow. Any artist would have thought twice. As Fischer tells it, he didn't have the luxury of getting nervous.

"Luckily, I had to do it so incredibly fast that I didn't really have time to think about the enormity of it," he says. "I got completely immersed. I was in such a fever of activity, doing forty illustrations over a month. I sent my wife and daughter down to Florida to have fun, and I just became a hermit. All I did was work," he recalls.

Young Man without Magic. Watercolor/digital.

The cover for *Young Man without Magic*, by Lawrence Watt-Evans (Tor Books, 2009), begins as a digital underpainting. Fischer "frankensteins," as he calls it, multiple photo sources together via Photoshop, to achieve a basic layout. Next he makes a drawing based on the digital image, then merges it and the digital underpainting into one layer. Deciding upon a traditional finish for more grainy texture, he prints out a very light version of the digital underpainting/drawing hybrid on watercolor paper and paints the final image in watercolor rather than his usual medium, oil. Finally, he scans the painted image and makes a few last digital enhancements.

Telling Time. Mixed/oil on board. © Wizards of the Coast.

Despite his many career developments, and the many worlds he's visited through them, the artist still gets excited when he speaks of his work illustrating Dungeons & Dragons and Magic: The Gathering. "In part it's because of what I dreamed of as a child, but it's also because of the fans. They are simply the best fans in the universe. I hope to be able to do at least one Magic: The Gathering card every year."

Little Grrl Lost. Mixed media/watercolor on board.

Savra. Mixed media/oil. © Wizards of the Coast.

Orphans of Chaos. Mixed media/oil on board.

Fischer's decision to paint silhouettes for the illustrations was, in part, out of respect for and an homage to the original illustrator. "Arthur Rackham was famous not only for illustrating *Peter Pan*—and so many other fairy tales—but also for his use of silhouettes. After I talked it over with Tony DiTerlizzi—who had done the cover for the book but didn't have time to do interior illustrations—we agreed that silhouettes were probably the *only* way to go, since so many people already have an idea of what Peter Pan looks like. It wouldn't be the same book if I'd gone in and drawn every eye and every ear. This had to be as timeless as Peter Pan himself." Fischer explains.

"Let me tell you, my real 'awe' moment came when I was doing the illustration for Captain Hook's pirate ship, the *Jolly Roger*. I literally got chills," he admits.

ALWAYS ABOUT ART

Art was Fischer's goal from early childhood. "My mom jokes that I came out of her womb holding a paintbrush." he says. Encouraged by both his artist mother—who put down her own paintbrush to raise a family and then successfully returned to the easel at age fifty—and a father who supported his son's artistic tendencies, Fischer was also nudged toward art by the family's peripatetic lifestyle.

"Being an Air Force brat meant I had to entertain myself because we moved a lot, didn't know anyone in town, and besides, all of our toys were packed," he recalls. "Once, when we had just arrived at a new base, my mother asked me what toy I wanted her to buy, to make up for all of my toys being shut up in boxes, and I asked for a package of tinfoil. I made castles and dragons and other stuff with it. With art I could always entertain myself. And I could also use it as a way to meet people."

Evil Guest. Digital. "What is happening in murky shadows is often more fascinating than that which is in the light," says Fischer. "I prefer ambiguity with a hint of reality. I try to give just enough 'real' to bring viewers in. Once they have arrived it is up to them to explore what is between the cracks."

Killbox. Digital. For this cover for the novel *Killbox* by Ann Aguirre (Ace, 2010), Fischer again begins with a digital underpainting, using many sources, including an image of his wife, toys, and random photos from the Internet. Once he likes the composition, he makes a drawing based upon the photo composite. He enjoys using unusual sources for images. Here, the ship in the background is mostly made up of pictures of the inside of a typewriter that have been cut, pasted, inverted, and cloned. The artist used impasto digital brushes to achieve a traditional painterly look, employing ArtRage for textured passages, and the pen tool in Photoshop CS2 to mask certain areas for later painting.

Fischer says that he enjoys playing with the viewer's expectations, encouraging his or her participation. Formal concerns and contrast are a big element of his work, with color functioning as an accent and a focal point. Fischer indulges in texture and pentimenti—visible traces of earlier painting—often employing looser, more painterly brushwork to emphasize abstract qualities of the piece.

His female subjects are powerful but never portrayed as sexual objects, a deliberate decision on his part. They are complex, sophisticated, fully realized individuals who might happen to be attractive, but that's not the most important thing about them.

Fischer loves certain digital tools. "The pen tool and the lasso tool are fantastic. I'll often use nothing but the polygon lasso tool and brightness and contrast to build up the planar shapes of a painting," he notes. "Then I usually knock back those planes with a palette knife—type digital brush to make the transitions a bit smoother. I have whole folders with nothing but scanned traditional brush marks that I will lay on top of a piece, playing with opacity, overlay, dodge, and burn, then erasing out areas where I don't like the effect. No two pieces are made quite the same. I don't really have a formula, and I use almost everything in my bag of tricks, to some degree, in every piece." He adds,

Upon his graduation from Savannah College of Art and Design, he got his first gig painting eighteen paintings in fifteen days for White Wolf Publishers. "It was a baptism by fire," he remembers.

"After White Wolf, where I did oil paintings, I next did concept work for Microsoft and gaming companies and got comfortable working with computers. So now I do both. But I always want to keep the hand in the work. I love blurring the line between what is computer and what is hand-generated so that it's seamless."

Imperious Perfect. Mixed media/oil on canvas. © Wizards of the Coast. Fischer advises beginning artists to concentrate on the composition as a whole. "Try to see the whole piece and not just a head or a hand or an eye or a nose," he says. "Focus on decorating the room after you've laid a solid foundation."

"The most important tool of all is your eye. The piece will start talking to you, telling you what it needs. You just have to see it. In the end I just keep messing with it until something looks cool."

Fischer gives props to his favorite artists, among them Brom, Rick Berry, Mark Zug, Odd Nerdrum, Norman Rockwell, Phil Hale, and Gustav Klimt. He notes, "I especially want to mention Mike Mignola. The way he thinks about shape and silhouette has been enormously influential to my art, even if it doesn't look like it."

The best advice he ever received was a blunt statement by his friend, illustrator Doug Gregory, who said, "Scott, you can paint like a *mo-fo*, but your drawings stink and you try to make up for it in the paint, and can't."

Fisher says, "From that moment on I began to pay *way* more attention to doing great drawings before I ever even touch a brush."

The artist says that his current process usually begins with a hand drawing. "From there, I work up the basic underpainting—the basic tones, etc.—on the computer, then paint it in oil."

He continues, "Often, I start by doodling, usually with my wife as my main model. I use parts of her combined with other references. I call it 'frankensteining,' because I'm literally using a piece of this and a piece of that. So my wife can recognize her eyes in somebody else's face, for example. And it's always fun to bring her along to conventions and introduce her as the model for a goblin, because, in reality, she is so beautiful."

Fischer is also a big fan of squinting. "Squinting is the most important skill. I learned that from *Alla Prima: Everything I Know about Painting* by Richard Schmid. That book had a huge effect on me. Schmid really helped me open my third eye. He said to constantly squint at your paintings, and don't commit to anything until you've squinted at it so long that the answer is obvious." Staying flexible about media is one of the skills Fischer employs in developing his third eye. "Every artist has to be able to develop a third eye—to know what you have to do, where, and when," he explains. "It's an editing process, literally art-directing your own work. So many young illustrators are so crushed by deadlines that they don't have time to let the work cool off and breathe."

He provides advice to young artists on his own website, www.fischart.com, and also recommends the site www.conceptart.org: "It's almost better than going to art school," he says. "I post some pieces on it and get a lot of questions, so I'll post discussions there about technique and break down what I did."

TODD LOCKWOOD

"Never stop learning. And I don't mean only art. Everything you can know will have value in your work: geology, geography, anatomy, history, mythology, math, literature, and on and on. The more you know, the deeper the well you draw from."

Musculature of the Greater Dragon. Digital.

Esteemed artist Todd Lockwood embarked upon his fantasy illustration career with a trip to a convention in 1994. Shortly after, TSR—and later Wizards of the Coast—asked him to become a dragon master, redefining the look of the popular Dungeons & Dragons game for its third edition release. Lockwood left his mark upon their dragons, giving them a new and dynamic realism. His work met with cheers, and today he has legions of

fans around the world. In addition to his famous work for Dungeons & Dragons, he's especially well known for the popular covers he painted for R. A. Salvatore's Drizzt novels (Wizards of the Coast).

"I do like dragons, but the challenge is to make them believable. You pretty much do have to use everything you know about reptiles and cats and birds and skin and light and volume. It all comes into play," he notes. "At the very least you have to be aware of the volumes in your head, think three-dimensionally," he says. "My dragons tend to have catlike anatomy in their forelimbs and hindquarters—and that's not by accident. Whatever it is that makes the lion the king of the beasts, dragons have in spades. And whatever it is that draws us to lions—and, for that matter, dinosaurs—such as fierceness, intelligence, predatoriness, and overwhelming presence and power, dragons have as well."

Over the years, Lockwood's work has appeared on the covers of *New York Times* best-selling novels, magazines, video games, and fantasy role-playing games. It has been

Stormcaller. Digital. Cover of novel by Tom Lloyd (Pyr, 2008).

honored with multiple appearances in *Spectrum: The Best in Contemporary Fantastic Art,* in the *Communication Arts Illustration Annual,* and with numerous industry awards, including the Chesley Award.

"I create fantasy and science fiction images using a mystic combination of acrylics, oils, Corel Painter, Photoshop, blood, epithets, and secret incantations," Lockwood notes, tongue partially in cheek. "When I work digitally, as I mostly do these days, I use Painter for almost the entire process, with a little bit of Photoshop here and there, especially at the very end when I make sure the image is ready for preproduction by the publisher. I prefer Painter because it has a more traditional pre-sentation with brush marks, paper textures, and other realistic effects, rather than the photomontage look that is associated with Photoshop."

Lockwood adds, "Graphite is underrated as a medium; it has fluidity and depth that are largely untapped, and unappreciated by most art viewers. There are times when an image is better served in black and white, when color says too much. Pencil is the first tool most artists learned to use, when they were very young, so it is familiar and intuitive. Add an electric eraser sharpened to a point and a smudge stick, and you have a truly versatile means of expression."

He also loves the look and feel of oil paints. "Oils are simply the most luscious and tasty of any color media. No other paint has as much luminosity and presence. I didn't really begin to excel as a painter until I switched to oils. I love how they respond to the brush and interact with the textures of the ground, how light shines into

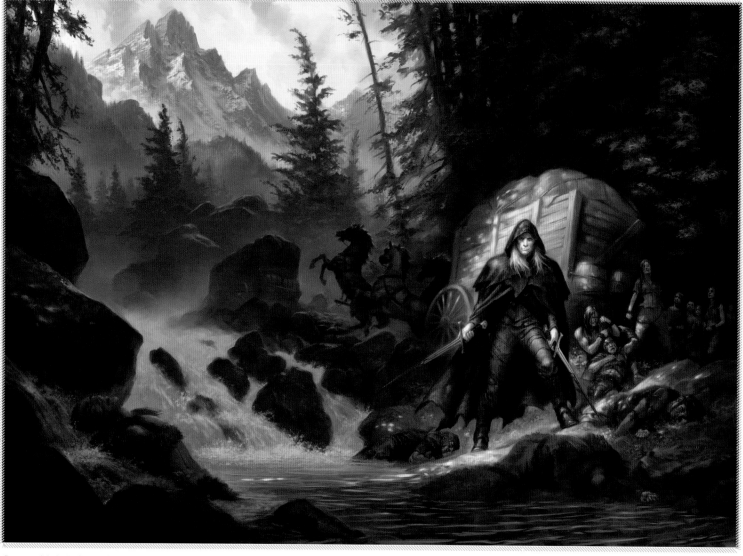

Reaper. Digital. Cover for *Reaper's Gale* by Steven Erikson (Tor Books, 2008).

them and then out again, enhanced. There is nothing so striking in person as a large oil painting."

A RELUCTANT DIGITAL ARTIST

"I never wanted to be a digital artist, but I saw how the industry changed when Photoshop appeared. I was determined not to be caught twice in that position, so when Painter appeared, delivering images that looked just like paint, I felt compelled to learn it. "He adds, "I haven't regretted it—of all the media, it is the most fun. There are no ancillary chores like brush cleaning, and scanning, and packaging. Painter is a digital medium meant for artists who are proficient in traditional media. It would be perfect if it delivered an actual painting . . . a physical object that one could hold or hang on a wall. But a print cannot compare to an oil painting in the end."

Like so many in the field, Lockwood discovered and was inspired by Frank Frazetta's artwork at an early age. He went on to find inspiration in other artists, including David Wilcox, Peter Lloyd, Boris Vallejo, Jeff Jones, and certain advertising luminaries. However, Lockwood confesses that he had one specific goal: "I really wanted to be Michael Whelan."

The young artist studied at the Colorado Institute of Art, then got a good job in a design shop in Denver right out of school and won several awards, including a silver medal in the Art Directors Club of New York annual show. But the work, he found, was not satisfying. After a year and a half, he quit to pursue illustration.

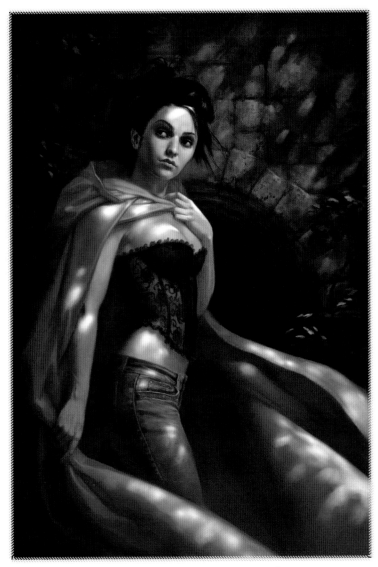

Blue Cloak. Digital. Adapted from cover art for White Wolf.

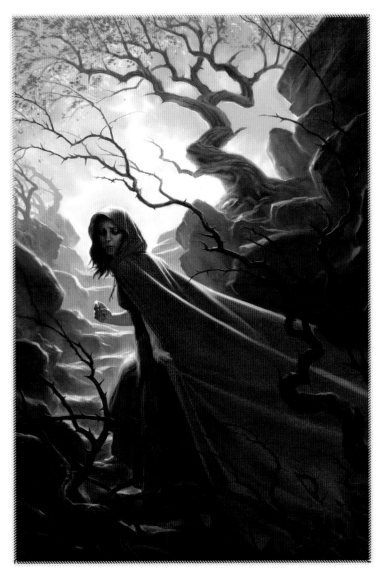

In the Shadow. Digital. Album cover for S.I.G.M.A. Project.

That led to fifteen years doing "hard time" as a freelancer in advertising art. Coors was one of his biggest clients. Another specialty was satellite dishes. "Some covers that I had done for *Satellite Orbit* magazine were recognized in the *CA Annual*," Lockwood recalls. "So for years after that I was the go-to guy for satellite dishes. If I'd ever had cause to do a painting with both a beer can and a satellite dish in it, my ad career would have been complete."

Science fiction and fantasy never completely faded into the background for Lockwood. "Throughout those years, I was an avid Dungeons & Dragons player," he recalls. "I flipped when TSR started having really good art on their products. Jeff Easley's stuff particularly interested me: so moody and fluid, so deft. Then Brom came along and really blew my doors off."

"I started to get more and more frustrated with the work I was doing, stuck in the wrong market. I had agents in New York—very high-profile, reputable agents—who were simply not interested in marketing me to the book companies. I was doing work I hated, for people as frustrated with their jobs as I was," he recalls.

"Then Terri Czezcko at *Asimov's* gave me a couple of magazine cover assignments," he says. "That was the beginning. I felt revived; I was painting things that interested me! I told her that I wanted more of that kind of work, and she suggested that I hang a show at one of the science fiction and fantasy conventions, preferably WorldCon. I had never heard of sci-fi conventions. I was *that* naive." Lockwood chuckles at the memory.

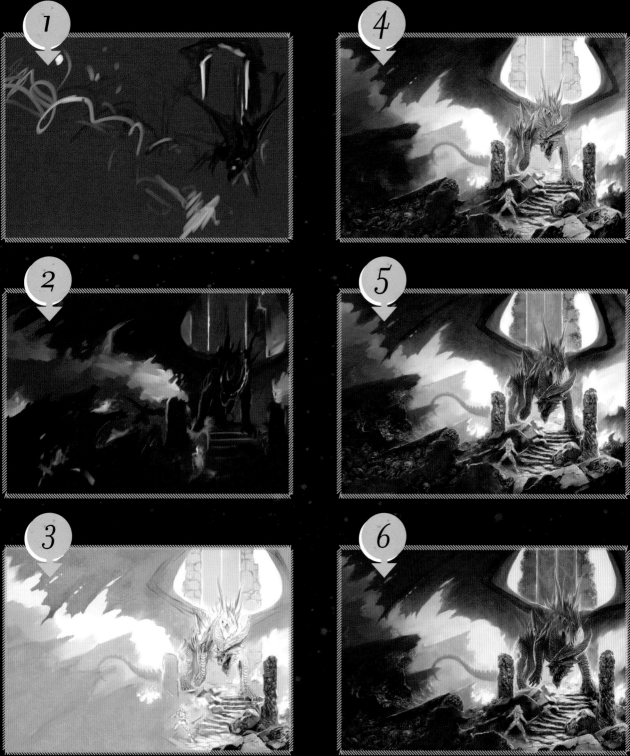

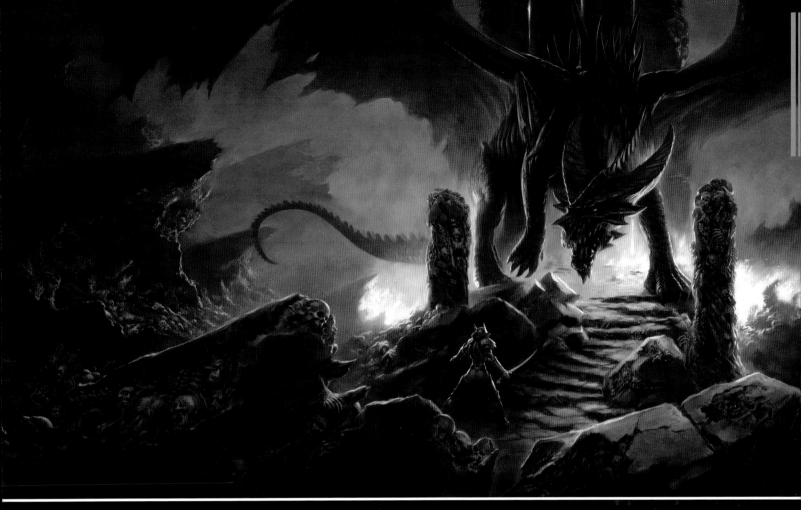

In Hell. Cover art for *The Ragged Man* by Tom Lloyd (Pyr, 2010); © 2010 Todd Lockwood.

IN HELL DEVELOPMENT SEQUENCE ❶ Lockwood begins every painting with a loose compositional study to determine the place-
ment of the focal point, center of interest, or what he calls the "star" of the painting, and to lay out the basic masses of light
and dark that will define the composition's movement. ❷ The artist develops the first loose study into his first value study,
which will guide further drawings. Although he sometimes adds color to value studies for presentation to the client, this is
going to be a monochromatic piece. ❸ Lockwood begins drawing in Painter using smeary oil brushes as his primary drawing
tool. He notes, "In this painting, I also do a fair amount of the drawing with the digital water tools; they're intuitive and
extremely flexible, allowing for a lot of detail without compromising the interaction of media with ground. In Painter, the
ground contains the texture, and the digital water tools react to it very nicely; you can see it in the wing and rocks on the left
side of the composition." ❹ Lockwood uses the digital water tools exclusively to draw the damned souls trapped in the stone.
He notes, "With these tools I can wipe in and out, working both additively and subtractively, to get nice transitions and detail
fairly effortlessly." ❺ When the drawing is finished, the artist "dries" it via the digital water tool. Lockwood next takes the image
into Photoshop to turn it into an underpainting. Using the color balance sliders and a brush set in color mode, he changes the
image from black and white to color. He selects a pinkish color range to show through the much cooler, grayer colors to come.
As Lockwood uses digital water to add the first passes of cooler color, he notes that the piece takes on a different look entirely.
The pink showing through the greens and grays gives it an "unwholesome, corpselike pallor" that the artist finds perfect
for the setting. ❻ Lockwood continues to lay down washes to build up the dark areas, and adds opaque highlights using the
smeary oil brushes. He develops the damned souls entirely in digital water without opaque highlights to sustain subtle textural
effects. Once the last washes are down, and the last highlights are laid in and brightened subtly, the painting is done.

Ocean Sovereign. Digital. Art for *Aquatic Gold* sculptures, Hamilton Mint/
Bradford Exchange.

War of Angels. Digital. Promotional poster, Bullseye Tattoos.

"I took my *Asimov's* covers and some personal work to the
WorldCon in Winnipeg that year. It was a revelation! I
met other artists, and saw so much amazing work. I met
Michael Whelan, who responded very favorably to the
black-and-white work I had done. I went home inspired,
and determined to do more and better work. From Win-
nipeg I got some interior work from Carl Gnam at *Realms
of Fantasy* and *Science Fiction Age* magazines. With those
two magazines and my *Asimov's* and *Analog* covers, I was
starting to build a portfolio of published work in the field
I had always wanted to be a part of. Long story short,
I fired my agents in New York," Lockwood says.

"My first work in the gaming industry was some cards for
Chaosium, and for Phil Foglio's naughty deck," Lockwood
recounts. "Then a friend suggested me to an art director
at TSR. I had sent portfolios to TSR in the past, but they
didn't want to look at ad work, and weren't going to give
covers to someone who couldn't show them what they
wanted to see. But now I had the beginnings of a real
portfolio. The art director, Stephen Daniele, gave me
some character portrait assignments for one of the Spell-
fire decks, followed by some book covers for TSR. Then,
when Fred Fields and Robh Ruppel both quit within a
month of each other, a magical door opened. It was very
much a matter of being the right person in the right place
at the right time," he notes. "I knew the games, had done
some work for them that they were happy with, and they
needed someone quickly. TSR had burned some bridges
with some of their other prospects, but that worked for
me. I was happy to jump into their pool."

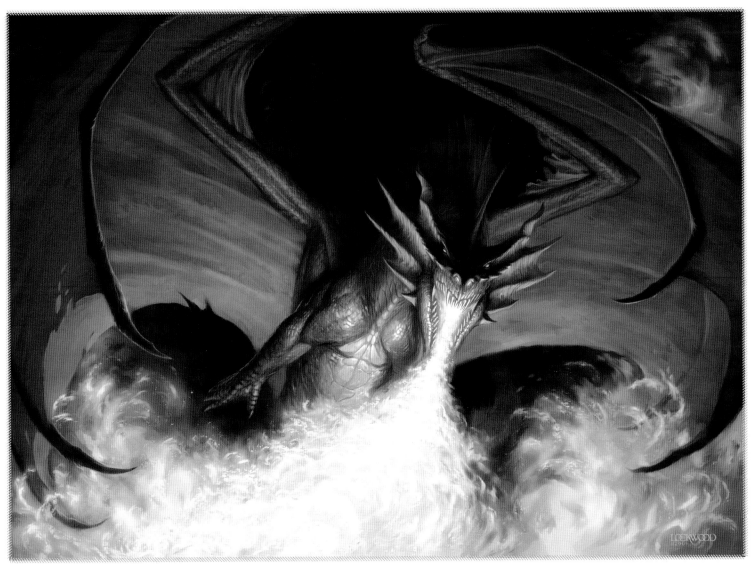

Wings. Digital. Cover of *Wings of Fire,* edited by Jonathan Strahan and Marianne S. Jablon (Nightshade, 2010). Lockwood became renowned for his dynamic depiction of dragons in action, especially for games such as Dungeons & Dragons.

About the same time as he made his transition to fantasy artwork, Lockwood became fascinated by mythology, particularly transformative mythology, the hidden meanings of myths, and the writings of Joseph Campbell. The artist notes, "The best advice I ever read was from Joseph Campbell, who said, 'Follow your bliss and the universe will open doors for you where there were only walls, and where there wouldn't be a door for anyone else.' That advice was truly inspirational for me when I had simply had my fill of advertising, and was in despair that art—which had been my greatest recreation and outlet and source of comfort—had become a burden."

He adds, "It encouraged me to risk firing my agents and seeking the work I wanted to do. It is the one piece of advice I am most likely to pass on to others."

Lockwood's other piece of advice for beginners is simple. "Never stop learning," he says emphatically. "And I don't mean only art. Everything you can know will have value in your work: geology, geography, anatomy, history, mythology, math, literature, and on and on. The more you know, the deeper the well you draw from."

Lockwood currently works as a freelance artist and lives in Washington State with his wife and three children. His first retrospective collection, *Transitions*, was published in 2003 by Chrysalis Books in the United Kingdom. You can see more of his work at his website, www.toddlockwood.com.

All images © Todd Lockwood unless otherwise noted.

DIGITAL TOOLS and TECHNIQUES

STEPHAN MARTINIERE

"Painting digitally allowed me to explore ideas and techniques I don't think would have been possible traditionally. Working with layers made the process even more enjoyable. In many ways it made me a faster and more efficient artist."

Desolation Road. Digital. Cover for *Desolation Road* by Ian McDonald (Pyr, 2009).

Admired internationally by fellow artists and revered by fans, Stephan Martiniere has won many awards and much acclaim for his accomplishments in film, publications, gaming, theme park rides, and animation. Martiniere is also an accomplished concept artist and has worked on movies such as *I, Robot*; *The Fifth Element*; *Star Wars Episode II: Attack of the Clones*; *Star Wars Episode III: Revenge of the Sith*; *Virus*; *Red Planet*; *Sphere*; and *The Time Machine*.

An artistic chameleon, Martiniere is comfortable working as a 2D and 3D artist. He won the Hugo Award for best professional artist in 2008, having been nominated for the award in the two previous years. He was nominated for an Emmy Award as director of the animated musical special *Madeline*, and received the Humanitas Prize, the Parent's Choice Award, and the A.C.T. Award for that feature.

His work has been gathered in two retrospectives, *Quantumscapes: The Art of Stephan Martiniere* (Design Studio Press, 2006) and *Quantum Dreams: The Art of Stephan Martiniere* (Design Studio Press, 2004).

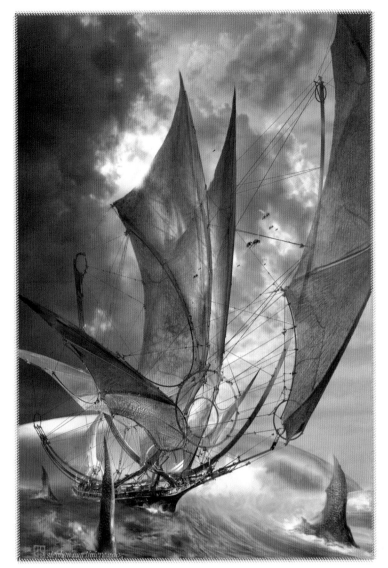

Autumn War. Digital. "The Autumn War is a complicated piece," says the artist. "It's a very literal piece with some graphic touches. There are thousands of soldiers approaching a castle. As complex as it is, the painting technique is very graphic and suggestive. The red palette is also something I hadn't done before."

Skinner. Digital.

Born in France, Martiniere attended high school at one of the most renowned art schools in Paris, where work by classical art and illustration masters stoked his imagination, as did landmark films such as *2001, A Space Odyssey*, *Alien*, *Blade Runner*, and *The Dark Crystal*. Initially, he expected to pursue a career in comic book illustration.

"I grew up in a comic book environment and decided very early on to follow that path. Only when I went to art school around the age of fifteen did I discover other fields like animation and illustration. For several years I learned different art disciplines, but I still wanted to become a comic book artist. Then I went to animation school at Les Gobelins in Paris, but I never completed the two-year program. I had completed my first year at Les Gobelins and

was lucky enough to land a job during the summer break working in Tokyo as a character and background artist on the animated series *Inspector Gadget*." He says the best advice he ever received was to not finish school. "The director of my animation section at Les Gobelins told me, 'Stay in Tokyo, learn all you can, and don't come back to school.' This was the beginning of my career," Martiniere recalls.

The next several years went by frantically, as Martiniere swung between continents, working in Asia and the United States on a variety of projects, including *Heathcliff*, *The Real Ghostbusters*, and *Madeline*. "As I traveled from Japan to California, I became more and more interested in the storytelling aspect of filmmaking," he says. "I started working on storyboards and eventually settled in California to become a director for such television shows as *Dennis the Menace*, *Where's Waldo?*, and, of course, *Madeline*."

Multireal. Digital.

Shadow in Summer. Digital.

Most artists would have been satisfied to stay put directing animated films and collecting awards for them, but not Martiniere. "In 1989 I left the director's chair and came back to the drawing world. I started exploring new avenues in the theme park industry, where I found great artistic excitement in creating whimsical fantastic environments. Theme parks led me to 3D motion rides, where I had another rewarding experience in designing for Star Trek: The Experience and The Race for Atlantis in Las Vegas."

A GAME-CHANGING MEDIUM

"My experience with Star Trek introduced me to Photoshop," he recalls. "This created a major shift in my career and later opened the gates of Hollywood and the game industry. From there I went on to design work in motion pictures."

"Digital has reshaped my career," the artist says. "For many years as a concept artist in the animation industry, I had to come up with ideas mostly in the form of sketches, finished black-and-white drawings, or grayscale renderings. I rarely was allowed to finish these ideas as paintings. The preproduction process in animation at the time divided the art team between background designer, character designer, prop designer, character colorist, and background colorist."

"During all those year I never had the chance to explore painting, much less find a painting style," he explains. "I was fortunate enough to be there at the beginning of the digital shift. Since I didn't have a particular technique or style of my own, moving into digital was easy and painless. I became very comfortable with Photoshop fairly quickly. Painting digitally allowed me to explore ideas and techniques that I don't think would have been possible

Dervish House. Digital.

City without End. Digital.

traditionally. Working with layers made the process even more enjoyable. In many ways it made me a faster and more efficient artist."

Armed with years of experience as a concept artist, Martiniere made his next foray into the game industry as a visual design director working for Cyan Worlds, the creator of Myst. For several years he designed and over-saw the artistic content for the games URU (Ages Beyond Myst), URU (The Path of the Shell), and Myst 5. In 2004, the artist joined Midway Games as a visual design direc-tor to work on several games and projects, including The Stranglehold and Area 51. He recently moved to ID Soft-ware, where he is currently art director for the game Rage.

While he was working in gaming, Martiniere also began to establish himself as a book cover illustrator. Considering the many artistic hats he's worn, it's a bit surprising where

he finds the greatest artistic satisfaction. "Generally speaking, working for the entertainment industry as an illustrator is not as rewarding as doing book covers in the publishing industry. There's little recognition for the artist and his work because an artist working on a film is but a tiny portion of that film. Very often your work is diluted and there's no control over how the work is used. Being a film or an animation illustrator is like being part of an enormous machine," Martiniere explains. "Also, the artist doesn't own his work, and therefore has a lot of difficulties exhibiting his art."

Martiniere notes that his experience in the publishing industry is very gratifying. "Over ten years—and a hun-dred covers later—I find myself loving it more and more every day."

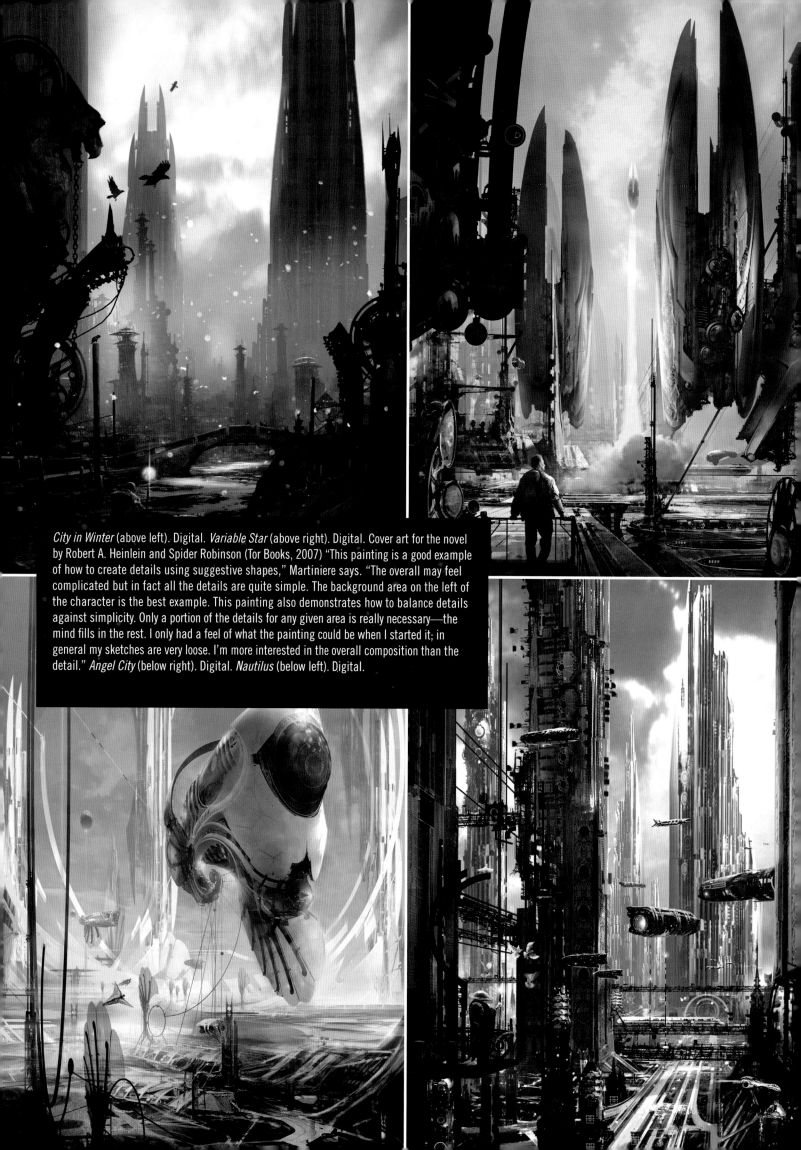

City in Winter (above left). Digital. *Variable Star* (above right). Digital. Cover art for the novel by Robert A. Heinlein and Spider Robinson (Tor Books, 2007) "This painting is a good example of how to create details using suggestive shapes," Martiniere says. "The overall may feel complicated but in fact all the details are quite simple. The background area on the left of the character is the best example. This painting also demonstrates how to balance details against simplicity. Only a portion of the details for any given area is really necessary—the mind fills in the rest. I only had a feel of what the painting could be when I started it; in general my sketches are very loose. I'm more interested in the overall composition than the detail." *Angel City* (below right). Digital. *Nautilus* (below left). Digital.

Martiniere uses an intuitive approach in his artwork. "My painting process is very organic," he says. "I usually start with a series of very rough thumbnails mainly to find a good composition. Keeping the sketch loose also allows flexibility during the painting process. I can explore many possibilities and be surprised. It's an organic and creative process where the elements, details, and nuances reveal themselves gradually as you add and manipulate layers."

Once Martiniere has sketched several images he can use as foundations of his painting, he moves to Photoshop and begins to block out colors and values to get a better overall sense of the composition. "This process is usually the most challenging. It takes me several attempts before I see something that visually clicks. After that, I work in layers upon layers of color washes, texture, details, and paint using the Photoshop arsenal to bring the painting home. While this may sound vague, my process is a lot about what I see as I'm doing it. One step dictates the next," he explains.

"Once I'm working in Photoshop, I begin to explore color and mood," says Martiniere. "I look at photo references to find a color palette or sometimes a particular light that will inspire me. It doesn't have to be connected to the subject. It's just about what that image communicates to me. This exploratory process of letting the painting progressively reveal itself is very creative, although at times the painting takes a while to come together," he notes. "There are frustrations and sometimes doubts, but at the end it all fits together."

He continues, "This is not to say that I don't sometimes have to scrap part of a painting or move in a different direction, but eventually the end result is always better than anything I could have imagined."

The artist concedes that he's startled by his own career path. "When I look back over the past couple of decades, I think the most surprising thing is how varied my career has been."

"When I began, the only thing I was really interested in was comic books and I really thought that's what I would end up doing," he admits. "In fact, I'd even gotten my first comic book contract—with *Heavy Metal*—at the same time I was offered the job in Tokyo to work on *Inspector Gadget*. Little did I know that choosing *Gadget* would take me to Asia and the States for many years. For a long time I still thought I would get back to comics. It took me a while to realize that I could use my drawing skills in so many different areas of the entertainment industry."

He adds, "A funny thing is that at the same time I was so into comics I was also a big fan of Syd Mead and Chris Foss. But it never occurred to me that I might follow in those artists' footsteps doing film concepts and book covers. One of the best things about my career is that I've never stopped learning. The new industries of 3D animation, games, and SFX keep my interest fresh and bring fresh artistic challenges. Software such as Photoshop, Painter, and other 3D programs has helped me reinvent my art and allowed me to explore new artistic possibilities."

Martiniere says that his greatest pleasure as an artist is to constantly challenge himself and to explore new artistic avenues.

For more information on Stephan Martiniere and his artwork, visit his website at www.martiniere.com.

All images © Stephan Martiniere unless otherwise noted.

TOMASZ MARONSKI

///

"You should love your work because when there is no love, nothing will come of it."

///

Sanctuary. Photo-Paint. Says Maronski, "This is an idea born at sea on a summer vacation. The notion is that this place was full of life before the war. After the war, The Sanctuary is now an uninhabited place and hideout for an old magician."

Colorful, surreal, filled with sinuous lines and futuristic details, the fantastic digital imagery of Tomasz Maronski is informed by the closely observed natural world. His works have an essence derived from living matter that adds to their mysterious power. Sophisticated composition and color give his digital paintings tremendous impact. But the most powerful thing about these works is the imagination producing them.

Maronski is an illustrator whose work frequently decorates the covers of science fiction and fantasy books in both his native Poland and the United States. He also creates powerful images for European mobile phone carriers; advertising agencies; film and animation studios, such as Human ARK, Platige Image, and Virtual Magic; and computer games companies, such as Cenega, Techland, and Uselab. Among his international clients are Imagine FX, Digital Art Masters, Ballistic Publishing, Laser Books,

Postcard from London. Photo-Paint.

and *Asimov's Science Fiction* magazine. In 2008 Maronski received the reader's award for best cover from *Asimov's*.

"I like to reflect my imagination in my art," the artist says. "I've lived in a world of fantasy as long as I can remember. Now that I'm an illustrator, my passion has become my profession."

His enthusiasm for science fiction and fantasy art is obvious in the elaborately detailed worlds he creates in every painting he does. "I love what I do," he admits. "To do this kind of work has been my desire and passion for many years. I work eight hours a day, and have a wonderful time listening to moody music and making my paintings."

Maronski is a longtime fan of science fiction and fantasy film, literature, and gaming. "I like the specific atmosphere and sophisticated reality. I also think that my imagination and my ideas, which are represented in my art, were influenced by those genres."

Originally trained in traditional art techniques, Maronski enjoyed the expressive range and richness of oil paints. "I painted on canvas for almost ten years," says the artist. "During that time I always tried to improve my technique. I've always searched for the proper and unique way of expressing either my personality or my ideas, which are reflected in the visions of my imagination."

However, Maronski acquired digital skills when the pressures of work became too demanding. "My adventure with computer graphics started when I realized that although I had the ability to create oil paintings, I didn't have enough time to do them and meet deadlines," he explains.

Chronicles of Majipoor 1 through 3. Photo-Paint.

INSPIRATION AT LUNCH

Maronski enjoys creating backstories and history for his images, and rarely runs dry. "Over the years I've had a lot of ideas and conceptions. I invent the history behind my subjects. Some ideas I haven't used yet but I'm sure they'll come in handy in future paintings," he says.

"Nearly all of my works share the themes and atmosphere of fantasy and the world of mystery. I'm very happy when some of my works have some hidden plot and they can tell the viewer some extraordinary story."

Maronski often bubbles over with ideas and keeps the ones he doesn't use in reserve. "My painting is always on the move," he says. "Those ideas which I haven't used yet will provide materials for future masterpieces.

"I see inspiration everywhere," he adds. "For example, in *Bone Hill*, I got inspired from the skeleton of a fish whose flesh my wife and I ate for lunch at a restaurant. Despite my wife's protests, I smuggled the skeleton out of the restaurant and back home to photograph it. I can make paintings with reference to any subject, but my attitude and mood varies the artistic viewpoint—which gives me more ideas!"

COLOR IS KEY

"I like to focus on landscapes. That's where I get a lot of inspiration for fantasy work." Color is one of the key elements with which Maronski begins his process. "I always define and describe the color palette I'd like to use at the beginning," he says. "I prefer to choose one color that dominates and accents the work's main motif."

Triffid. Digital.

He adds, "One in every five paintings is made spontaneously. However, even if the work begins spontaneously, I usually refine and specify the aim of the piece by preparing some pre-painting studies or drawings before I begin to compose the actual artwork."

Publisher Wojtek Sedenko of Agencia Solaris in Warsaw has regularly used Maronski's artwork on the covers of the science fiction and fantasy books he publishes. He says, "Tomek [Tomasz's nickname] is a great artist who prefers painting landscapes. The features that distinguish his work from that of other Polish artists

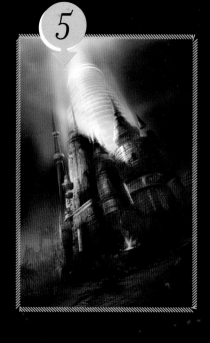

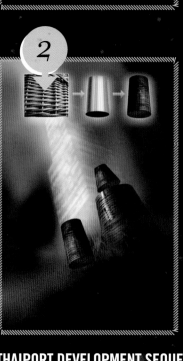

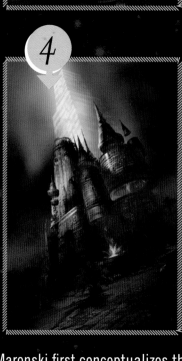

THAIPORT DEVELOPMENT SEQUENCE ❶ Maronski first conceptualizes the entire composition: the image of a futuristic Thailand with rockets, exotic flora and fauna, and towering construction at its urban core. Next he makes a quick selection of the background color, type of frame (leaning), and brush (airbrush). He blurs the background using the Gaussian blur tool. ❷ With the help of 3D modeling the artist creates simple cylinders, cubes, and textures using shapes he had prepared earlier, color-matching them so they correspond with the background while remaining separate from it. Note the sample cylinder featuring wicker basket texture that he will use in his next step. ❸ Using photo references, he determines the horizon line and further develops the shape of the cylinders in the foreground, adding some detail and texture. ❹ Working more with details at the bottom of the illustration, Maronski accentuates the urban atmosphere with futuristic elements and adds some plants—palm trees—to indicate the tropical environment. To add interest to the tower on the right he divides it into segments and uses the color red for emphasis. ❺ The artist fills in some of the emptiness at the bottom of the illustration, adding foreground details while rounding the shape of the tower in the background. By placing textures in the skyscrapers' windows, and adding neon lamps and new towers, he gives urban density and personality to the entire illustration.

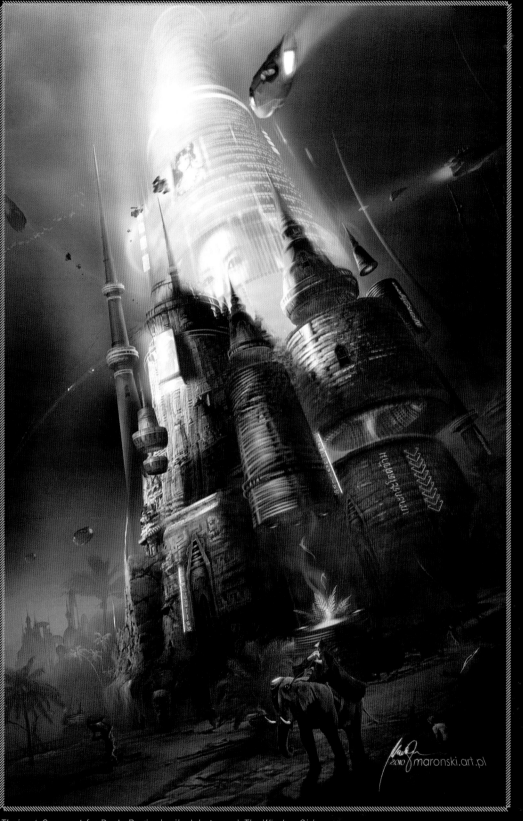

Thaiport. Cover art for Paolo Bacigalupi's debut novel *The Windup Girl.*

In this last step Maronski adds air traffic and a sense of life and movement. To add a "cyberpunk" element, he fits a large curved video display along the façade of the background tower. To emphasize the mood and atmosphere of the locale, he draws a man on an elephant in the bottom foreground. All together, the image takes him two weeks to complete.

Factory Planet. Photo-Paint.

are imagination, brave visions, and courage when it comes to using colors. He listens to my suggestions regarding the content of a book, and he is ready to apply those remarks to his vision and work."

Agencia Solaris has published books by such authors as Robert Silverberg, John Crowley, Samuel R. Delany, Joan D. Vinge, Greg Bear, Robert J. Sawyer, Robert A. Heinlein, and John Wyndham—and Maronski has done illustrations for all of them. Sedenko adds, "Although these books are all science fiction, Tomek avoids using visual clichés like spaceships or space marines with laser cannons. He depicts landscapes, people, and situations."

Maronski's favorite digital tool is Corel Photo-Paint. "I've worked with Photo-Paint as long as I've been doing digital work," he notes. "I like it the most because it has so many useful tools. My favorite among them is the airbrush. It allows me to create very smooth strokes. Another tool I frequently use is the color balance option, because I consider color to be the most important feature of my illustrations." Maronski knows that Photo-Paint doesn't get much love from digital artists in general, but that doesn't bother him. "Over the years I've met a lot of people who think that Photo-Paint is worthless, and

almighty Photoshop is the only reasonable software to use when it comes to digital painting," he says. "But, from my point of view, it's simply a matter of what software you had at the beginning."

As much as he enjoys the act of painting, he enjoys finishing each work even more. "The greatest pleasure for me is when I can look at the finished work," he says. "I enjoy it whether it's on TV, on a book jacket, or on a box at the video game store."

His imagination takes even this pleasure to a new, science fictional level: "That said, the absolute greatest pleasure would be the possibility of meeting myself in the past," he says, "at the time when I hadn't even thought about becoming an illustrator, and presenting myself with some of my artworks from the future."

To see more of Tomasz Maronski's artwork, visit http://maronski.cgsociety.org/gallery/, http://maronski .deviantart.com/gallery/, and http://maronski.itsartmag.com/.

All images © Tomasz Maronski unless otherwise noted.

Big City Life (top). Photo-Paint. *Cervantes* (above left). Photo-Paint. *Bone Hill* (above right). Photo-Paint. The artist begins by taking a picture of fish bones on a uniform background and "cutting out" the bones using Corel Photo-Paint. Next he uses the bones in a sketch of a lonely skeleton lying atop a hill. As Maronski works on it he begins to yearn for a sense of scale and mystery. He decides to paint a city nearby. That idea morphs into the bones becoming a mysterious ruined city. He paints some of the buildings and samples others from reference photos he has taken in his own hometown. Next he makes the lower parts of the city a bit darker, intensifying the contrast between the hill and the morning sky. Dividing the image into several parts, he works each one separately and digitally pastes them together for the final image. The piece takes fifteen hours to complete.

CAMILLE KUO

"*Self-motivation is one of the important factors for creating good works. I do not work just because it is my job; I work because it is what I want.*"

Lena Concepts. Photoshop. © Vivendi 2008.

Mascot. Photoshop.

In Water. Digital. © Keystone Game Studios 2009.

One of the brightest new stars in concept art, Camille Ching-Yun Kuo—aka Camilkuo—makes a good argument for natural ability in art. She's a self-taught digital artist from Taiwan whose concept work has been in demand practically from the moment she got online.

She's currently working as a concept artist at Keystone Game Studio, Taipei, Taiwan, where she has contributed to the development of the new Xbox 360 title, Cold Energy.

Kuo has been a featured artist on such websites as www .cgsociety.org, www.deviantart.com, www.elfwood.com, and www.epilogue.net. Her work has appeared in *Exposé* 7 (Ballistic Publishing) and other publications. She's also worked for several gaming studios. "I love to create my vision and bring it to life," she says. "I work with enthusiasm and passion, and no matter what kind of subject I'm working with, I always find it interesting."

Before she moved to Taiwan, Kuo worked as a concept artist at Vivendi Universal Games in Los Angeles, where she contributed to several projects, including Time Shift, Tribes 3, Fear, and Wet. Before her stint at Universal, she worked at Heavy Iron Studios.

She entered the art business armed with a BFA in illustration from California State University at Fullerton. She uses both traditional art skills, including pencil, oil, pastel, and acrylics, as well as digital. Among her favorite digital tools are Maya, Photoshop, Painter, Illustrator, and Flash MX. She is fluent in English and Chinese.

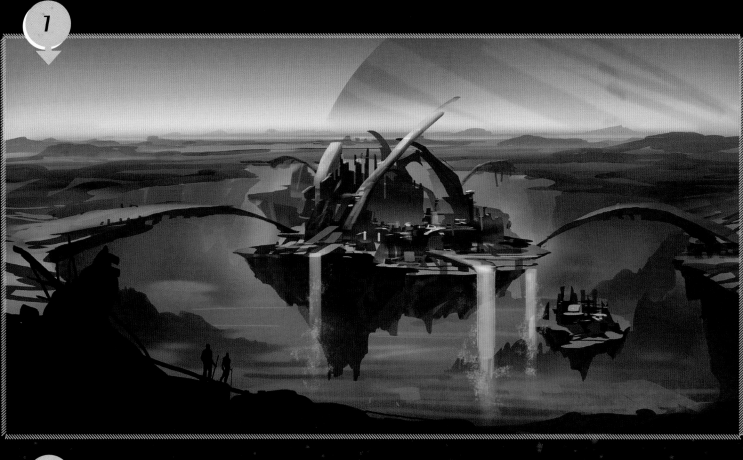

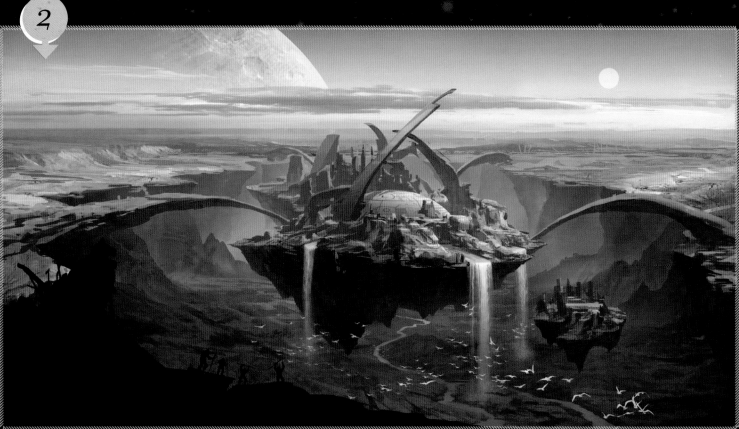

Secret of the Abandoned Land. Photoshop.

SECRET OF THE ABANDONED LAND DEVELOPMENT SEQUENCE ❶ The artist wants to create a vision of the beginning of human life on Earth. She establishes a rough black-and-white painting by sampling photos and painting on top of them, creating a matte painting. ❷ As this is a concept piece, Kuo doesn't bother to paint the entire detailed image; she merely provides the essence of her idea, including a huge moon and some figures in the foreground.

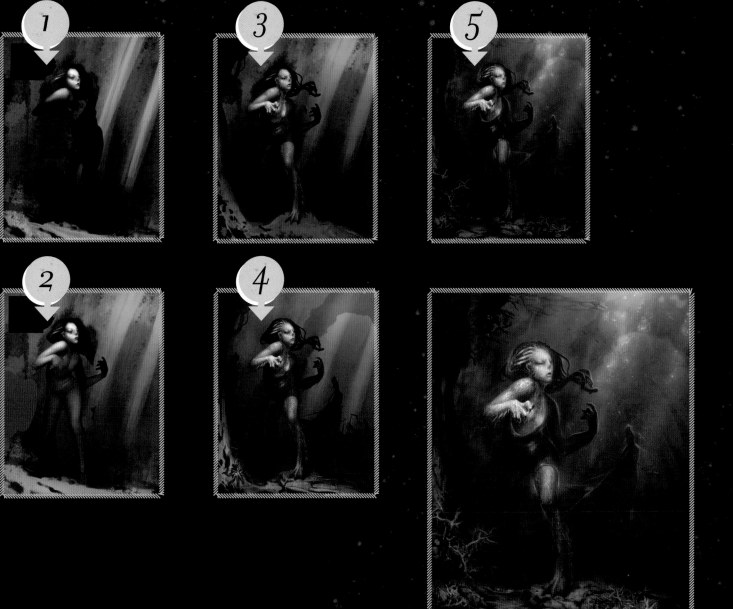

Evolution in Time. Photoshop.

EVOLUTION IN TIME DEVELOPMENT SEQUENCE

Kuo wants to create an undersea creature that looks human but has the ability to swim and breathe like a fish, perhaps the end result of evolution over thousands of years. The artist wants to show the creature's form clearly and make the subject stand out from the background. She decides to show her halfway out of the water but still half behind the dark watery background, as though moving toward the viewer. The entire image is created in Photoshop.
❶ To give the subject a dynamic stance, Kuo sketches her with one hand reaching out toward the viewer. Although she knows that the most efficient approach would be to paint the entire figure so that each part is at the same level of development at each stage of the process, the artist decides to paint the face first. ❷ Using Photoshop's healing tool, Kuo smoothes color onto the figure's skin. ❸ The artist adds more details to the figure. Veins and texture are painted first, then cloned using the clone stamp tool in Photoshop. ❹ The artist knows that one way to draw attention is by adding varied amounts of detail. She uses the figure's face and right hand as details to attract the viewer's eye. She notes, "One should never paint an image that's full of the same amount of details everywhere, because it'll confuse viewers, and they won't know where to focus." ❺ Kuo punches up the image by making final adjustments to lighting and color. She flattens the entire image into just one layer and uses different brush property modes such as hard light to provide a light source and blend colors between layers for highlights.

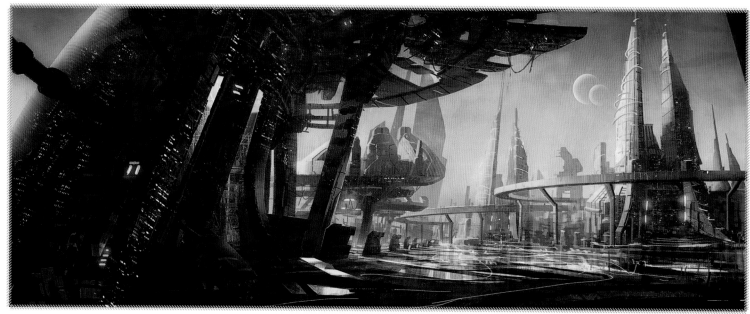

Twin City. Photoshop.

"Self-motivation is one of the important factors for creating good works," Kuo says. "I do not work just because it is my job; I work because it is what I want."

Kuo says she uses Photoshop for 99 percent of her work. "Photoshop was my first digital tool, and I'm very used to it. But it's not perfect," she notes. "For example, in Painter, 'add water' is the best tool to use for blending and smoothing skin tone. However, there's no such thing in Photoshop, so I usually use [the] smudge or blur tool to do the job. I've painted skin tones many times using those tools, but I don't think they give a quick or great result. However, I prefer not to switch back and forth between Photoshop and Painter on one job."

Kuo's greatest frustration in the field is watching other artists complain about lack of artistic freedom. "Some people think artists should have more control over the end product," she says. "However, once art becomes something commercial, I think it's inappropriate and unpro-fessional for an artist to insist on having things the way she wants. If control is that important, one should become a fine artist and stay away from commercial work."

Her greatest pleasure is to be able to do what she enjoys as a career. Her long-term goals include establishing an art school to help others achieve their artistic goals.

"Just do it" is a mantra that Kuo likes to adhere to. "Many people find difficulties in beginning a drawing or painting. I'd say they put too much pressure on themselves at the beginning to be perfect, and get frightened away from learning more and moving forward."

To see more of Camille Kuo's work, visit her website at camilkuo.cghub.com.

All images © Camille Kuo unless otherwise noted.

Straight Ahead (above). Photoshop. *Termination* (center). Digital. *Time Machine* (below). Digital.

V1

V2

Fairy (above). Digital. *Tribe* (below). Photoshop.

Camille Kuo

Silent Threat. Photoshop.

GALAN PANG

"There are many cool artists in the world, and you can learn a lot from them. But don't forget to practice your skills in both digital and traditional ways. Also, don't just look at the Internet. Go to the museum and look at real oil paintings and sculpture."

Village Guardian. Photoshop.

Galan Pang has spent ten years working in the computer gaming industry. He has wide-ranging experience as a matte painter, conceptual artist, and special effects supervisor. Pang has worked for a high-profile computer graphic studio in Hong Kong, Menfond Electronic Art and Computer Design Co. Ltd., as head of the creative and visual department. A senior concept artist, he currently works for CCP Asia in Shanghai.

Beginning as a special effects animator in 1999, Pang worked on several gaming projects, providing cinematic effects for Final Fantasy IX and X. Next, he moved into creative and visual direction.

The artist enjoys creating science fiction art. "I think that it's very interesting—and challenging—to create your own world," Pang notes. "As a science fiction artist, I can put all my imagination into my works, whether it's a vehicle I invent or a creature I create that doesn't exist anywhere."

Robot Lovers. Photoshop.

Birth. Photoshop. This concept painting was created for a challenge held by *ImagineFX* forum. The topic was a tribute to H. R. Giger. "This was very interesting—and very challenging—to create a horrific scene based on the style of Giger," says Pang. "I developed this painting showing a mother alien giving birth to her child, concentrating on the sense of pain and disgust."

"Everything in the world gives me inspiration," he says. "Sometimes I get inspired by random shapes and lines, or leaves, or the shape of a cloud, or I may reference an insect when I want to design a hostile galactic spaceship. Whatever I design, it must have a reference to real-world objects. This increases its believability."

Pang has been featured as a sci-fi characters digital artist in *Advanced Photoshop Magazine* Issue 60, giving tips and techniques on science fiction character painting in Adobe Photoshop. He has also given a digital painting workshop in *Digital Painter 2009* (inRage Publishing). His work has also appeared in Ballistic Publishing's *Expose* and *Exotique* annuals.

"Young artists should keep practicing and looking at other people's work," Pang advises. "There are many cool artists in the world, and you can learn a lot from them. But don't forget to practice your skills in both digital and traditional ways. Also, don't just look at the Internet. Go to the museum and look at real oil paintings and sculpture."

To see more of Galan Pang's work, check out his online portfolio at www.galanpang.com.

All images © Galan Pang unless otherwise noted.

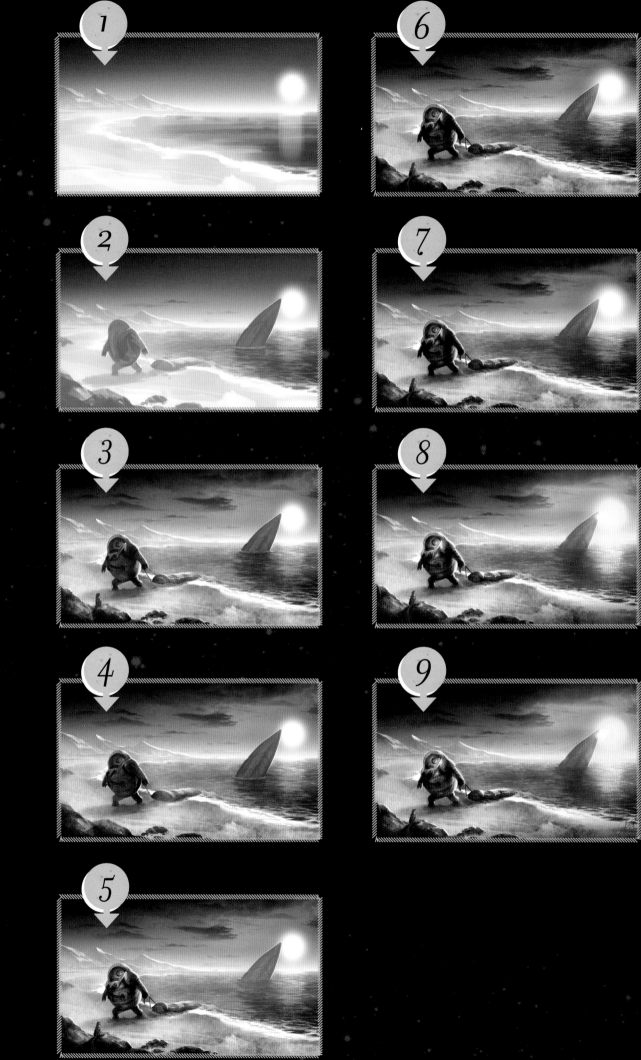

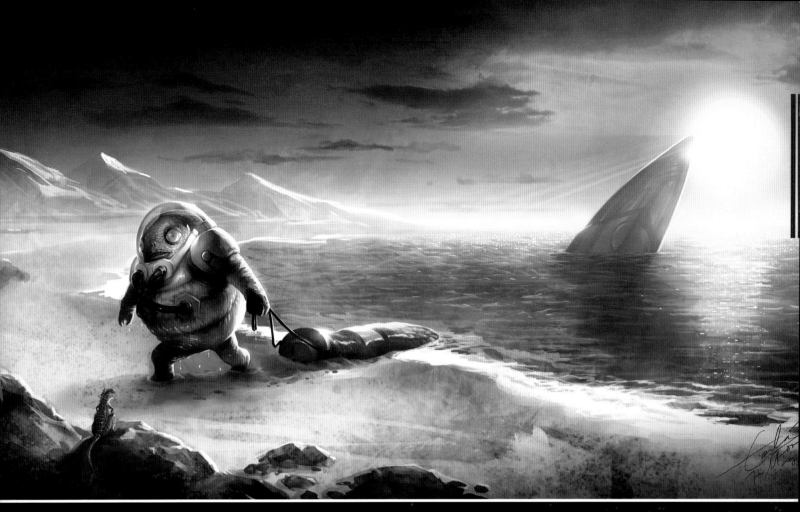

Unlucky Alien. Photoshop.

UNLUCKY ALIEN DEVELOPMENT SEQUENCE ❶ The artist begins the painting by just roughly laying out the composition and lighting in grayscale. This basically defines the perspective and light source in the picture. ❷ Pang adds main elements to the picture—the alien character and spaceship—and also adds more detail to the surrounding background. ❸ Pang adds further details to the character and environments, using custom brushes to add some texture to the picture, making it look more organic. ❹ In this step the artist adjusts lighting effects. He also adds details to the alien's face and space suit. The spaceship has been "pushed back" by adding a fog to it. ❺ Pang adds an overlay layer on which he paints the first color pass, defining light color and shadow color in the picture, yellow and blue, respectively. These warm and cold colors provide good color contrast for the image. ❻ Pang uses several hue and saturation adjustment layers to color different small areas, intensifying color and contrast. ❼ Pang uses replace color to add richness of color in the mid-tones. ❽ Pang uses a linear dodge layer to create a nice blooming effect for the sun. He also adds a warm color photo filter adjustment layer to unify the color temperature of the whole picture. ❾ The artist adds a layer of texture on top to give some painterly effect and signs the work.

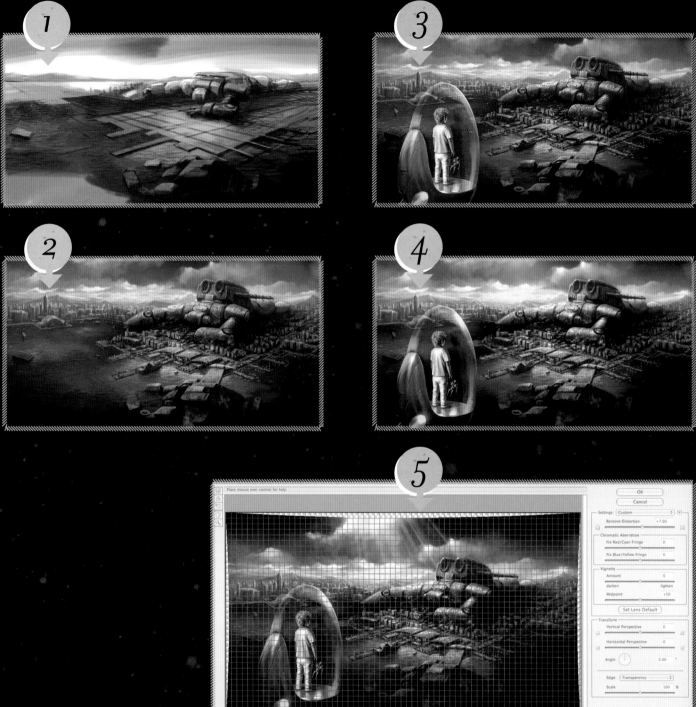

WASTELAND DEVELOPMENT SEQUENCE Pang explains, "The idea behind this painting is that fifty years ago, the world was at war, and nearly ruined everything. But there's hope, if you look carefully." He continues, "In the war, giant humanoid robots were used by countries to fight each other. These powerful robots battled until they couldn't move and collapsed on the ground. After the war, survivors escaped the heavily damaged and polluted city and went to live on a space station, where they continued their lives. The city had become a wasteland. In this image, one of the members of a new generation has traveled to this site to view it. The kid is carrying his favorite robot toy. On the wasteland, he sees the giant robot is lying on the ground, trees, plants are growing everywhere around the [ruined] city. The growing plant is telling people that this place is still a suitable place for living. The kid hopes one day he can come back and help build the new city."

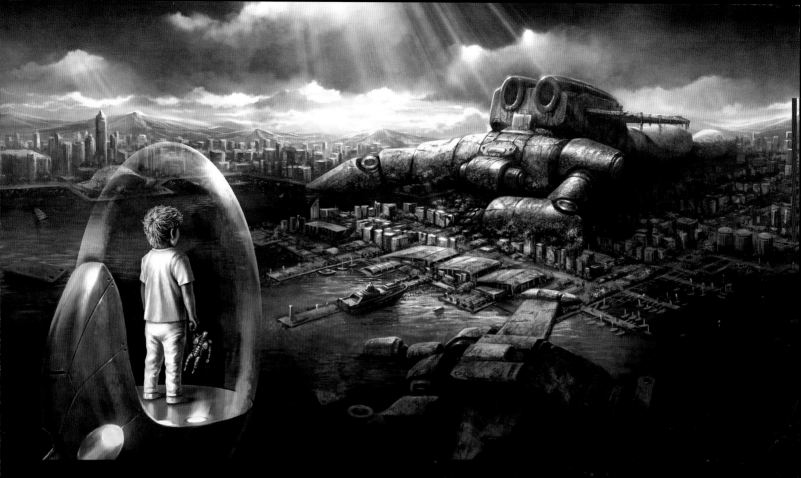

Wasteland. Photoshop.

❶ Using his Photoshop default brush setting, Pang roughly lays out a black-and-white composition and the value of the painting. He notes that it's important to determine the light source and shadows of objects in the painting in this early stage. ❷ Next he begins to add detail elements to the ground, painting them by referencing the general lighting conditions of the previous stage. ❸ After tightening up all the elements and adding more detail, Pang modifies the sky for more dramatic lighting and perspective, and to give the illusion of three dimensions. He uses a very soft airbrush to add a layer of atmospheric perspective to the left and far area. Next, he adds the little boy in the space pod at the very front of the drawing in a different layer to make the later coloring process easier. ❹ Now Pang begins to add color, using the hue/saturation adjustment layer with colorize. First he establishes the main color of the whole environment, bluish gray. Next, he adds several layers for different elements in color mode. He adds touches of orange, pink, and yellow to enrich the color relationships. The boy in his space pod is painted in a light blue to make him distinct from the background and give a more high-tech feeling to this element of the painting. ❺ He adds highlights with linear dodge (add) mode, and enhances the focus and drama of the painting by adding light rays through the sky. Next he supplies a layer of texture generated by a custom brush in soft light mode. When finished, he brings the layers together through copy-merge. Using distort and lens correction, Pang creates a wide-angle lens effect. The slight distortion makes the lines in the picture less stiff and more realistic for a finishing touch. Finally, because the lens correction effect created empty area along the sides of the image, he uses the crop tool to trim the picture.

MARTA DAHLIG

"If you do not know how to paint something, practice every day doing dozens of sketches until you master it. Only knowing what needs working on will guarantee you improvement and give you a chance of succeeding in the industry."

Umbrella Sky. Photoshop/Painter.

Marta Dahlig has worked as a digital illustrator for nearly eight years, completing painting projects for various publishing houses and gaming companies. Her clients include Ballistic Publishing, Future Publishing, Imagine Publishing, Radical Publishing, and Paradox Interactive. She is one of the most popular illustrators on www .deviantart.com, and her work frequently inspires tribute images from other artists on the site.

"Painting has always been a part of my life," says Dahlig. "When I was fifteen, I was introduced to the digital art field by a friend of mine. I soon bought my first tablet and simple software and started doodling. It didn't take long for me to realize that this is what I wanted to get involved in."

"Traditional media have a romantic side to them, making the act of painting a very intimate, pleasant experience. But I'm a very pragmatic person, and was thrilled to see and experience the chances that digital art had to offer."

She adds, "After that, it was all a natural process, a matter of displaying my work online in various galleries. When I was eighteen, I received my first commercial

Moths. Photoshop. Dahlig was commissioned to push the photorealistic elements of the image here as far as possible. The artist uses Photoshop with dozens of custom-made brushes for color application, blending, and texturing.

Judith. Photoshop/Painter. Dahlig begins her first sketch for this portrait by applying colors in very low opacity, gradually building up more layers of color. She starts the painting with the background, simulating objects with a few "messy" strokes that will make it easier for her to merge the character with the background later in her process. She uses two digital tools: a regular airbrush and a variation of the default hard round brush with slightly ragged, blurry edges. Because of its heavy detail, the painting takes her approximately forty hours to complete.

commissions. One commission simply led to another and before I was twenty-one, I was involved in serious, long-lasting projects."

"I can't say there was one groundbreaking bit of advice I received at a point in my life that changed my career. I did, however, receive many comments that greatly helped me improve my craft. Soon after I displayed my work online on www.deviantart.com for the first time, I received dozens of mostly helpful comments."

She adds, "Of course, reading critiques can be tough for an aspiring artist, but I tried to maintain a good attitude. I wanted to consider the feedback seriously."

The result of the feedback was Dahlig's renewed commitment to craft, and a payoff in improved skills. "I began working on my art in areas that I heard needed improve-

ment," she says. "Gradually, after much practice, I saw that elements I'd felt extremely awkward painting began to feel much more comfortable."

"My favorite painting program is Photoshop," the artist says. "It offers many great solutions and possibilities for artists who are already accustomed to digital painting and are seeking software that will provide great flexibility. Photoshop makes it possible to easily recreate any brush of any medium as well as create tools that replicate photo-realistic textures. This can save dozens of hours in the painting process."

FEELING VS. FORCING THE ART

"Working as an illustrator under various art directors can teach you many things and is often a great learning opportunity. However, sometimes it's also a tough lesson and a difficult experience," says Dahlig. "It really does depend on the company, but in some cases, the artist is forced to withdraw from his own interpretation of the image and is expected to exactly replicate the vision of the supervisor. Personally, I'm strongly against it. While it's important to have a guideline to follow, it's also important to remember that artists are not merely craftspeople."

Seven Deadly Sins: Wrath (top left). Photoshop/Painter. *Seven Deadly Sins: Vanity* (top center). Photoshop/Painter. *Seven Deadly Sins: Gluttony* (top right). Photoshop/Painter. *Seven Deadly Sins: Sloth* (center left). Photoshop/Painter. *Seven Deadly Sins: Envy* (center). Photoshop/Painter. To prepare to paint her *Seven Deadly Sins* series, Dahlig builds up a symbol database from research. After visualizing the character and pose, she defines the symbolic meaning of each background and decides how to utilize specific symbols in the round framing design. As a modeling aid, the artist occasionally uses a "wireframe" on top of the face to indicate the most convex and concave areas in a portrait. The artist also studies how textiles react to light in different fold configurations and lighting situations to master fabric painting.

She continues, "Having to depict the vision of someone else, while having absolutely no say in the matter—whether the colors fit, or the composition works—is for me the worst thing that could happen. From my experience, forcing the vision of a third party onto the painter will never result in a better image.

"When you paint, it is absolutely crucial to 'feel' what you are doing in order to do it right," the artist notes. "Fortunately, it's been my experience that many professional employers already know this and leave a lot of artistic freedom to their illustrators rather than directing them too much."

For Dahlig, the greatest satisfaction comes with the completion of a difficult assignment. "I really enjoy moments where I complete a project which, at the beginning, seemed impossible. At the start of my career, I was most challenged by having to paint hands or hair or cloth. I remember how hard I worked to learn how to paint hair convincingly. It took dozens of sketches and hours upon hours of practice. I had a feeling of absolute bliss when I finally managed to paint it right."

Dahlig's enthusiasm for learning continues to fuel her career success. "There is always so much to learn," she says. "I still get that blissful feeling from very demanding projects."

She recalls, "A while back, I painted a battle scene with soldiers and horses. When you look at my portfolio you can see it definitely isn't something that is typical of my work. It was an extreme challenge to learn the anatomy, and to plan the composition and characters convincingly. I have to admit it felt *absolutely* amazing when I finished the project with a good result!"

Dahlig's advice to beginning artists is simple: Work as hard as you can. "The field for aspiring artists is, I believe, quite different from what I encountered when I was

Glamour. Photoshop/Painter. "I like twisted and humorous things, so I had quite a lot of fun painting *Glamour.* I try to approach everything I do with a pinch of salt, and I think this image reflects that quite well," she says. "It was also a fun challenge to design a gown out of rubbish and stylize it slightly to resemble a *haute couture* creation." The artist employs a looser style than usual. She allows the brushstrokes to show, giving the painting a slightly messy feel to further underline the stylization of the character.

starting," she says. "It's much more developed, the competition is greater, and clients are more demanding. And employers nowadays expect you to be flexible," she notes. "Therefore, seeking constant improvement is an absolute must if you ever want to achieve anything in the field. It's important to know what your strengths are, but in my opinion it is even more crucial to know where your weaknesses lie. Knowing what to work on will guarantee you improvement and give you a chance of succeeding in the industry," Dahlig says.

To see more of Marta Dahlig's work visit www.marta-dahlig.com, http://blackeri.deviantart.com, http://blackeri.deviantart.com/gallery, and http://dahlig.blogspot.com.

All images © Marta Dahlig unless otherwise noted.

TRADITIONAL TOOLS and TECHNIQUES

JAMES GURNEY

"The job of the artist, then, in composing pictures about people is to use abstract tools to reinforce the viewer's natural desire to seek out a face and a story."

Song in the Garden. Oil on panel. From *Imaginative Realism*. The artist tapes off the edge of his board, carefully draws the entire scene in pencil, seals it, and tints the board light pinkish brown. Using a small color sketch as his guide he blocks in color with big brushes in semitransparent oil, quickly establishing the overall appearance of the painting. Next, using smaller brushes, he begins to paint the figures. The entire painting, from posing models to final art, takes fourteen days to complete.

James Gurney, author and illustrator of the *New York Times* best seller *Dinotopia: A Land Apart from Time*, saw his first dinosaur, a towering allosaurus skeleton, when he was eight years old. He's been hooked on paleontology ever since. From that initial encounter, his boyhood daydreams focused on prehistoric behemoths and ancient civilizations, fueled by a steady diet of *National Geographic*.

Small wonder that he would grow up to become not only an award-winning artist who worked for *National Geographic* and other publications, but also an author whose colorful, detailed images and tales of dinosaurs in the Dinotopia series have been applauded around the globe and made into a TV miniseries for ABC.

Gurney is also known for his science illustration, including work for the U.S. Postal Service: the Sickle Cell Awareness Stamp issued September 30, 2004; the World of Dinosaurs commemorative panel of fifteen stamps, issued May 1, 1997; and the Settling of Ohio, Northwest Territory, 1788, postal card, issued in 1988. Gurney's numerous industry honors include seven Chesley Awards, two Hugo Awards, and best of show from the Art Director's Club. His Hudson River landscapes were a cover feature in the November 2006 issue of *American Artist* magazine, and his art currently appears in museum exhibitions around the world.

Market Square. Oil on board. From *Imaginative Realism*. Gurney plans this scene using a scale tableau to investigate different lighting effects, and to get beyond two-dimensional thinking. He especially wants to see how the forms of the dinosaurs and buildings are affected by the reflected light bouncing up from the warm, sandy surface in the foreground.

DEDICATED TO TRADITIONAL SKILLS

A devotee and booster of traditional painting skills, he dedicated his most recent book, *Imaginative Realism: How to Paint What Doesn't Exist* (Andrews McMeel, 2009), to the topic, using text and artwork based on his award-winning blog, www.gurneyjourney.blogspot.com.

Gurney excels at both landscapes and detailed painting, enabling him to give the long and short views of a land and its people. Regardless of the subject, he's deeply aware of the abstract qualities of a painting, and how they contribute to the illusion of a realistic image.

"One reason I never understood the quarrel between realism and abstraction is that representational painting involves a constant attention to the dance of pure shapes," he says, "both at the micro level of brushwork and at the macro level of composition. Concept artists in particular need to be able to freely invent and resolve abstract forms. H. R. Giger, John Berkey, Moebius, and Syd Mead are a few artists who create fascinating abstract forms without sacrificing their representational power."

He adds, "Of course, as pictorial designers we shouldn't think in abstract terms alone. Abstract design elements do play a role in influencing where viewers look in a picture, but in pictures that include people or animals or a suggestion of a story, the human and narrative elements are what direct our exploration of a picture. The job of the artist, then, in composing pictures about people is to use abstract tools to reinforce the viewer's natural desire to seek out a face and a story."

Gurney's own art media are traditional: pencil, paper, pens, paint, brushes, cardboard, and modeling clay. His approach to composition is centered on tonal organization in the service of a representational image. He uses several art terms, some of which he has invented, such as *clustering* and *shapewelding* (the compositional device of linking up related tones to make larger units), to describe compositional principles that he feels artists use but lack vocabulary to talk about.

Steep Street. Oil. From *Dinotopia: The World Beneath*. Gurney gives his memories of Venice's narrow, crooked streets a Dinotopian spin, introducing heavy traffic—an 80-foot-long (24 m) apatosaurus—to a busy street scene. Along the narrow lane he places shop signs written in the dinosaur footprint alphabet he invented, and in which young fans write him letters. As he was finishing the painting, he noticed that the right side of the composition seemed too empty. Just then, his two young sons came into the studio in their pajamas, hoping to stay up late. The artist drafted them as models.

As an aid to his creative process he frequently builds maquettes and models. "It takes me four months to do elaborate paintings, including the research, building models, and so forth."

Gurney acknowledges that despite paleontological discoveries, there's an element of fantasy required in depicting dinosaurs. That seems to be where the fun is, for him. "They're on the boundary between fantasy and real. It requires an effort of imagination to bring them fully to life. And I work hard not to anthropomorphize them. I didn't want to get into the silly side, seeing them in unrealistic poses, doing unrealistic things.

"*Dinotopia* is a kitchen-sink world," Gurney says. "So many things can work in it. I can take a discursion into philosophy and play with ideas here, with different concepts from different times and places thanks to the various characters—castaways—who wash up there and provide a form of 'time travel' with their varied world and time views."

RESEARCH IS PARAMOUNT

The artist knows that he'd better stay tuned to the latest developments in dinosaur discoveries. "Kids now are very up-to-date on dinosaurs and I have to stay on my toes regarding nomenclature when I do a road trip, or they'll correct me."

He stays current by maintaining close contacts with paleontologists and visits the Museum of Natural History in New York to catch up with experts. Thanks to his continued research, his own 'saurian sense has changed over the years. "Now when I look back on the paintings of oviraptors I did in the 90s, they look naked without their feathers! It just goes to show that we can never assume that we know everything about them," Gurney says.

Several years ago Gurney took a break from all things dinosaurian to get some fresh air. "I felt I was getting rusty, so I took a year off to paint outdoors, in the Catskills where the Hudson River School painters worked." He returned refreshed and inspired. His recent paintings and illustrations bear the mark of increased confidence and a looser, more painterly approach that pays loving homage to many of the great Golden Age artists, such as Sir Lawrence Alma-Tadema, Adolphe William Bouguereau, Maxfield Parrish, and Howard Pyle.

"Regardless of your subject matter," says the artist, "if you want your paintings to touch the heart as well as to win over the eye, you must make them real on many different levels: optically, emotionally, and spiritually."

For more information, visit www.jamesgurney.com.

Mountain Tribesman (above). Oil on board.
Desert Crossing (below). Oil on board.

Waterfall City—Afternoon Light (top). Oil. From *Imaginative Realism*. To keep the view of the city consistent from various angles, Gurney builds a schematic maquette out of gray-painted Styrofoam to use for reference, especially for tone studies and to plan lighting effects. He keeps the maquette simple with characteristic geometric forms, and adds detail in sketches and the final paintings. *Dinosaur Parade* (center). Oil. From *Dinotopia*. Gurney creates a painting reflecting emerging theories about dinosaurs as intelligent and complex creatures. To prepare for this composition, a springtime parade where dinosaurs and children move through the streets of a Roman-style city, he buys costumes and silk flowers, and asks neighbors to pose for reference photos and sketches. Next he arranges model dinosaurs in a mock-up of the city crafted from cardboard, and incorporates these images into his image. The resulting oil painting eventually appeared on the cover of *Dinotopia: A Land Apart from Time* (HarperCollins, 1992).*Outsider Artist* (opposite page). Oil on canvas mounted to panel. From *Imaginative Realism*; earlier version published as cover for *Fleet: Sworn Allies*, ACE Books, 2004. Gurney again builds maquettes to help visualize the alien subject of this portrait. He sculpts both the head and the hand of the alien artist in Plasticine and draws studies on tone paper with charcoal and white chalk. From this reference he draws a small charcoal layout to establish the size and placement of the head. Although an earlier version of the painting had a row of warriors in front of the tightly cropped portrait, he eventually paints out the figures, extends the wood panel, and changes the elf into an artist.

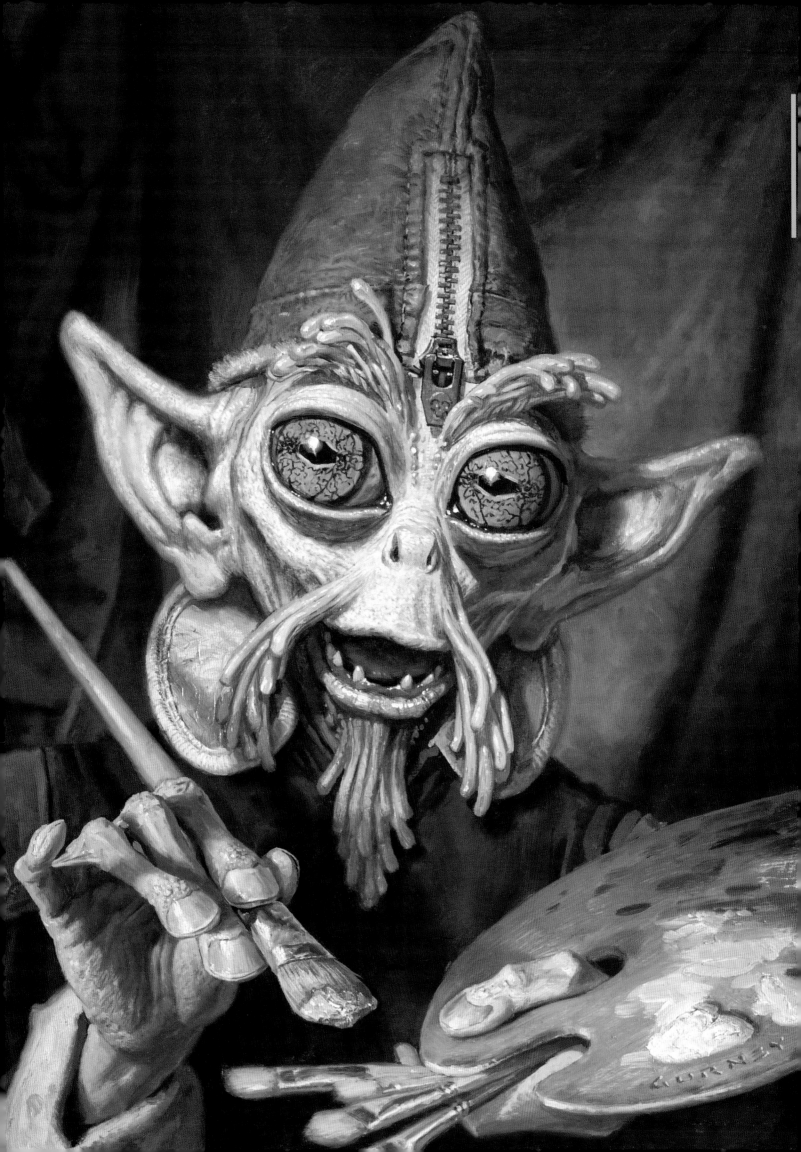

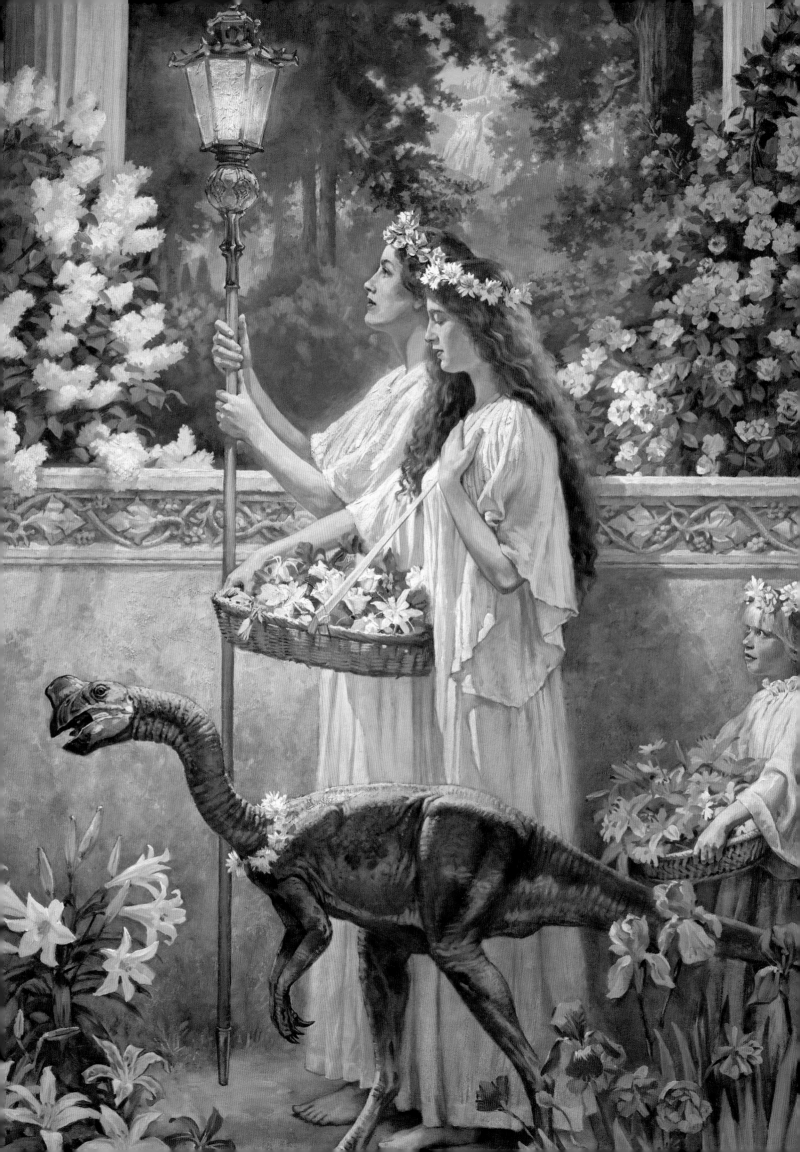

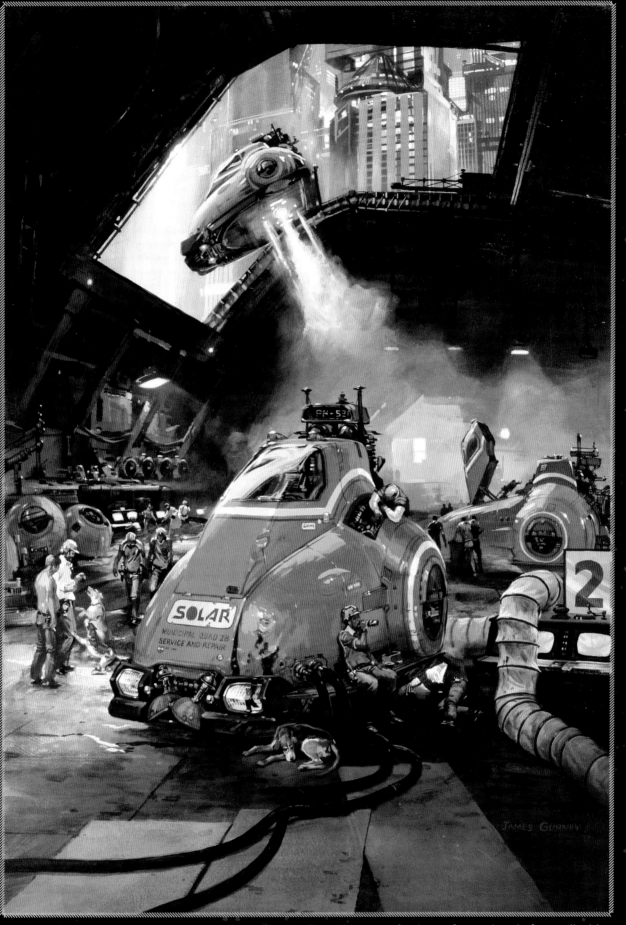

Skysweepers (above). Gouache/acrylic. From *Imaginative Realism*. To avoid an overperfect image, Gurney gives the future a lived-in look in this science fiction painting, adding signs of rust, dents, chipped paint, and other homely details. *Garden of Hope* (opposite page). Oil. From *Dinotopia: The World Beneath*, Harper Collins, 1999. The artist based the image of both women on a single model, the granddaughter of his editor, whose profile and long red hair reminded him of various pre-Raphaelite paintings. Once she was properly costumed, the artist had her pose holding a broomstick with an electric workshop light stuck on top of it to simulate a lantern.

KINUKO Y. CRAFT

"I choose my jobs by instinct, by my reaction to the theme or manuscript. The writer's sensibility must meet me halfway. There must be room for my imagination, for my heart. I can't just be a hired hand."

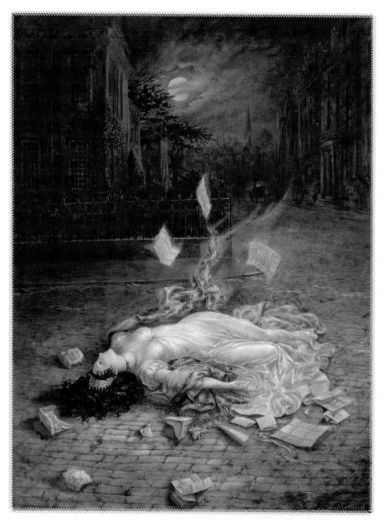

Jane and the Barque of Frailty. Oil on gesso panel. Cover painting for *Jane and the Barque of Frailty* by Stephanie Barron, Bantam, 2007. The artist doesn't make color studies, preferring the spontaneous discovery process that occurs while she paints with oils on gessoed board.

Kinuko Y. Craft is celebrated for her romantic imagery and rich detail in oil, and has a roomfull of awards testifying to her several decades at the top of the fantasy illustration field. Her scenes of fantasy heroes and heroines are filled with detail and recurring floral motifs, twining vines, faerie folk, and other imaginative delights.

"I don't know why I go into details," says the artist. "It's like an obsessive disorder—like binge eating—and I can spend months on them. I have to tear myself away. It's a good thing there's a thing called a deadline."

Craft's art education began as a child in her grandfather's study in Japan, where she was allowed to look at his art books. The inspiration she gained there led her to become one of the most widely respected and well-known imaginary realist artists in the United States today. During her career she has become famous for her meticulous attention to detail, a passionate love of fine art, and an extensive knowledge of art history.

A graduate of the Kanazawa Municipal College of Fine and Industrial Art (known in Japan as the Kanazawa Bida), Craft came to the United States in the early 60s, where she continued her studies in design and illustration at the

Baba Yaga Smoking. Oil over watercolor on Strathmore board. Internal illustration for *Baba Yaga and Vasilisa the Brave* by Marianna Mayer, Morrow Junior Books, 1994. The subject, a 2,000-year-old witch, is an interesting challenge: a departure from the beautiful, innocent young women Craft often paints for the covers of fantasy and fairy-tale books. The artist enjoys the opportunity to depict different textures.

The Mists of the Dusklands. Oil on gesso panel. Cover painting for *Elfland* by Freda Warrington, Tor Books, 2010. The artist began with a very different concept for this book cover: two figures in the center, a winged human male standing behind a nonwinged female. But when Craft painted the male subject she saw that something was wrong. After some consideration, she painted out the male, put the wings on the female, and the final composition came together.

School of the Art Institute of Chicago, and subsequently was employed for several years by well-known Chicago art studios. By 1970 her work was in wide demand and she had begun her long and successful career as a freelance illustrator.

Craft has received more than 200 awards, including five gold medals and the Hamilton King Award from the Society of Illustrators, as well as *Spectrum* gold and silver awards, Chesley Awards, and best in show from the Renaissance 2001 show at the Franklin Mint Museum. Her paintings are part of many permanent collections, including the National Portrait Gallery at the Smithsonian, the National Geographic Society, and the Museum of American Illustration in New York City. Her paintings have been featured on the covers of books by Stephen King, Diana Gabaldon, and many fantasy and science fiction authors, including C. S. Lewis, Isaac Asimov,

Marion Zimmer Bradley, Andre Norton, and Patricia McKillip. In recent years the artist has concentrated on illustrating picture books, private commissions, and other projects.

BORN TO PAINT

"I think you're born an artist," Craft says. "As a child, I was totally captivated by my maternal grandfather's art books. He was a calligrapher—among many other skills, a real renaissance man—and he shared his art library with me. Those were my childhood books: art of the world. They made a big impression, more than anything else, and gave me a sense of direction."

These influences have shaped Craft's aesthetic sensibilities and helped her hone her instincts when it comes to her art.

Queen Elizabeth I and The New World. Oil on panel. Cover painting for *Roanoke: A Novel of Elizabethan Intrigue* by Margaret Lawrence, Delacorte Press, 2009.

"I choose my jobs by instinct, by my reaction to the theme or manuscript. The writer's sensibility must meet me halfway. There must be room for my imagination, for my heart. I can't just be a hired hand. If something is not right, if I read the story, and it's like a blank, then I know I can't do it. If the story is so offensive or alien, or too much for my psyche to take, I will know long beforehand, even before I can take on the research," Craft explains. "Stories have a color, a certain smell and taste. I have to spend time with that, inhabit it, taste it, know it. I want to bring out my fantasy about that flavor."

"I enjoy the variety and diversity in the assignments I choose, and especially those jobs which invite maximum creative freedom and unbridled use of my imagination. Although I greatly respect the need for authenticity of period costume or a specific ethnic design motif, I feel even my historical portraits have an aspect of my own fantasy of the character in them."

Craft says, "I welcome opportunities for unique assignments or subjects. I'm comfortable creating imagery that crosses over many different cultures, both real and imaginary times and places."

In fact, the artist really enjoys a challenge. "Regardless of the project, there must be something asked of me in the work, or I won't take the job," she says. "More than half of a project is my being able to express how I feel about it, to show my reaction. My mission is to tell my version of the story. I spend many hours with the manuscript, reading. After page one hundred, a mood sets in and ideas begin to take shape. The more time I put in, the more something lives in the image," she notes.

"I actually live in the book while I work. I function much like an actor taking on a role. The outside world fades away," she says, laughing. "It can be a real problem, especially when we run low on food during an ice storm, and I've just spent twelve hours in my studio. But I think I've been in a fantasy world all my life."

ENJOYING THE PROCESS

The artist revels in process and details. "I visualize the finished cover in my head," she says. "I make the preparatory sketch and send it in for approval. After approval, I set the model up to see what the body looks like. I prefer naked models, as I make up the costumes and draw in the clothing with pencil."

"Since I design and paint all the clothing, one of the greatest compliments I've ever received was from a woman who came to see me at a convention wearing a wedding dress she had made based on one of my paintings. And that was a complicated dress!"

Craft says, "I use a number of models, and take digital pictures. From these I do the drawing, but it's also informed by my life drawing. To keep my skills sharp I take a weekly model-drawing class."

"I like spontaneous discovery. I'm not patient enough to do color studies. When I do the sketch I have a vague idea about the color in my head already, but I like the surprise that can happen during the painting. It motivates me," she explains. "The process of discovery as I'm painting is the part I like best. That's where the fun is. I think I enjoy the process more than the finished painting."

After making her preliminary sketches in charcoal and then in pencil on tracing paper, the artist draws the image in pencil on gessoed board. She then paints from corner to corner with Winsor & Newton watercolor. When that underpainting dries, she gradually covers it with oils over a series of weeks and even months. The final painting is varnished to provide extra shine.

Craft doesn't make a distinction between painting illustrations for adult books or children's books. "For me, picture books are not children's books. Though they are called *children's* books, I create the images mainly for me—both the mature woman and the child within myself. I believe we are always young inside and psychologically never grow old and worn out, from birth to death. My paintings for picture books are a form of narrative fantasy, a string of images all linked together by the subject matter, telling its own story and completely under my control. My paintings let me live in a world of my own imagination and fantasy, which I often prefer to reality."

"Some of my favorite commissions have been paintings for opera companies," Craft says. "They're unique challenges. I especially enjoy the artistic freedom they allow me, and the high quality of production on the posters. I like the

Psyche Weeping. Oil over watercolor on board. From *Cupid and Psyche* by M. Charlotte Craft, Morrow Junior Books, 1996, recipient of the gold medal from the Society of Illustrators. Inspired by eighteenth-century Romantic paintings and intrigued by the compositional challenge, Craft paints an inverted portrait reflected in water. To prepare for the painting she first observes the surface of a lake, makes sketches on tracing paper, and then works in watercolor, then oils, in her studio.

music, too, so I listen to it to set the atmosphere I need to form the idea for the image in my head."

THE PLEASURES OF INFINITE POSSIBILITIES

For Craft, the best moment of artistic creation is before the painting even begins. "When I look at the white gessoed board, I see infinite possibilities for masterpieces," she says. "It's the best, most hopeful time. I also relish the watercolor process, when it's becoming something that I like. And then I've got the oils on the palette and am ready to go, to cover the watercolor. These are the moments when I forget about everything. It's like heaven."

This is not to say there aren't frustrating moments for her. "I can keep trying and trying with a sketch, and all the while there's this finished painting in my head that

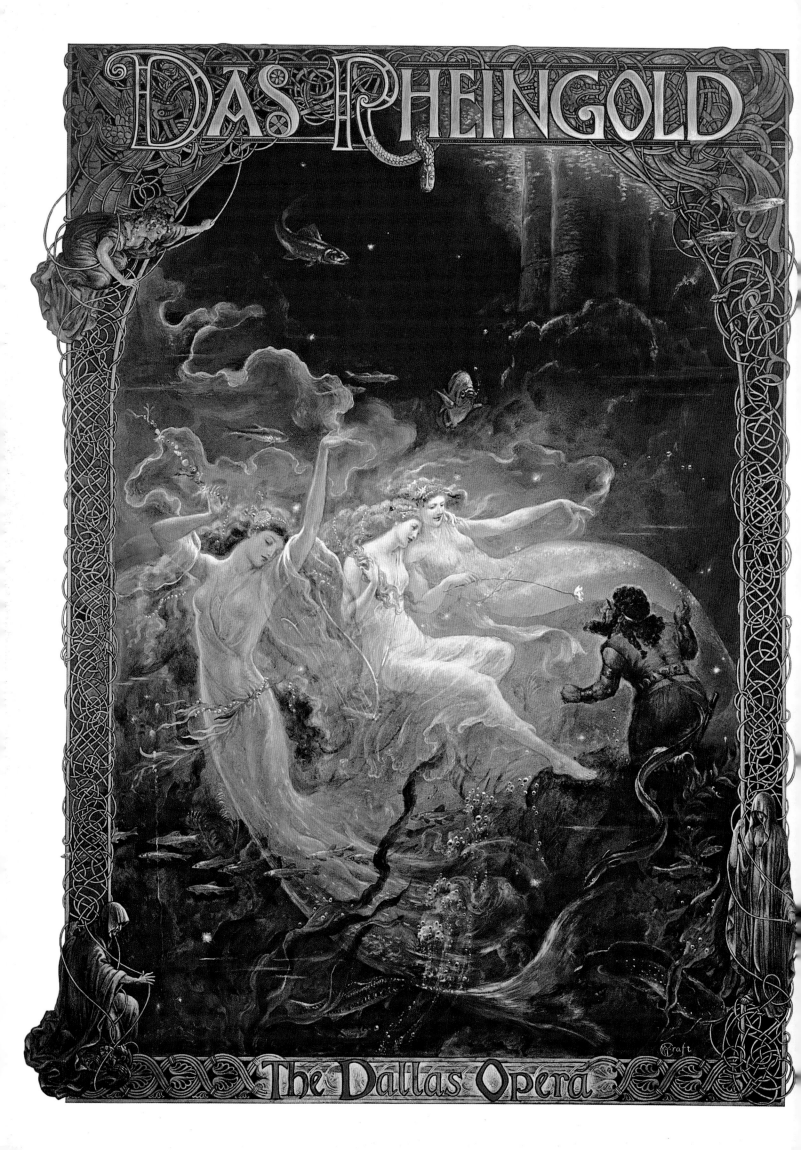

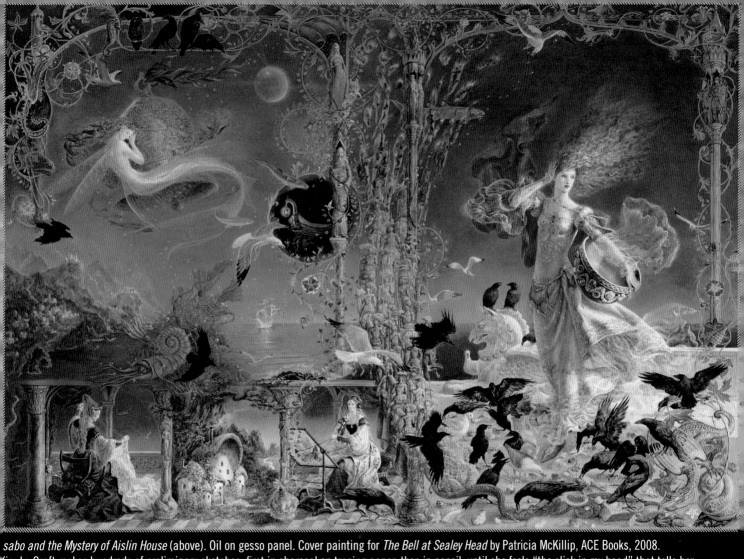

sabo and the Mystery of Aislin House (above). Oil on gesso panel. Cover painting for *The Bell at Sealey Head* by Patricia McKillip, ACE Books, 2008.
Kinuko Craft makes hundreds of preliminary sketches, first in charcoal on tracing paper, then in pencil, until she feels "the click in my head" that tells her she has the right idea. Once she has decided upon the composition she spends at least two months on a painting, sketching on gessoed panel, painting the underpainting in watercolor, then covering it with oils, refining details, and working over the painting like a jigsaw puzzle. *Das Rheingold* (opposite page). Oil on board. Created for the Dallas Opera. The artist borrows from ancient Celtic patterns and Art Nouveau imagery to provide the framing motif for the poster of the Dallas Opera's production of Richard Wagner's *Das Rheingold*, the first work in his epic Ring Cycle.

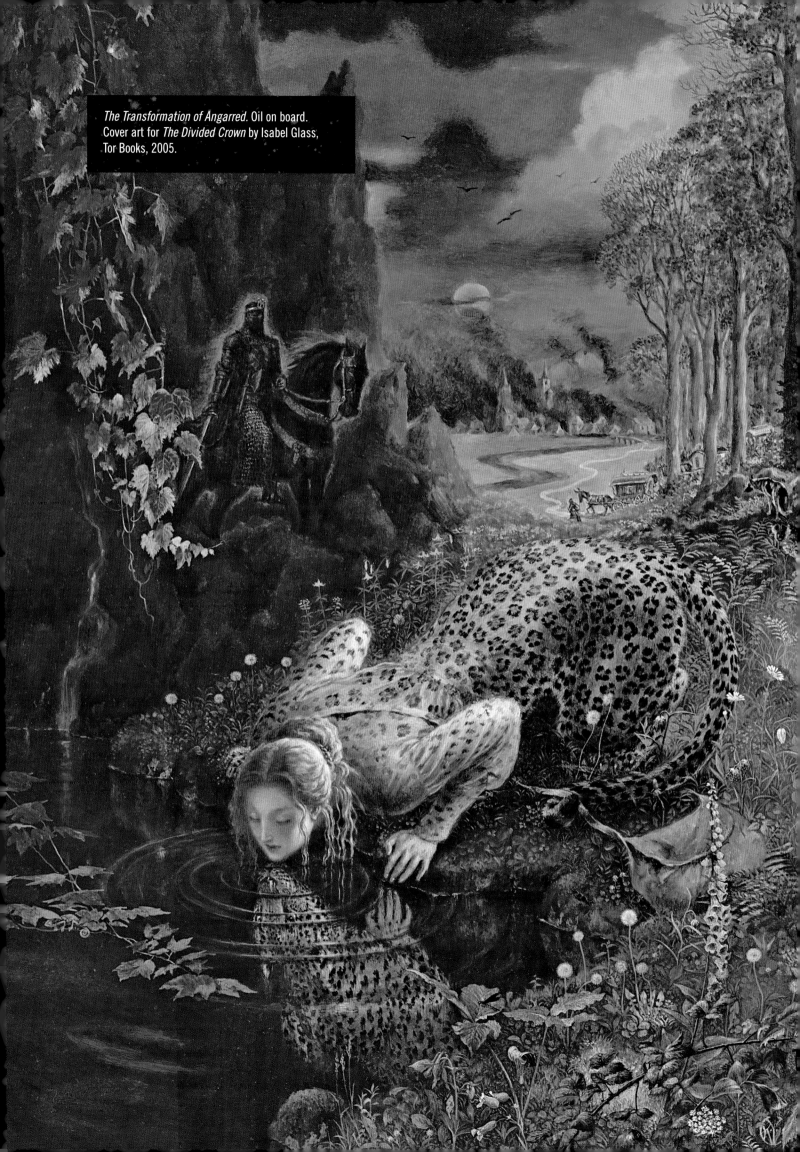

The Transformation of Angarred. Oil on board. Cover art for *The Divided Crown* by Isabel Glass, Tor Books, 2005.

I see. And even when I can envision it working out won-
derfully, it doesn't necessarily work out that way when
I try to draw it. However, at that sketching point I still
have lots of hope for the painting. I just try to do my
best," Craft explains.

"If I'm very lucky, I can do the conceptual stage somewhere
between two days and two weeks. Then I do the final
refinement, a very tight drawing on the board, in pencil.
I overpaint this in watercolor, then finish the painting
in oil. It can take months to finish."

The artist takes an extremely personal view of the work.
"For me, the most important relationship is between me
and my painting. I live with it, live in it. It really is like
being obsessed."

Her advice to beginning artists begins with the pencil.
"You must take drawing classes. If necessary, seek out
or hire models. Photographs have a tendency to make
everything flat. Real bodies show muscles, and you must
see that, and know how to draw it," she explains. "If you
understand the body in three dimensions and can draw
it well, you can draw just about anything. You must have
a fantastic imagination *and* draftsmanship. It's so easy
to neglect draftsmanship, because it takes time, but
drawing is the key to everything."

For more information on Kinuko Y. Craft and her art-
work, please see the artist's website at www.kycraft.com.

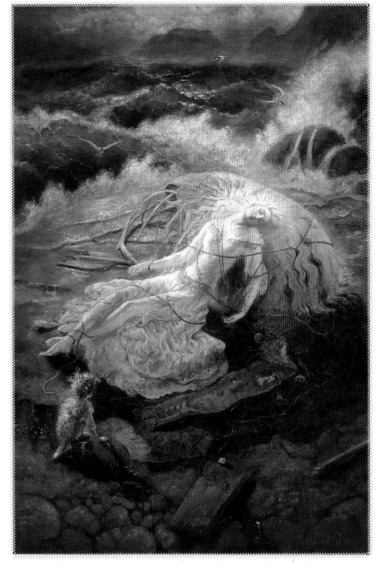

Criedhe. Oil on board. Cover art for *Foxmask: Children of the Light Isles*
by Juliet Marillier, Tor Books, 2007.

CHARLES VESS

"Too many people remain dazzled by slick rendering techniques as opposed to well-thought-out, interesting ideas, no matter the medium used."

A Song of Stone and Tree. Colored inks. From *Instructions*, HarperCollins, 2010.

Mysterious forest glades filled with winsome faerie creatures glisten under enchanted lights. Graceful tree limbs curve down to frame cavorting faerie folk dressed in rich colors. Fabled denizens of fantasy tales and ballads stride through these fabulous landscapes, expertly rendered with loving detail by acclaimed artist Charles Vess.

For more than three decades, Vess has delighted fans and publishers of fantasy art with his romantic, detailed, evocative illustrations. He's enjoyed a multifaceted career that has encompassed comics, books, movies, museum exhibitions, sculpture, and running his own press, Green Man Press.

Vess has a BFA from Virginia Commonwealth University. After working as a commercial animator with Candy Apple Productions in Richmond, Virginia, he moved to New York City in 1976 to become a freelance illustrator. Among the publications and publishers he worked for were *Heavy Metal*, *National Lampoon*, Epic Comics, and Klutz Press.

His award-winning work has graced the covers and interior pages of many comic book publishers, including Marvel (*Spider-Man*, *Raven Banner*) and DC (*Books of Magic*, *Swamp Thing*, *Sandman*). His recent book illustration work can be seen in *The Ladies of Grace Adieu* (Bloomsbury,

Once Every Nine Years There Is a Market. Colored inks. Issued as limited-edition print by Green Man Press, 2008. © &™ Neil Gaiman and Charles Vess's *Stardust*, 2007.

2006), *Green Man—Tales from the Mythic Forest* (Viking, 2002), and *Peter Pan* (Starscape, 2003). *Stardust*, a novel written by Neil Gaiman and illustrated by Vess, was made into an acclaimed film by Paramount Pictures in 2007. Other recent Vess-Gaiman collaborations include the *New York Times*—bestselling children's book *Blueberry Girl* (Harper-Collins 2009) and *Instructions* (HarperCollins, 2010).

Drawing Down the Moon: The Art of Charles Vess, a lavish, 200-page retrospective of his art, was released by Dark Horse Books in 2009. The artist recently completed a three-year project: the design and co-sculpting of a sixteen-foot (4.9 m) bronze fountain based on *A Midsummer Night's Dream* for the Barter Theatre in Abingdon, Virginia. Vess lives and works in Virginia, where he runs Green Man Press with his wife, Karen Shaffer.

FASCINATING RHYTHM

"Any art is rhythm and pattern," Vess says. "The artist's decision involves how much you show and how much you don't show. If you show too much information, you tire the viewer. You have to have that rhythm. The more you develop it, the more you can do."

Vess's work is distinguished by his sinuous use of line and attention to detail, both of which are derived, in part, from his passion for great illustration of the past. "In the early 1970s, I fell in love with the Edwardian book illustrators. Of course, I also loved modern illustrators like Frank Frazetta and Roy Krenkel. But I really feel a romantic connection to Arthur Rackham and the entire history of fantastic art. For a few years I taught the history of fantastic art at Parsons School of Design in New York, in part because I get inspired by these artists and enjoy sharing their work. I love that work, it makes me want to paint, and anything that does that is good. I feel sometimes that I'm engaged in a long metaphorical conversation with all these dead artists."

Instructions, page 13. Colored inks. From *Instructions*, HarperCollins, 2010.

The Village of Wall. Colored inks. Issued as limited giclee print to benefit the Comic Book Legal Defense Fund in 2007. © & ™ Neil Gaiman and Charles Vess's *Stardust*, 2006.

COMICS AND ARTISTIC SENSIBILITY

Early in his career, Vess worked in comics, eventually drawing for Marvel, DC, Dark Horse, and Heavy Metal. He remembers it as demanding work that wasn't entirely a good fit for his romantic sensibilities. "When I worked in comics, I tried various techniques, as my style isn't really suited for those publications. I think it's good to go outside your comfort zone, to stretch your abilities," he says.

"Mainstream superhero comics ask you to draw more than is really necessary. They are usually very exaggerated, and I tend to like more subtle, poetic, atmospheric imagery," Vess says. "I'm definitely a romantic, so I've segued into book illustration, children's books, etc."

"Comics do teach you to get it done without models, to draw out of your head, which helped a lot in my evolution as an artist. What I don't like about superhero comics is that the outcome of the story—who will win and who will lose—is determined by whomever has the biggest fist, the biggest muscles, etc. I don't want to endorse that way of thinking because life doesn't have to work like that," he explains.

ON MEDIUM

"For almost thirty years now I've used colored inks—I prefer FW inks—to layer multiple washes of diluted color down over my image, adjusting the density and hue of the color until it feels right. I do not use color wheels or have any hard-won, scientific knowledge of color. I just keep layering light washes of ink until the piece looks good to me. The trick is to know when to stop," Vess notes. "Only practice and repetition clue the artist as to when that 'magic' moment will be."

Vess adds, "Digital tools are incredibly useful. And with them I don't have to worry about shipping the art. I will sometimes clean up a picture digitally. Photoshop enables you to zoom in and fix it, but I'd much rather feel

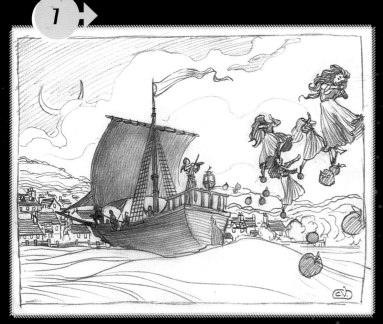

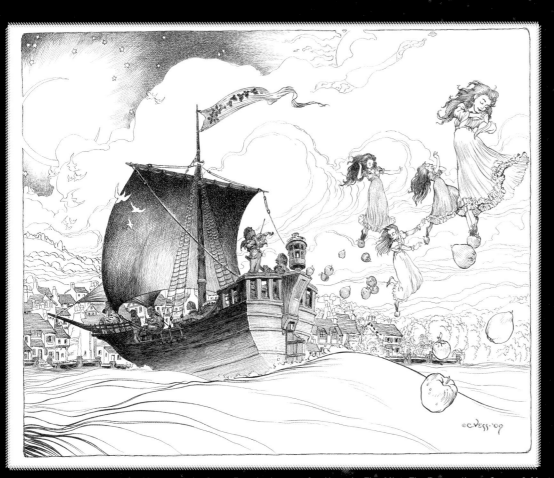

By the Sun and the Moon and the Stars: Frontispiece art for *Hope-In-The-Mist: The Extraordinary Career & Mysterious Life of Hope Mirrlees* by Michael Swanwick, Henry Wessells, 2009.

BY THE SUN AND THE MOON AND THE STARS DEVELOPMENT SEQUENCE ❶ Vess makes a quick pencil sketch on a sheet of typing paper. Next, he enlarges the finished sketch via a copy machine and loosely traces it onto the 2-ply Strathmore Bristol series 500 board with a smooth finish for ink work. ❷ He carefully finishes the pencil work, keeping in mind that it's much easier to correct the art with an eraser at this point rather than to change things at the ink stage. He leaves lots of broad areas to be detailed with his final pen strokes using a Hunts Crowquill 102 in order to preserve the spontaneity of his line work.

Proposal art for *The Life of Taliesin* by John Matthews, 2008.

THE LIFE OF TALIESIN DEVELOPMENT SEQUENCE ❶ The artist makes several extremely quick pencil sketches on typing paper, and chooses a mid-ground between his first two sketches as the viewpoint of the finished piece. **❷** He next enlarges the second sketch, centers it on a sheet of 4-ply Strathmore Bristol Series 500 board with a semi-rough finish, and traces it very loosely. **❸** After carefully working up the details from that sketch, he inks over the pencil lines, this time with a sepia-toned ink, leaving some areas for pure color washes to establish shape and mood.

Cover art for *The Beastly Bride*, edited by Ellen Datlow and Terry Windling, Viking, 2010.

After the artist's third sketch for this cover painting is accepted, Vess transfers it onto his board and outlines the figures in sepia ink. Next, in pencil, he carefully works out the reflections in the water that reveal the characters' alternate forms and avoids outlining the figures so that they appear soft and transmutable. Next he washes layer after layer of FW colored inks onto the piece. Finally, he picks out and enhances some of the dappled sunlit spots by erasing several layers of ink with a small, hard eraser.

Instructions, pages 16–17. Colored inks. From *Instructions*, HarperCollins, 2010.

pencil on a piece of paper or a brush in my hands. I prefer the sensuality. Besides, I don't ever want to totally clean something up. I want to play with it, to see the mark of a hand in the work.

"I prefer hands-on transparent media: watercolor, colored inks, watercolor pencils. With them I can layer many different colors. I don't use color theory so much as I just build up layers," Vess notes.

His greatest frustration in the art field is an overwhelming prejudice toward craft over idea. "In other words, too many people remain dazzled by slick rendering techniques as opposed to well-thought-out, interesting ideas, no matter the medium used," he says.

DRAWING FROM THE HEART

"Always draw from the heart," Vess advises. "No matter what kind of money you're being offered, just say 'No' if you can't completely embrace the given concept. Of course, the young artist also needs to be practical and accept some assignments that will pay the rent and put

food on the table. Being a working artist is always a daredevil balancing act between these two opposites."

"I always tell young artists to read as much as they can, both within the field and outside of it. Look at as much 'live' art as possible. Getting out of the house and into a museum is an imperative no matter what stage of your career you're at. Go to conventions and meet and talk ideas and techniques with other artists. Travel as much as possible. No one learns in a cultural vacuum."

How does he sum up the wisdom of a life lived in the service of art? "The eraser is the most important tool an artist has. You must make difficult choices sometimes. Yes, you *must* erase, even if it hurts. The best face I ever drew I had to erase—*of course*—because I hadn't integrated the head and the body properly. Everyone, even the most advanced artist, makes mistakes. How else can we learn?"

For more information, visit Charles Vess's website at www.greenmanpress.com.

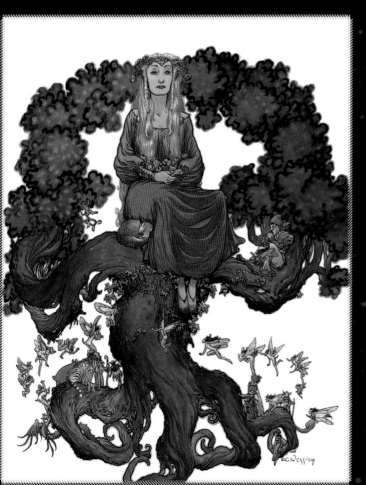

A Bounty of Apples (above left). Pencil. *A Bounty of Apples* (above right). Ink. *A Bounty of Apples* (left). Colored inks.

Vess notes, "I'm very intuitive about composition and color choices. I don't spend a lot of time considering composition. I just draw until it feels good and the objects are in the right place. I have a very highly developed sense of that, of placement and composition. There are houses and rooms I don't want to be in because things aren't placed right."

DONATO GIANCOLA

"I view each painting as a work of craft. I want it to be much more than an illustration."

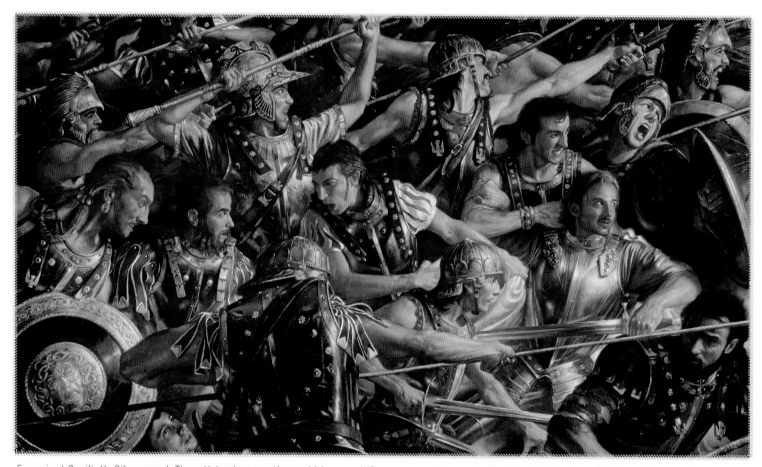

Faramir at Osgiliath. Oil on panel. The artist enjoys creating ambitious, multifigure compositions and often has his friends and fellow artists pose for him, as in this work. Donato uses horizontal elements of the spears and the golden glint of metal to keep the viewer's eye moving through the painting. For accuracy he uses photographic references, either posing and shooting them himself, or using professional photographers and models.

"For me, the most important issue about painting is not the commercial printed image that reaches millions," says Donato Giancola, award-winning fantasy illustrator and painter, "but what a person takes away when experiencing the original work."

The artist, professionally known by his first name, Donato, has been a member of the Society of Illustrators for nearly a decade. His honors include three Hugo awards, eighteen Chesley awards, and many gold and silver medals from the *Spectrum* annuals among others.

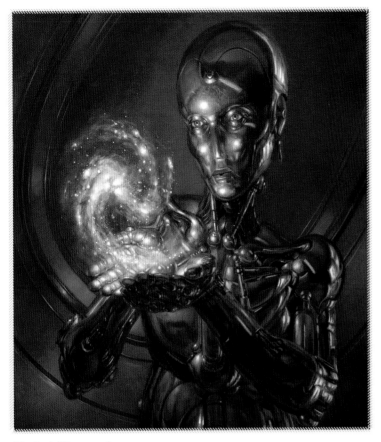

Stardust. Oil on panel.

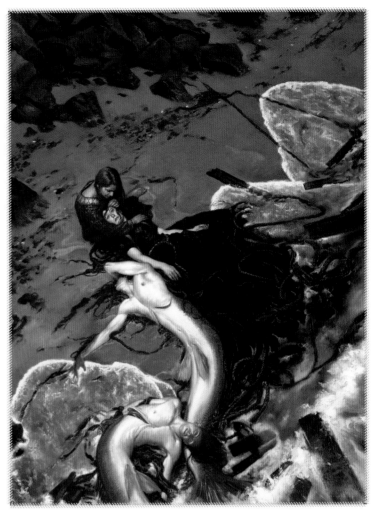

The Golden Rose. Oil on panel.

Donato graduated summa cum laude in painting from Syracuse University in 1992. Since then, his inspiring realistic paintings have appeared on the cover of more than 300 books. He has provided artwork for The United Nations, the U.S. Postal Service, *National Geographic*, LucasFilm, CNN, DC Comics, the Syfy channel, Microsoft, and major publishers and concept design firms.

The artist says, "I recognize the significant role that fantasy art plays in our culture and make special efforts to contribute to the expansion and appreciation of the genre." Part of his effort includes serving as an instructor at the School of Visual Arts and lecturing extensively at conventions, workshops, and universities worldwide.

OLD MASTERS' RULES AND TOOLS

Whether he's painting portraits, book covers, or collectible gaming cards, Donato employs the time-honored techniques of northern Renaissance artists like Rembrandt and Hans Memling. Then he adds a pinch of Islamic pattern or, perhaps, Cubist fragmentation just

to keep things interesting. "Drawing is what dictates my artistic choices," he says. "I want to be able to meld the idea of abstraction—pure gesture—with the reality of what I'm going to make."

The influence of the old masters has inspired him to create paintings whose audacious composition, brilliant color, and dizzying perspective are the delight of art directors and collectors.

"I really believe in looking at other artists. Their craft, their ideas. Being able to stand in front of a 15-foot [4.5 m] painting instead of flipping through a catalog is really important," he explains.

"I rarely use any vanishing point perspective," he adds. "Blame the Cubist influence: fracturing the vectors. I watch for strange overlaps or foreshortening. I'm very

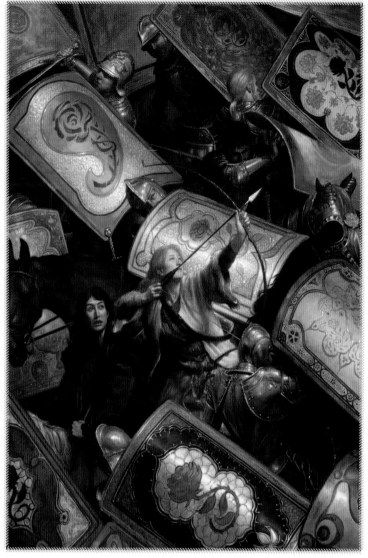

The Archer of the Rose. Oil on panel.

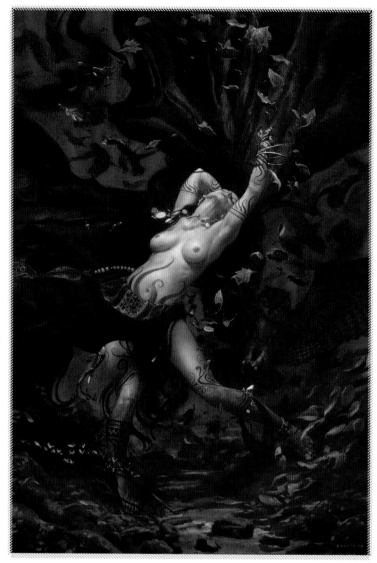
Shaman. Oil on panel.

conscious of composing my pictures along a two-dimensional layout. That helps them read graphically.

"I use a lot of tools in the process of creating art, but I don't think I could ever do without brushes and oil paints. The advent of the computer has certainly made my life a lot easier, but I will always be a traditionalist at heart. I love the tangibility of the artist's hand in the work."

"The best advice I ever received was from my first agent, Sal Barracca, who told me to buy myself some better brushes," Donato recalls. "Of course at the time Sal meant that literally, but it applies broadly to art, and I've taken this to heart. When you get the best materials and invest in your art, it encourages you to respect your craft on a higher level. I never shrink from spending money when I think it is a good investment for my career. From promotional materials to oil paints to frames, you must first invest in yourself before others will invest in you." Donato's passion for drawing and painting started at a young age. "My childhood is peppered with memories of making models and toys, drawing military hardware and spaceships, and finding highly creative projects in almost anything in the afternoons: reading comics, painting lead figurines for Dungeons & Dragons, creating maps and art for role-playing, making art projects for school, and producing my own 8mm films. Art was a passion, yet always a hobby," he says.

FROM ENGINEERING TO FINE ART

"My formal training came late," the artist admits. "I began my college career at the University of Vermont (UVM)

The Mechanic.

THE MECHANIC DEVELOPMENT SEQUENCE
❶ Donato uses models and photographic references to add a high degree of realism and detail to his thumbnail sketch. ❷ The artist refines his concept during the sketch phase. ❸ To achieve the finished work in oils, Donato builds up layers of subtleties through glazes—thin layers of oil paint—and emphasizes eye-popping metallic surfaces.

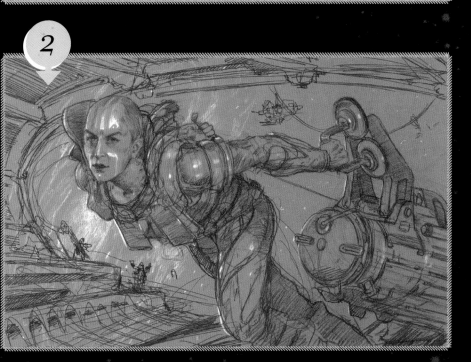

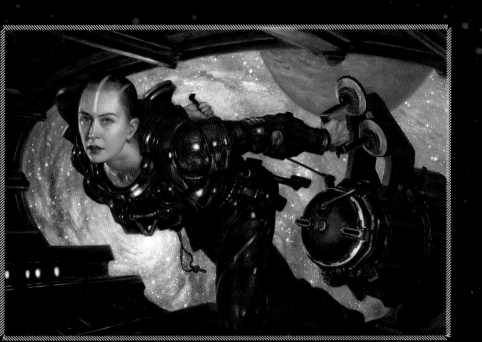

Legolas in Mirkwood. Oil on panel. The artist frames his subject between the almost abstract forms of two tree trunks while creating the look of dappled shade through careful control of color and contrasts.

Out of the Frying Pan, Into the Fire. Oil on panel.

Lovers. From *Do Androids Dream of Electric Sheep?* Oil on panel.

majoring in electrical engineering, but it wasn't until my second year at UVM that I withdrew from this career path, frustrated by the lack of creativity in classes, subjects, and assignments.

"I still remember the day I dropped out of three engineering classes in mid-semester, shocking my friends, my family, and even myself. I enrolled in an art course the next semester, and began my very first formal lessons on drawing. That same year I picked up my first set of oil paints, created some horrible initial paintings, and realized I needed guidance—*lots* of guidance," Donato recalls.

"Very quickly it became obvious that to take painting seriously I needed to pursue an education at a more challenging art college with competitive peers. I enrolled at Syracuse University in the fall of 1989 and majored in fine art painting."

At the heart of his success is hard work and study. "The doors that were opened to me at Syracuse proved innumerable: color theory, composition, anatomy, paint techniques, experimental drawing, postmodern, modern, and abstract theorizing. Anyone who talks about natural talent hasn't seen the hours labored to understand how to properly put an oil glaze on a painting. Study. Practice. Create. One of the greatest lessons I learned at school was that no art is perfect; keep moving onto your next project/ vision with additional challenges," he says.

"All told, my 'college career' lasted seven years, but my training did not stop after I graduated from Syracuse in 1992," Donato says. "I still attend drawing sessions, visit the studios of other artists, make pilgrimages to museums, and create challenges in my work to push the understanding of my craft. I am a perpetual student."

Robert Heinlein. Oil on panel. One of Donato Giancola's favorite painting genres is the portrait. He enjoys creating ambitious multifigure compositions but says that there's something about the challenge of a single figure that always delights him. He uses color and motifs associated with Robert Heinlein's writing to create a warm and dynamic portrait of the science fiction legend as a youngish man.

Donato is most pleased when a painting comes together. "It's like magic even after nearly twenty years in the field. Even though I have a very strong and set technique, there are so many unknown variables that can make a painting fail or fly, especially when you are under time constraints. When I reach that level of flow, where everything—the composition, the reference, the color, the drawing—are all working together to tell the story in a clear, harmonized way, it remains one of the greatest feelings in the world."

"Whether on concept design, private commissions, or commercial illustration, I love the process of creating art so much that I often feel I'm not able to devote the time I feel each project deserves. Because of this passion, there are no days off in this business, but when you love what you do, that doesn't really matter."

"I'd advise young artists to visit galleries, exhibitions, other artists' studios, and museums. Open your eyes to life immediately around you. The more you look, the better you see—both literally and metaphorically. And the better you see, the better you can transform the world for your art. Take art classes, open new doors. Challenge yourself constantly and learn to struggle in order to win."

To see more of Donato's work, visit www.donatoart.com.

All images © Donato Giancola unless otherwise noted.

Red Sonja. Oil on panel. The artist indulges his love of Islamic design in the background tile work. Framing his subject between two marbled pillars while pushing the contrast between her skin and the darker, intricate background, Donato ensures that all attention is focused on Red Sonja.

REBECCA GUAY

"You must develop the emotional side of yourself as an artist, and that's nothing you can get doing digital work. You have to develop it. It takes years of looking and painting."

Cupid and Psyche. Oil on paper.

The best advice anyone ever gave Rebecca Guay was: Keep your butt in the chair. "No amount of thinking alone can complete the work you need to do to get where you want to go as an artist. Certainly personal passion and style play into it, but in the end it's about putting in the 10,000-plus hours. This applies both to the art and to the business sides." She says, "I don't think there was ever a time when I didn't want to be an artist. I won a drawing contest in first grade, and right around that time, I discovered Wonder Woman and started to draw her everywhere. So, really early, I wanted to draw really specific stuff—princesses, fairies, and superheroes—everything that was fantasy- and comics-related."

She notes, "My mom had gone to art school, so she was really supportive of it. She was amazing. She had the courage to tell me, 'You can do it, but you have to work really hard.'"

Guay listened to her mother, worked hard, attended Pratt Institute, and graduated with a degree in illustration. Right out of school she began to get work. "I was pretty lucky," she says. "I got published right away by *Cricket* magazine and a few others."

A friend with a job at Marvel introduced her to the editors there. She got a cover assignment and then her friend offered her a job as an assistant. "I got to know everyone

Psyche (sketch). Pencil/digital.

Angel of Dreams. Oil on panel.

at Marvel, and they all knew I wanted to do comics. I spent all my spare time penciling demo pages."

Her break came when one of the editors who had seen some of her demos asked her to pencil a ten-page story—in three days—for *Spider-Man*. It was an insane deadline. Guay took a deep breath and plunged in.

"Basically, I didn't sleep," she says. She met her deadline and began to work as a penciler full time. "Being a comics penciler is like being in bootcamp for an artist," she notes. "I had never done it before. I spent a lot of time looking at other artists' work. Mike Mignola, in particular, was a great influence on me."

She adds, "Penciling is a very hard job, a constant grind. I would not go back to it. It's high-pressure work: you do a page a day and you have to draw on a very tight formula

so the inker can read your lines," she explains. "It's a grind, but it's perfect for young artists with high energy. If you had any flaws in your ability to draw they go away pretty quickly when you're a penciler."

Guay made good use of her tryout for *Spider-Man*. "Eventually, I took those ten pages over to Karen Berger at DC/Vertigo. It was a case of right place, right time. They needed a penciler for *Black Orchid*." She spent a year as the artist for *Black Orchid*. But all the while, she was also casting a wider net. "While I was doing *Black Orchid* I was sending out my portfolio to try to get painted work."

Her efforts paid off and the assignments flowed in: White Wolf and Magic: The Gathering came calling for gaming cards and book covers. She also painted trading cards for DC Comics and Tops, Inc.

Persephone. Oil on heavyweight watercolor board.

Guay estimates that she has painted more than 150 Magic cards. "The Magic fans are *so* loyal," she says fondly. "So passionate. It's a gift. I'm really grateful."

By the time her gig at DC/Vertigo ended, she was ready to go freelance and move on to painted comics. Among the graphic novels Guay has painted are *Green Lantern: 1001 Emerald Nights* (DC Comics, 2001), *Veils* (DC/Vertigo Comics, 2000), the 1998 Eisner Award nominee *Sandman: The Book of Destiny* (DC/Vertigo Comics, 1997), and *Magic: The Homelands* (Acclaim Comics, 1995)

She also pursued her dream of writing and painting children's books, which meant diversification of her portfolio. Over a decade ago, there were rigid divisions between children's and comics illustration. At the time, children's book editors disdained artists who worked in comics. It was a challenge to artists like Guay with wide-ranging goals.

"In comics you have to work at a level of detail in anatomy that you just don't have to do in children's books," she remembers. "I had to have two separate portfolios for children's books and comics. The two simply didn't meet in those days, and if I wanted to work in both I had to keep them separate."

The artist adds that that bias has lessened considerably in recent years. "There's been a real change, which is great, but it was a different, stratified world then."

In 2003 her first children's book, *Goddesses: A World of Myth and Magic*, written by Burleigh Muten, was published by Barefoot Books, to critical acclaim. Around that time she also achieved gallery representation with B. Michaelson. Guay followed that with *The Barefoot Book of Ballet Stories* by Jane Yolen and Heidi E. Y. Semple (Barefoot Books, 2004), *Muti's Necklace* by Louise Hawes (Houghton Mifflin, 2006), and *Black Pearls: A Faerie Strand*, also by Louise Hawes (Houghton Mifflin, 2008).

Guay has also painted book covers for such authors as Ursula K. LeGuin (the Earthsea series), Bruce Coville (the Unicorn Chronicles), and Jackie French Koller (The Keepers series). Recently published in England by Fernleigh Books was a children's pop-up book of *Beauty & the Beast*. Other projects have included *B Is for Ballet: A Dance Alphabet*, written by ballerina Sonia Rodriguez and figure skater Kurt Browning for Sleeping Bear Press, and *The Last Dragon*, with Jane Yolen, for Vertigo Comics.

Angel of Solace. Acryla-gouache on paper with oil glaze.

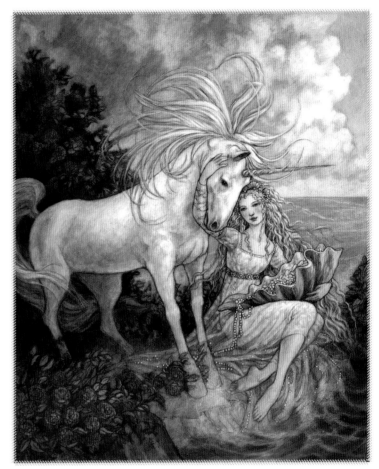

Beauty at Sunset. Acryla-gouache on paper.

Guay's work has received many awards including best in show (*Gen Con*, 2004), and best artist (*InQuest* magazine's Fan Choice awards, 2005). She has been an Eisner Award and a Chesley Award nominee, and served among the judges for the 2007 student show at the Society of Illustrators in New York City, where her paintings have also been exhibited. Her clients include Lucasfilm, Topps, DC Comics, Marvel Comics, Houghton Mifflin, Scholastic, Simon & Schuster, Wizards of the Coast, TSR, Barefoot Books, Charlesbridge Press, Realms of Fantasy, Farrar Straus & Giroux, MTV Animation, Easton Press, Dark Horse Comics, Acclaim Comics, White Wolf Inc., and Gale Group.

Guay's influences include the pre-Raphaelites, Sir Lawrence Alma-Tadema, Adolphe William Bouguereau, N. C. Wyeth, Arthur Rackham, Edmund Dulac, Alphonse Mucha, Rose O'Neill, Elizabeth Shippen-Green, and Kinuko Y. Craft.

MAKING A CONNECTION

"I really have to discover the spirit of the character and make an emotional connection there," she says. "Then I ask myself: How am I gonna do that? If I can't connect emotionally I don't feel I can do it justice."

She adds, "People may look at my work as ethereal, but it's not a word I would ever use to identify with my work. What interests me is emotion, the edgier, darker part of it. I love mythology and romantic stories, yes, but from an earthy and gritty perspective."

Her powerful treatment of *Orpheus and Eurydice* is a case in point. The painting is filled with light, movement, and emotion. "Their story is so passionate, so dark, so wracked by pain," Guay says. "Those are the subjects that

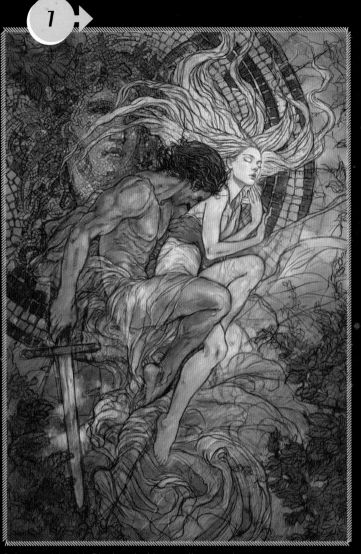

Guinevere (sketch). Black and white pencil on toned paper.

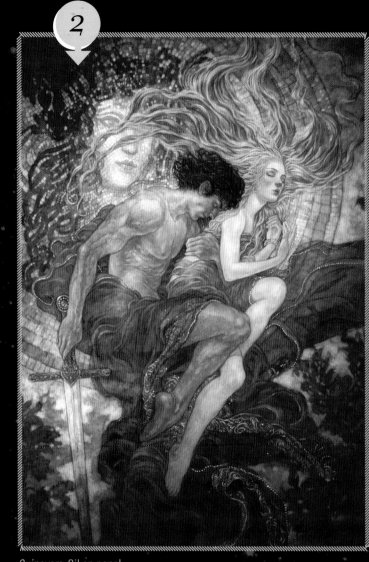

Guinevere. Oil on panel.

THE GUINEVERE DEVELOPMENT SEQUENCE ❶ The artist
says, "The single most important part of my technique
is to begin with a really beautiful, resolved sketch." She
transfers her preliminary sketch to the final surface either
with a projector or by mounting the paper sketch on
a board with matte medium. ❷ For the finished version
of the preliminary sketch, Guay paints *fat over lean*,
using lean (oil paint mixed with more turpentine to
promote faster drying) for her first layers, and as that
dries, moving on to fat (oil paint straight out of the tube).
The underpainting is often in watercolor or acrylic. When
the painting is complete she coats it with a glazing

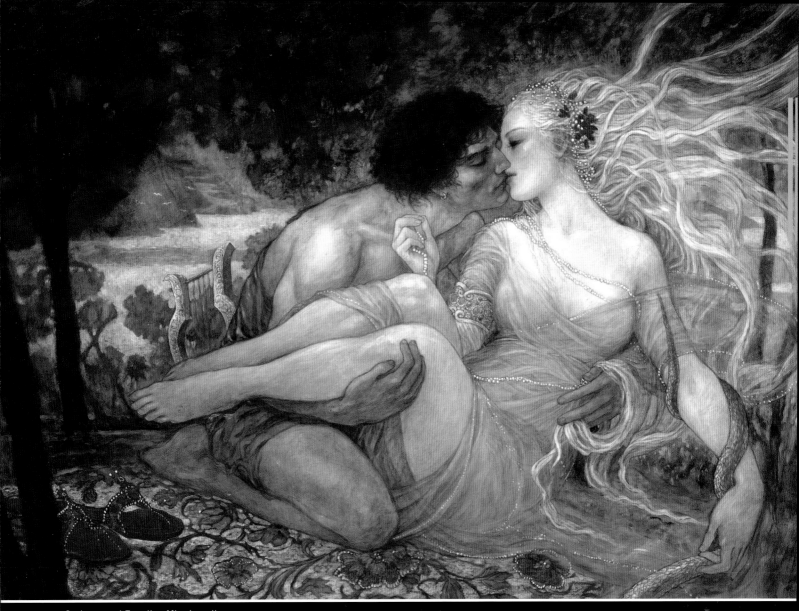

Orpheus and Eurydice. Mixed media.

The artist does a lot of glazing, working out of a neutral ground, always letting the drawing show through. She works up layers of acrylic until, halfway or two-thirds of the way through the painting, she shifts to oil for added richness in color and transparency.

Ivy. Oil on paper.

and oil on paper or paper mounted on panel. I do a lot of glazing, working out of a neutral ground, always letting the drawing show through. I don't want to cover every line with paint: I never want to lose the gestural stuff," she says.

"Once I've created a preliminary image that has good composition—no funny junctures—and beautiful anatomy, I then transfer that to my final surface, either with a projector or mounting the paper sketch on a board with matte medium," she explains. "I like to do my underpainting in watercolor or acrylic, then finish in oil. I'll work up the layers of the acrylic and, about halfway or two-thirds of the way through, shift to oil."

She adds, "There's nothing like oil for super rich color, and transparency. When the painting is complete I coat the final with a glazing medium to bring all the surfaces together."

Although Guay experiments with the digital side, she prefers to use traditional paint and hand skills. "There's a big love affair going on between artists and digital tools right now," she says. "I'd like to see digital stuff used more as tools toward finishing a painting rather than the whole thing. Painting is all about gestures. How gesture in a drawing creates an emotion. Think about what makes a body turn or gives breath to a figure. If you don't have a trained eye and don't know how to draw, if you're a bad draftsman, that will show regardless of your medium."

"You must develop the emotional side of yourself as an artist, and that's nothing you can get doing digital work. It takes years of looking and painting," Guay says. "I love sketching in pencil, and I prefer working on paper or panel, not canvas. Pencil has a beautiful variable line and I don't like fighting with the tooth of canvas even when I paint in oil. I like watercolor and oil paint and acryla-gouache, and I usually start my paintings with a water medium and finish in oil. In the end, though, I could

call to me. I love the complexity of it, the multifaceted view of a passionate moment. That's what draws me to a subject."

"Sometimes a poem will hit me," she says, "or a bit in a movie that resonates, or looking at art books. Myth also— the legend of Psyche had a lot of impact, with all of that vulnerability, faith, love, trust, trouble."

The visual possibilities of the work also attract her. "I love to explore rich color, to play with pattern, detail, and hue," she notes. "And I love skin: its luminous qualities, how flesh captures every color. I particularly enjoy portraying the earthiness in skin."

Although Guay began her career as a watercolorist and penciler, she has grown in a different technical direction over the past decade. "I work in pencil, acryla-gouache,

Eve. Oil on board.

make a picture with any medium, on any surface, within reason. There is no magic medium or secret surface or technique, only good-quality materials."

She is a firm believer in mastering drawing skills. "Getting to the place where you can pull together great anatomy and a beautiful composition is a matter of putting in the focused time into figure drawing classes from a live model, and doing hundreds and hundreds of sketch concepts and having them critiqued by people whose opinions you respect."

"My advice for young artists is to just keep practicing and be persistent. A deep obsession is what started me on my path and keeps me there," the artist says.

Guay has been an instructor at Pratt Institute and a guest lecturer at Savannah College of Art and Design, University of Massachusetts, Eric Carle Museum of Picture Book Art, and Rhode Island School of Design. In addition, she helped create the illustration master class at Amherst College, where she also instructs at the annual workshop.

"What I try to convey about my technique when I teach at my masters classes is that there is no one surface or

medium that makes what I do look like a Rebecca Guay painting," she says. "I could pick up almost any good-quality artists-grade medium and make something that people would recognize as one of my works."

"Certainly quality of materials is important," she notes. "Nice brushes—synthetic or sable—that hold a point or a nice clean edge, and good canvases, whether primed linen or nice watercolor paper, are very important."

"Great art may be possible to achieve with poor-quality material," she says, "but the poorer the materials the better the artist has to be to compensate for the failings of the raw materials."

She adds, "There's a good quote I heard once about the creation of art, and although I can't remember who said it, they have my admiration for how true it is: *Sometimes what we think we want is comfort, when what we need is inspiration.*" To see more of Rebecca Guay's artwork, visit her website at www.rebeccaguay.com.

All images © Rebecca Guay unless otherwise noted.

DAN DOS SANTOS

"I've always known exactly what I wanted to do. I very much believe that anybody can achieve any goal. The hard part is knowing the goal to achieve."

Green. Oil. Cover of novel by Jay Lake, Tor Books, 2009. When painting various surfaces, Dos Santos makes a special effort to handle the paint differently. For example, he uses larger brushstrokes with less refinement when painting fabric. This helps makes different elements appear to have discrete textures.

Dan Dos Santos is so busy that he plans a year's painting schedule in advance. Recently named as one of the 50 most influential fantasy artists working today by *ImagineFX* magazine, the Chesley Award–winning artist is an expert at traditional brushwork.

The strength of his painting is his mastery of the face and figure. Dos Santos excels at portraiture. He can paint tight or loose, work with painterly effects, and always creates a dynamic composition, never losing his original emphasis: portraiture. Each of his paintings conveys the sense of a living, breathing individual.

His ease at the easel seems to invite art directors to pile on the number of subjects per painting. Dos Santos laughs about it and says, "One? Three? Even better! Bring 'em on!"

"I like painting women," Dos Santos says. "But beyond that, it's about the portrait. The subject is really a person. A particular visual I read in a book gets me excited, and gives me a key image to work on—something as simple as a haircut. For example, in *Black Blade Blues*, there's a tough female lead fighting dragons in Seattle, with nice cool urban fantasy elements. She's a blacksmith, and she has a half-shaved head with white hair and a black sword and glowing red runes. How can an artist go wrong with that!?"

Doppelgangster. Oil. Cover of novel by Laura Resnick, DAW, 2010.

Stalking the Unicorn. Oil. Cover of novel by Mike Resnick, Pyr, 2008.

He acknowledges that he's become known for his portraits of strong women. "I keep getting tough-girl covers," he says. "It probably has something to do with the nature of the literature. More than half of what I do is vampire-related. There's been an incredible increase in vampire literature, and there are *a lot* of tough women characters in these books."

He adds, "I grew up on comic books where everybody is tough. The guys are tough, the girls are tough. So the strong woman as a subject was no problem: It's what I've always drawn."

Dos Santos didn't expect to be painting fantasy art. "I prepared for science fiction art in school, but got a fantasy job first: a unicorn," he notes. "Gradually, I got accustomed to the visual tropes of that field."

"It takes me two weeks to do a painting," he says, "including reading the manuscript, model shoots, and so on. It's always a rush. I wish I had three weeks for each painting, but I don't."

He notes, "I have to paint two a month to make a living. Right now I have two covers going simultaneously, but I usually do them in sequence. I don't split my focus very well."

Dos Santos says that working with live models adds a dimension to his work. "Models really make a difference," he notes. "I go out of my way to find exceptional models. A lot of my favorite models are not professionals—most pros don't work for illustrators. You really need an actor more than a model. People have so much individual character, it helps bring a different flavor to each cover."

Black Blade Blues. Oil. Cover of novel by J.A. Pitts, Tor Books, 2010.

Once his thumbnail sketch has been accepted by the client, Dos Santos scans it and colors it for reference in Photoshop. Next, the artist replicates the sketch in a photo session with live models and redraws the sketch using his new reference for freshness. He uses this final sketch as his painting guide.

Warbreaker. Oil. Cover of novel by Brandon Sanderson, Tor Books, 2010.

Miss Shimmer. Oil. Cover of novel *Shotgun Sorceress* by Lucy A. Snyder, Del Ray, 2010.

HAND SKILLS VERSUS DIGITAL TOOLS

Although the artist sees the usefulness of digital tools, he prefers traditional brushwork. "It's this constant inner battle," he admits. "Hand skills versus digital. I think that the love affair with digital is a fad. In twenty years, people are going to miss analog skills. They're going to want to see paintings."

"I learned oil paints very traditionally," he explains. "I picked this medium because you can make oils look like anything. You can't make those other mediums do that. And if you know how to paint, you can pick up Photoshop easily, but not vice versa."

"When I graduated college, Photoshop was just taking off. I learned it and began using it for preliminary sketches. It saves so much time. And for print work, Photoshop is easier and looks better. But I just won't go there for the final portrait."

"I love having an actual painting, a product we can hold in our hands," he says. "There's never going to be an LCD Museum. You want to have something tangible left over. I want to give a client something to hold in their hands, a finished work."

Dos Santos credits a high school art teacher for putting him on the road to being an artist. "It definitely changed the course of my life," he notes. Now he wants to pay it forward, working with and encouraging young artists. "If somebody wants to learn how to paint and I can show them, it's my obligation to show them."

One of the ways he honors that obligation is by doing paintovers for www.conceptart.org in which he literally corrects beginning artists' work, overpainting it to show them how to better achieve an effect. "I do it while I'm eating breakfast," he admits. "The Internet has changed

Fires of Heaven. Oil.

Dos Santos knows that many subtle colors evolve while developing
the flesh of the subject. At the beginning he paints wet into wet in
one sitting, initially indicating the facial features but not refining
them until later in his process.

Ancient Bloodlines. Oil. White Wolf, 2009.

Poison Sleep. Oil. Spectra, 2008. Dos Santos projects his final sketch onto his gessoed cold-press Strathmore illustration board and begins the painting process by drawing the sketch in raw umber and ivory black oils.

everything, forever. It's amazing. A kid in Albania can be having trouble painting a belt and, five minutes later, a guy in Ohio can help him with it."

Dos Santos also participated in an instructional DVD for Massive Black, the company behind www.conceptart.org. "I did it because I'm unhappy about the cost of workshops and many tutorials," he says. "That's why I started working on Art Out Loud with Irene Gallo, the art director at Tor Books. Last September, a group of artists painted together in a simultaneous demonstration at the Society of Illustrators in New York for four hours while people walked around, watched, and asked questions. It was amazing."

"I used to teach formally at the University of Bridgeport," he notes. "But it was just a job. The teaching gigs I do now are so much fun. Those students are just voracious. They *want* to be there, and it gets you pumped up."

PAINTING AN ICON

Dos Santos may only be in his late twenties, but he's already achieved a goal many artists would envy. He's painted one of the most iconic images to grace a book cover in recent publishing history: Mercy Thompson, mechanic/shapeshifter and runner with the really big dogs—werewolves—from Patricia Briggs's *New York Times* bestselling series.

The painting, *Moon Called*, won the 2007 Chesley Award for best illustration for a paperback, and inspired the other covers that Dos Santos has painted for the Mercy Thompson series as well as the related Alpha and Omega series. At least onc of the paintings is owned by the author herself, and another by fellow artist Jon Foster.

Dos Santos likes to paint alone, saying, "I don't play well with others." But his most famous image to date was done via teamwork.

The idea for the first cover image of Mercy Thompson began with a request from an art director for a female mechanic posing with hands in pockets, with a pawprint tattoo on her abdomen.

"I'd sent in roughs with werewolves in the background," he says. "Then they told me they only wanted to insinuate the werewolves rather than show them, so we decided on the gates."

"I thought that the pawprint tattoo looked lonely, and that she would look so cool with all these tattoos on her," he adds. "I took pictures of the painting, worked it up with tattoos in Photoshop, sent it in, and they liked it so much that Patty [Briggs] decided to write the tattoos into the book! Literally everybody had a little part in the conversation: artist, art director, and writer."

"I've done all the covers for the Mercy Thompson books except for the Science Fiction Book Club edition," Dos Santos notes.

"The model for the character of Mercy is a bartender I know. She and her family get a big kick out of seeing the covers and paintings." He also reveals a fact that emphasizes the difference between art and reality: The model he used for Mercy Thompson doesn't have any tattoos.

As much as Dos Santos enjoys painting portraits for book covers, his favorite job to date was painting the poster for the movie *Hellboy*, for which he won the 2008 Chesley Award for best product illustration. "That was a dream job on many levels," he admits.

"I'm a big fan of the comic and I really loved doing it. It's a big imposing piece of art. I would still love to paint movie posters and renew that art form, but the market has disappeared."

"I want to do more movie work, conceptual and actual design. I just did some costume design for the lead character in *Sorcerer's Apprentice*, starring Nicolas Cage, and really enjoyed it."

He adds, "I also want to do more comic book covers. And I'd like to work on writing comics or children's books. Most likely I'll do picture books. But I've got to make the time for that."

From tattooed ladies to comic book icons, Dos Santos wants to paint them all. "I've always known exactly what I wanted to do," he notes. "And I very much believe that anybody can achieve any goal. The hard part for many people is knowing the goal to achieve."

To see more work by Dan Dos Santos, please visit his website at www.dandossantos.com.

All images © Dan Dos Santos unless otherwise noted.

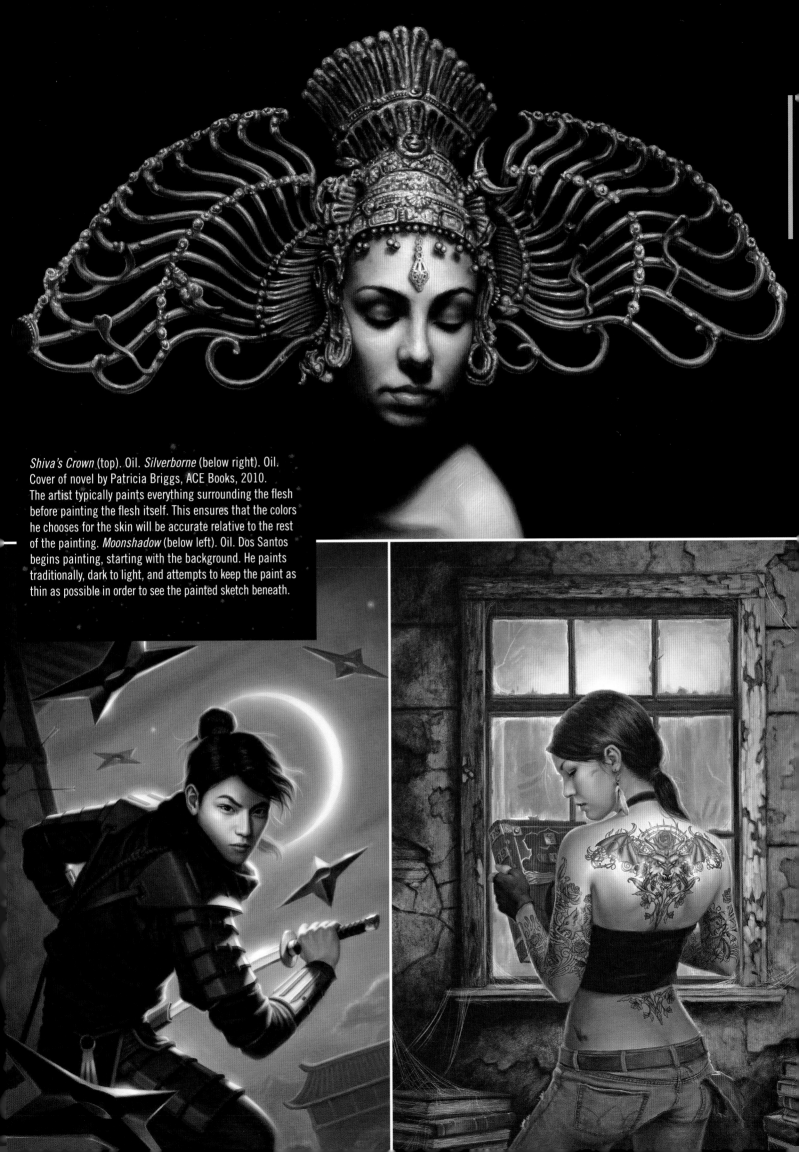

Shiva's Crown (top). Oil. *Silverborne* (below right). Oil. Cover of novel by Patricia Briggs, ACE Books, 2010. The artist typically paints everything surrounding the flesh before painting the flesh itself. This ensures that the colors he chooses for the skin will be accurate relative to the rest of the painting. *Moonshadow* (below left). Oil. Dos Santos begins painting, starting with the background. He paints traditionally, dark to light, and attempts to keep the paint as thin as possible in order to see the painted sketch beneath.

PETAR MESELDZIJA

"I combine fine art and illustration, first of all by trying to be suggestive rather then descriptive. This process of suggestiveness penetrates all levels of my work, starting from the choice not to illustrate the text lines exactly but rather what is between them."

The Hunt. Oil on canvas.

"Great art is able to withstand the judgment of time," says Petar Meseldzija. "It has a certain universal quality, which connects people and societies from different times and places. The thing I do is to try to combine fine art and illustration."

The Netherlands-based artist began his artistic journey in his native Serbia—then Yugoslavia—where his passion for comics led him to pursue a career in art. Along the way, both his artistic direction and his physical location underwent considerable change. His focus shifted from comics to fine art while, at the same time, he found himself fleeing his home as civil war consumed the country. Once safely anchored in the Netherlands, he began a more intense artistic journey that ultimately brought him full circle by utilizing the myths and traditions of his homeland in a fairy-tale book that embraced both old and new inspirations.

The artist has won many awards, including the International Golden Pen of Belgrade (1994), the 59th World Science Fiction Convention Art Show Judges' Choice Award (2001), two silver awards in *Spectrum: The Best in Contemporary Fantastic Art 4* and *10*, and a gold award in *Spectrum 16*.

Gandalf. Oil on Masonite.

The Exit. Oil on canvas.

Meseldzija's artistic development began with a love of comics and the desire to draw them. A graduate of the Academy of Arts in Novi Sad, Meseldzija has a degree in painting. The artist started drawing the comic strip *Krampi* in 1981. It was published in *Stripoteka*, one of the best-known Serbian comic magazines. While attending art school, he created drawings for the licensed comic book *Tarzan* and also drew other short series.

A NEW BEGINNING

Soon after he settled in the Netherlands in 1991, Meseldzija illustrated his first book, *Peter Enkorak*, published by Mladinska Knjiga from Slovenia. Over the next decade, he stopped working on comics and dedicated himself to illustration and painting, producing roughly 120 posters and greeting cards, mostly for Verkerke Reproduktie in Holland. For Grimm Press, Taiwan, he did illustrations for

the book *King Arthur and the Knights of the Round Table*. He held his first solo exhibition of illustrations and paintings in 1998 in the Tjalf Sparnaay Gallery in Amsterdam. He also painted book covers for Scholastic and illustrated the Serbian folk tale *Prava Se Muka Ne Da Sakriti (Real Trouble Cannot Be Hidden)* for Bazar Tales, Norway.

Homesickness began to take its toll on the young artist. He recalls, "After two years of very commercial work I started to feel the urge to do something just for myself. I was, also, terribly homesick. Eventually, the solution presented itself in the form of an idea to illustrate a well-known Serbian folk tale, *The Legend of Steel Bashaw.*"

The Legend of Steel Bashaw is based on Baš Ðelik, a Serbian folk tale about a dragon. The long process of writing and painting the story led Meseldzija to cultural and artistic

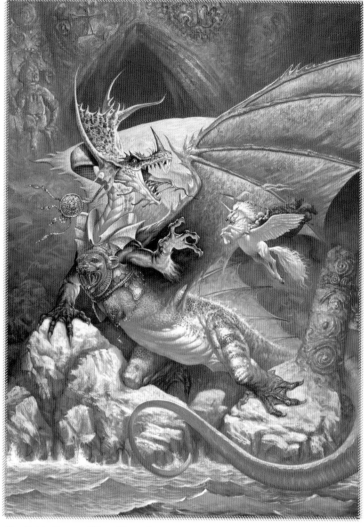

The Noble Dragon. Oil on Masonite.

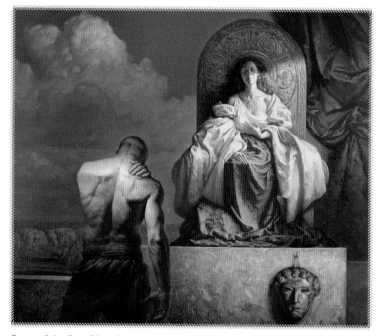

Dawn of the Day. Oil on Masonite. The artist defines all shapes, tonal values, and the balance between light and dark areas in his very detailed underpainting. Once this has been achieved, he moves on to painting in color, working in one layer, wet on wet.

resources of Eastern Europe. He cites the work of four artists—two Serbs and two Russians—as being deeply inspirational to this project: Viktor Vasnetsov (1848–1926), Ivan Bilibin (1876–1942), Paja Jovanović (1859–1957), and Uroš Pedić (1857–1953).

"In order to add a certain archaic quality to the look of the art, I started to dig into the medieval past of the ancient city of Novgorod," Meseldzija recalls. "The beauty of the medieval Serbian monastic architecture and its frescos helped me infuse the book with spiritual symbolism and harmony."

The Legend of Steel Bashaw is a tale about the wonders of life, the joys and pains of living; it's about love, responsibility, dedication, and compassion. It is a story that does not promote the sharp division line between good and bad, but rather sees these opposites as the indissoluble parts of the whole."

Meseldzija is a self-taught master of alla prima—expressive brushwork technique. His work appears realistic from a distance, but as the viewer approaches the painting, abstract elements begin to emerge until the powerful strokes of rich paint come to dominate the surface of the painting.

Meseldzija notes, "I combine fine art and illustration, first of all by trying to be suggestive rather than descriptive. This process of suggestiveness penetrates all levels of my work, starting from the choice not to illustrate the text lines exactly, but rather what is between them; through use of the secondary compositional forms to emphasize the primary aspect of the composition; to the use of alla prima, expressive brushwork technique in order to imply a sense of dynamic movement and vitality in my paintings."

Meseldzija begins his creative process with sketches, then moves on to photos for reference. "Usually, I start with making the rough sketches, trying to find the best visual expression of an idea or a feeling I want to capture," he explains. "Narrowing the choices, I am gradually working toward a relatively detailed drawing, which I later use to find the right models, costumes, and props.

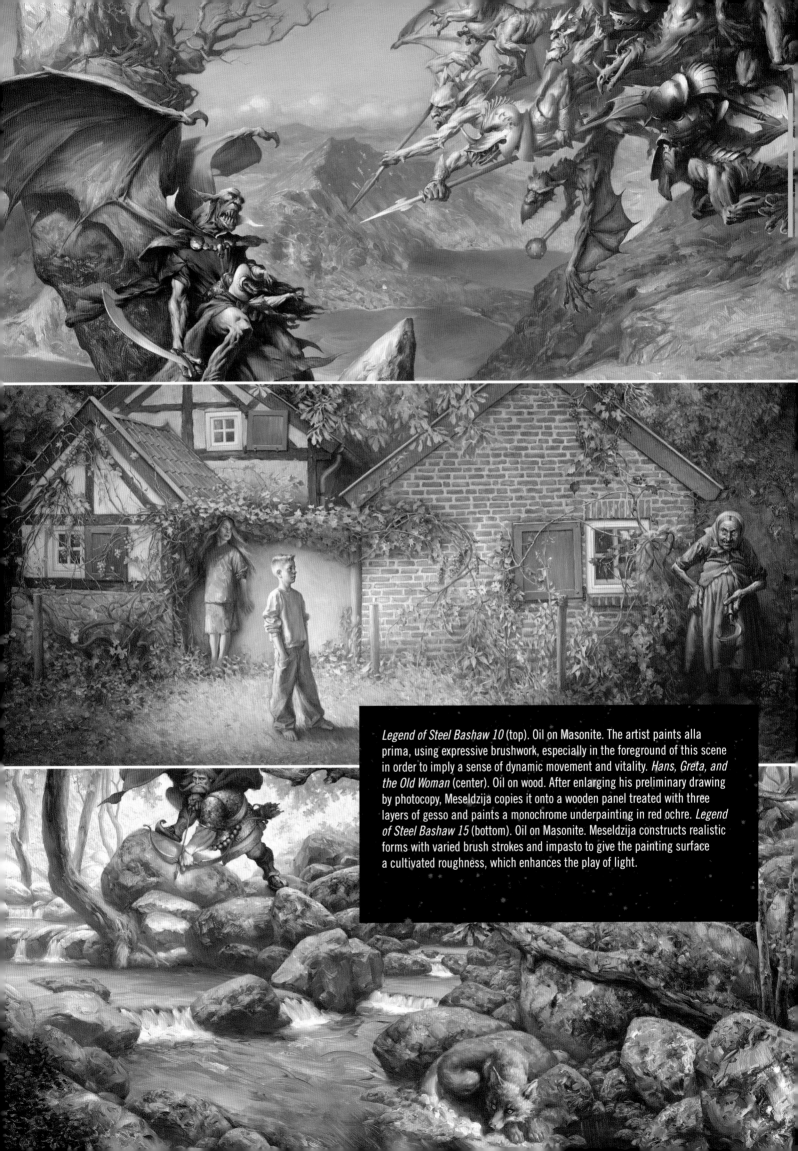

Legend of Steel Bashaw 10 (top). Oil on Masonite. The artist paints alla prima, using expressive brushwork, especially in the foreground of this scene in order to imply a sense of dynamic movement and vitality. *Hans, Greta, and the Old Woman* (center). Oil on wood. After enlarging his preliminary drawing by photocopy, Meseldzija copies it onto a wooden panel treated with three layers of gesso and paints a monochrome underpainting in red ochre. *Legend of Steel Bashaw 15* (bottom). Oil on Masonite. Meseldzija constructs realistic forms with varied brush strokes and impasto to give the painting surface a cultivated roughness, which enhances the play of light.

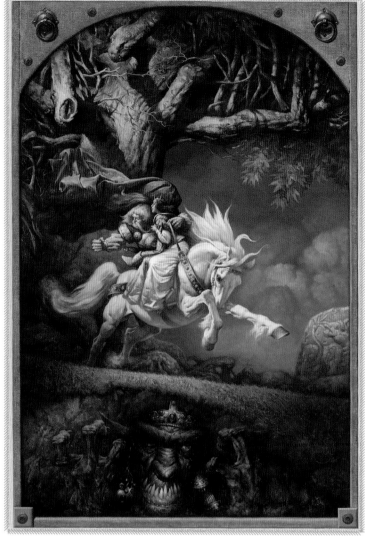

Legend of Steel Bashaw 9. Oil on Masonite.

The Legend of Steel Bashaw. Oil on Masonite.

"After that, I do the photo session. With the help of the initial drawing(s), the photo references, and, if necessary, some props, I start making the final drawing, which is sometimes more and sometimes less detailed. When I'm satisfied that all the elements of the composition are in the right place, I enlarge the drawing on the photocopier. Then, I copy the drawing onto the wooden panel or canvas, which I have already treated with three layers of gesso. After that, the real work starts."

Meseldzija starts the painting process with a monochrome underpainting in red ochre. "As my use of alla prima technique has grown through the years, my underpainting has, of necessity, become quite detailed," he says. "This means that all shapes are defined and that the tonal values and the balance between the light and the dark are satisfactory. Once this is set, I can immediately

start painting in color and finish each part of the painting in one layer. In other words, I work wet on wet," he says.

"I enjoy the challenge of the wet paint, its fluidity and disobedience. Through the years, I developed a kind of aversion to applying a second layer of paint as I was becoming more and more attached to the spontaneity and freshness of the first layer," he explains.

"To apply this technique and achieve desired results, one has to work very hard to practice, learn, and develop perseverance in order to reach a certain level of understanding of the technique, or a kind of enlightenment in using the color. Your mind and hand work . . . together; they just know what to do. Suddenly you get the feeling that, as soon as you press the brush, with paint on it, to the painting's surface, the 'magic' starts happening.

Legend of Steel Bashaw 4. Oil on Masonite.

It's a wonderful feeling, I have to admit, but the road to it is backbreaking," Meseldzija says.

"Nobody in the academy helped me learn these skills. I had to gain them on my own by learning from the great masters of alla prima technique like Sargent, Sorolla, and [Ilya] Repin, among others."

Meseldzija adds, "I try to construct realistic forms from brushstrokes of different kinds in combination with more or less thick paint, so-called impasto. If done properly, this gives the painting surface a quality of cultivated roughness, which invites the light to play on it, enhancing its 'magic.'"

"When seen at a close distance the painting looks quite abstract. But when a viewer looks at it from farther away, all the strokes fall into place and the realistic forms appear. This principle is partly based on the experiments of the Impressionists, especially the pointillists, who applied different colors next to each other while the actual mixing happened in the eye, or the brain, of the viewer."

"This method appears to be highly effective in convincing the viewer that what he is viewing is almost as real and as vibrant as the reality itself," he claims.

To see more of Petar Meseldzija's artwork, visit his website at www.petarmeseldzijaart.com.

All images © Petar Meseldzija unless otherwise noted.

TERESE NIELSEN

"*Creating beauty is a compelling drive, and the idea that beauty helps evolve the spirit ignites me. I try to incorporate principles of beauty, harmony, and balance into every illustration, even if it's some phantasmic creature for a role-playing game.*"

A Calculus of Angels. Acrylic/oil/colored pencil/collage.

Terese Nielsen spent her childhood on a small farm in Aurora, Nebraska. Her interest in art led her to enroll in a junior college in Idaho right after high school. From there she made her way to the Art Center College of Design in Pasadena, California, where she earned her degree in illustration in 1991, graduating with highest honors.

Nielsen began freelancing immediately after graduation, contributing to everything from theme park design to editorial illustrations. In 1992, she entered the comic book field, illustrating superheroes for numerous collectible card sets. Soon to follow were fully painted comics for Marvel, *Ruins I and II*, and *Code of Honor*, and covers for both Topps' *Xena the Warrior Princess* and Dark Horse's *Star Wars* line.

She began her long association with Wizards of the Coast (WOTC) and Magic: The Gathering in 1996. Nielsen has painted hundreds of images for the renowned game. The artist has worked with every major gaming company in the industry. Her artwork can also be found on numerous book covers, including those published by WOTC, Del Rey, HarperCollins, and Tor Books. She has received

many awards, served as a juror for several art shows, and been showcased in the *Spectrum Annual* for seventeen years and counting. Recently, Nielsen designed, art-directed, and helped illustrate Angel Quest: The Acts of Kindness, an interactive game featuring a hundred pieces of art created by twenty-nine different artists. She has also contributed imagery for World of Warcraft.

Nielsen's masterful line work, bold composition, and powerful use of colors and mixed media have brought her the admiration of art directors and fans around the world. Early in her career she got involved with comics, but not as an inker. "I'm a painter, so I never did the traditional 'penciling' or 'inking' that most comic book artists are known for. I created a few painted graphic novels. It takes a tremendous amount of time to do a 'painted' comic, and the page rates were never high enough to compensate for the amount of time needed to do a nice job. It was a good foot in the door, early in my career. However, I soon shifted to cover work in comics, as well as books, and also superhero trading cards, back in the day when those were so popular." Her artistic perspective underwent a shift in 2005 during her work for Angel Quest, created by Brian and Alex Tinsman. Although Angel Quest fell victim to the economic downturn of 2009, its spiritual, positive intent deeply affected the artist.

"Angel Quest was the first project in which my talents, heart, and soul completely converged in a profoundly fulfilling way," Nielsen says. "I found it incredibly satisfying to create the *Angel of Thankfulness*. It conveys the feeling of profound gratitude I had conceived and tends to uplift the viewer."

"For *Angel of Thankfulness*, I was inspired by Gustav Klimt in my tight rendering on the hands and face," says the artist. "Another influence, Drew Struzan, can be seen in the lens-flare light effect, and the stylized feathers in colored pencil. The variegated gold leaf halo was inspired

Angel of Thankfulness. Acrylic/colored pencil/found objects/gold leaf. On wet-stretched Epson Velvet fine art paper, Nielsen applies acrylic washes to provide the foundational mid-tones and general colors, then builds up the lights and darks with thicker, more opaque applications of acrylic. From there she carves out edges with colored pencil, then uses airbrush for some final touches.

by Adolph Mucha. The decorative elements around the halo are pieces of an old necklace that I attached using my Dremel rotary tool."

She adds, "I've always loved Mother Teresa. She's the quintessential wise woman whose rich life experience, compassion, humility, and love bless the world, and I can't imagine better inspiration for this angel."

Nielsen continues to seek out projects that enable her to combine her artistic talents with her personal values, and currently cooperates with the RAINN (Rape, Abuse & Incest National Network) Charity Calendar directed

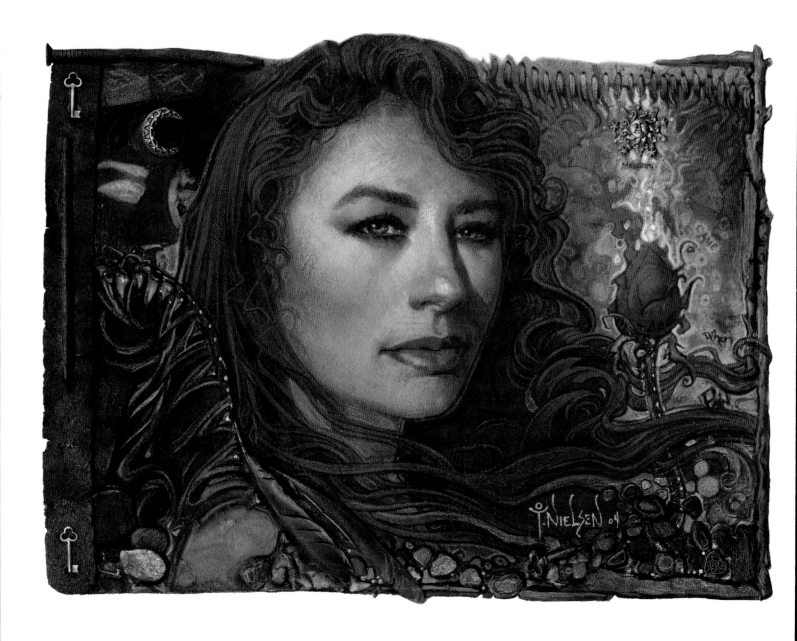

Tori Amos. Acrylic/oil/colored pencil/found objects.

Nielsen doesn't prepare a rough sketch with a fully planned composition here but, instead, lets the image evolve from a photo reference. The artist glues three-dimensional elements—found objects, metal scraps, stones, rusty nails, feathers, shark teeth, bandages, and bits of jewelry—to the illustration board. She then uses acrylic, colored pencil, and oil to seamlessly merge all of the elements visually within the piece.

by Tori Amos, as well as with other charitable projects. "I identify with the philosophies of visionary artist Alex Gray, who says, 'Spiritual imagery can give us a new worldview, a new way to interpret reality,'" the artist says. "Since the transcendent force is embedded in sacred art, it can empower us to transform the ways we think, feel, and act by awakening our own creative spirit. [In turn, the artist can offer] gifts of sensuous beauty through art while also offering a deeper gift: a contribution to spiritual growth."

Nielsen credits restless creative energy for her artistic range. "I find myself constantly shifting as to what it is I think I want to do," she admits. "I thought I wanted comics, and I got into that, and that was great. And then, well, that wasn't what I wanted anymore. And then the gaming stuff looked really cool, so I got in there, and that's been really exciting because there's so much variation in what you can do. And then my focus moved to book cover work, which I've liked a lot. It seems like I get to one place and I'm ready to move into another spot."

One thing that hasn't changed in Nielsen's creative life has been her deep connection with gaming fans, and her longtime association with Wizards of the Coast. She likes to stay in touch with the fans by attending gaming conventions around the globe, and Comic-Con in San Diego. She also customizes gaming cards she's designed for serious collectors. "I like to be available to fans and budding artists, especially the artists. I've had such great teachers and I'd like to repay my debt to them by helping young artists."

EXTREME ALTERATIONS

Magic: The Gathering fans can't seem to get enough of Nielsen's "extreme alterations," where she radically alters cards by painting over them. These works have been collected and two series of posters displaying the altered cards are currently selling on her website.

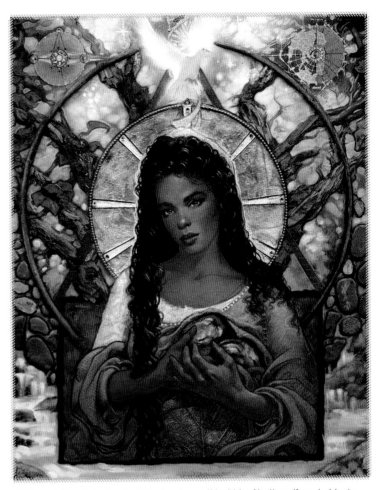

Miriam of Magdala. Acrylic/oil/colored pencil/gold leaf/collage/found objects.

"It's considered über cool to have the artist 'sign' the card," she says. "But if the artist modifies the card in any way, then that is just *beyond* cool. The European and Asian collectors are extremely hot for these sorts of collectors' items. I've always loved miniature things, so these are fun little miniature pieces of collectible art. I create them using the same mediums I use on large illustration jobs, just mini versions. You have to place one tiny dot of paint with pinpoint accuracy or it all looks wrong. I've been known to use a magnifying glass on some of these."

Painting, for Nielsen, is a means of escape from the ordinary. "I'd like to say that the reason I'm an artist is that I had a near-death experience, or perhaps an angelic visit that irresistibly ordained for me a creative destiny, but my life has probably been defined by an obsession for escaping boredom as much as—or more than—anything else. The quest to soothe heated neurons has probably defined not only what I do, but also how and why in every area of my life."

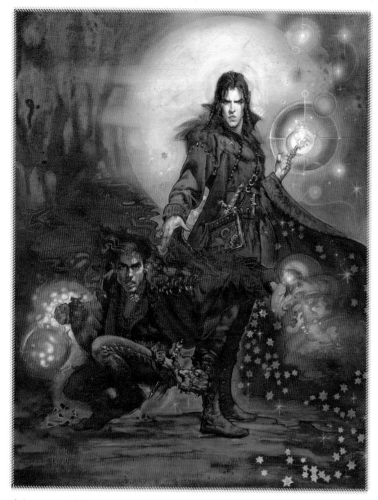

Julsenor and Atticus (bottom left). Acrylic/oil/colored pencil. The artist turns to other artists for inspiration, frequently referencing Gustav Klimt or Alphonse Mucha for compositional ideas and details. Using Klimt for inspiration here, she meticulously renders the faces and hands of her subjects, but allows the rest of the painting to become an interplay of symbolism, organic shapes, textures, and colors.

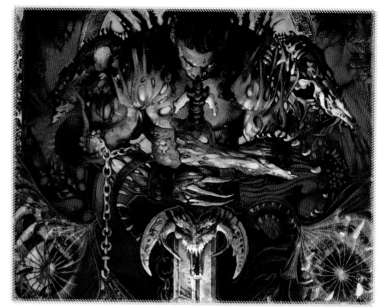

Unholy Strength. Acrylic/oil/colored pencil/gold leaf.

KEEPING IT INTERESTING

"Avoiding boredom is also the reason I use mixed mediums," the artist says. "As I've said, I need to keep it interesting. It's the reason my creative expression can't possibly be confined to a strctched canvas, regardless of how many mediums I can squeeze onto a palette."

"On any given piece, I'm likely to dip my Series 7 brushes into acrylic, oil, and gouache, as well as pull out the airbrush and Prismacolor pencils. If I can get away with it, I'll add a little Klimt-induced gold leaf, and sometimes, if I'm really letting myself live, I'll incorporate three-dimensional elements like the bark from a tree or the smooth flat stones you'll find embedded in *Miriam of Magdala*."

"Creating beauty is a compelling drive," Nielsen says. "The idea that beauty helps evolve the spirit ignites me. I try to incorporate principles of beauty, harmony, and balance into every illustration, even if it's some phantasmic creature for a role-playing game."

Nielsen cites compensation—or lack thereof—as her greatest professional frustration. "The pay rates for illustration work haven't risen to match the rate of inflation," she says frankly. "Despite the fact that billions are now spent on advertising, the allotment for art has steadily diminished as a percentage of the overall advertising budget."

She adds, "To anyone who remains undaunted by the challenges of a career in art and wants to follow their creative passions deep into the rabbit hole, I say: Draw, draw, draw from life like your life depended on it. Know your anatomy inside and out, and while you continue to master the technical skills, educate yourself on how to be an entrepreneur. Being good at networking and negotiating will make your life a whole lot easier and more enjoyable. You need to know how to create a brand and effectively market and promote yourself."

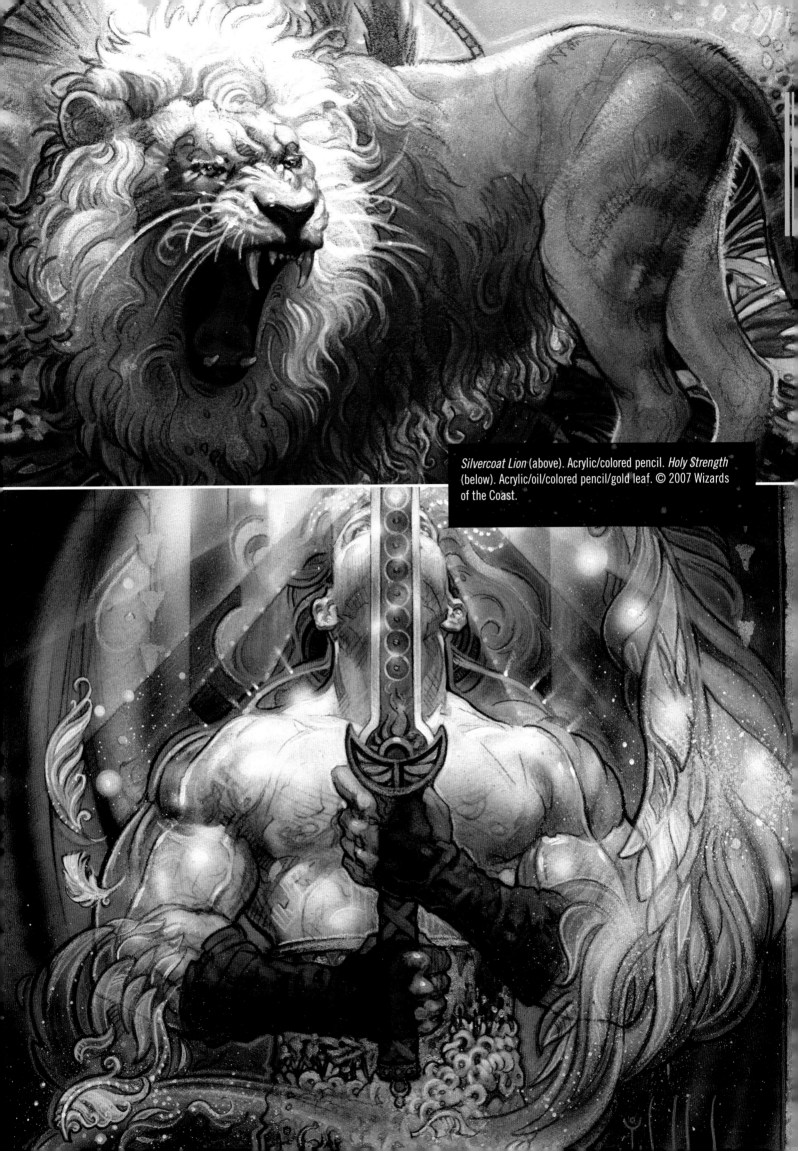

Silvercoat Lion (above). Acrylic/colored pencil. *Holy Strength* (below). Acrylic/oil/colored pencil/gold leaf. © 2007 Wizards of the Coast.

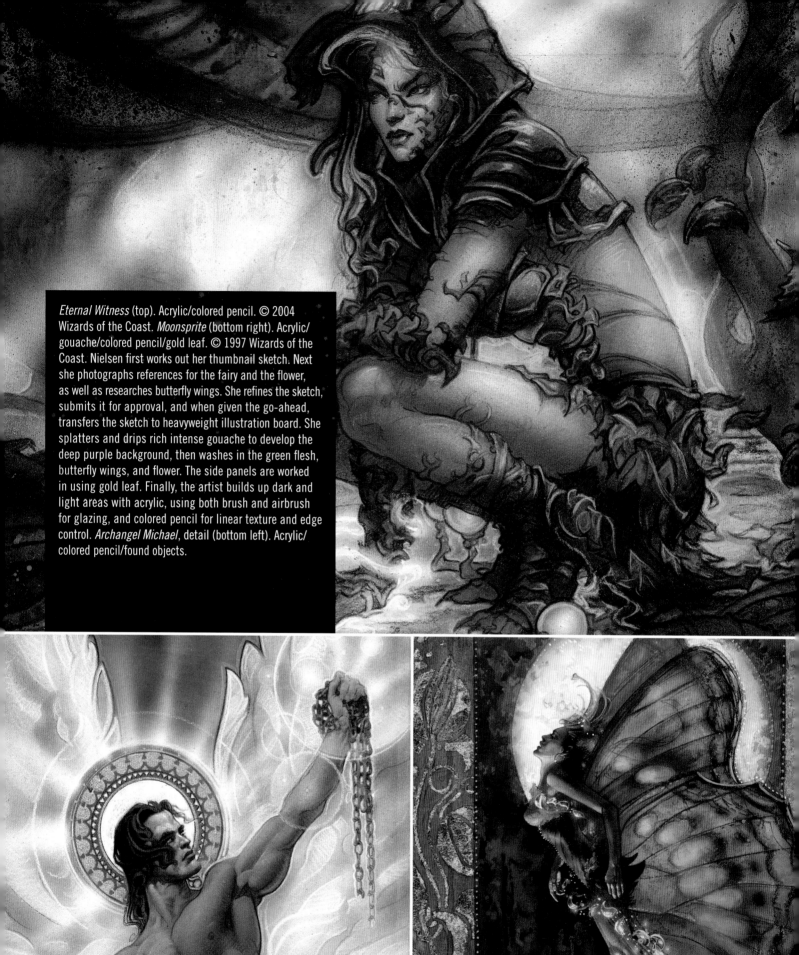

Eternal Witness (top). Acrylic/colored pencil. © 2004 Wizards of the Coast. *Moonsprite* (bottom right). Acrylic/gouache/colored pencil/gold leaf. © 1997 Wizards of the Coast. Nielsen first works out her thumbnail sketch. Next she photographs references for the fairy and the flower, as well as researches butterfly wings. She refines the sketch, submits it for approval, and when given the go-ahead, transfers the sketch to heavyweight illustration board. She splatters and drips rich intense gouache to develop the deep purple background, then washes in the green flesh, butterfly wings, and flower. The side panels are worked in using gold leaf. Finally, the artist builds up dark and light areas with acrylic, using both brush and airbrush for glazing, and colored pencil for linear texture and edge control. *Archangel Michael*, detail (bottom left). Acrylic/colored pencil/found objects.

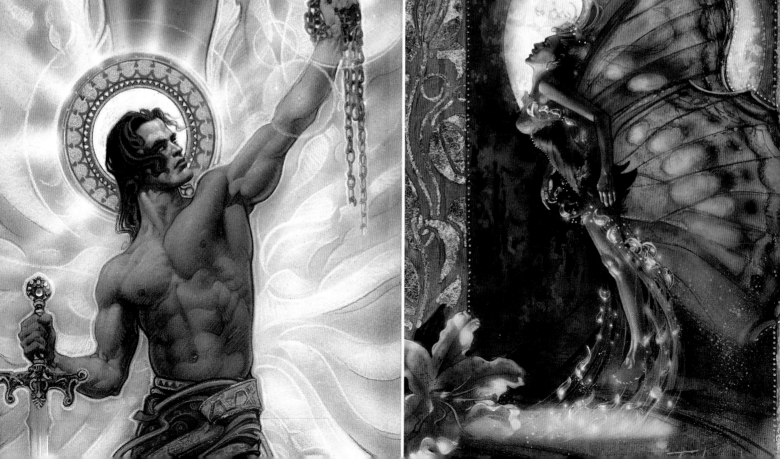

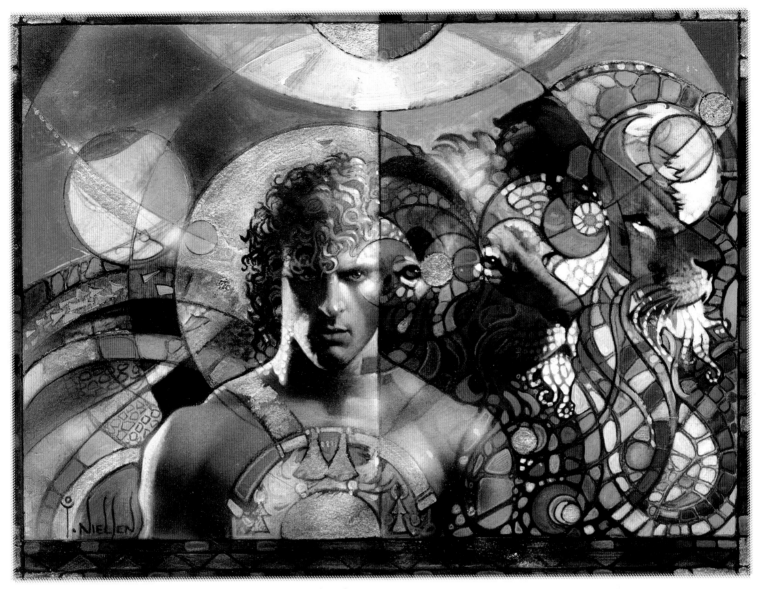

Lifelink. Acrylic/gouache/colored pencil/gold leaf. © 2009 Wizards of the Coast.

But, she warns, "Above all, never, never, never embrace the 'starving artist' stereotype. Don't let any such reference ever cross your lips. Go forth and prosper, and I promise you will never be bored."

Nielsen is currently developing educational materials that teach artists important aspects of technical skill, creativity, and business development. She resides in Temple City, California, with her partner and their four teenagers. To see more of her work, please visit her website and blog at www.tnielsen.com and teresenielsen.typepad.com.

BOB EGGLETON

"Romance and believability are what's important. The scientific content should never draw too much overt attention to itself. I consider myself a Romantic artist."

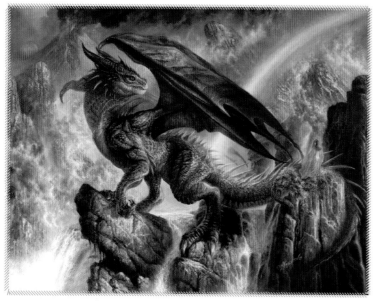

The Rainbow Dragon. Oils. The artist indulges in atmospheric effects and textures, exploring and enjoying the possibilities of his new medium, oil.

"I think sometimes people take themselves way too seriously," says Bob Eggleton. "Science fiction is entertainment. It's fun. If it's not fun, then you're doing it wrong."

For more than two decades, Eggleton has been doing it right—and winning awards—painting science fiction, fantasy, horror, and landscapes on canvas or board. Winner of nine Hugo Awards, twelve Chesley Awards, as well as various magazine awards, Eggleton is considered one of the most commercially successful artists in the science fiction and fantasy field. His art appears on magazine covers, books, posters, trading cards, stationery, journals, and jigsaw puzzles. A fellow of the International Association of Astronomical Artists and of the New England Science Fiction Association, he's also worked as a conceptual illustrator for movies such as *The Ant Bully*, *Jimmy Neutron: Boy Genius*, *Sphere*, and *The Idol*, and thrill rides such as Star Trek: The Experience in Las Vegas.

Between deadlines for book covers and movies, he's managed to squeeze in time to illustrate two books of experimental artwork about dragons: *Dragonhenge* (Paper Tiger, 2002) and *The Stardragons* (Paper Tiger, 2005). Other books of Eggleton's artwork include *Alien Horizons: The Fantastic Art of Bob Eggleton* (Paper Tiger, 2000), *Greetings from Earth: The Art of Bob Eggleton* (Sterling, 2000), *The Book of Sea Monsters* (Overlook TP, 1998), and *Primal Darkness: The Gothic and Horror Art of Bob Eggleton* (Cartouche Press, 2003). Last year saw the publication of *Dragon's Domain: The Ultimate Dragon Painting Book* (Impact Books, 2009) and in 2012, *Bob Eggleton's Ice Age America* (Impossible Dreams Press) will appear.

Earthblood. Acrylics. Eggleton takes a fanciful approach to imagery, using red tones for the background to symbolize the bleeding Earth. His handling of the classically imagined alien ships emphasizes their size and menace.

THE KEY TO FANTASY IS REALISM

Despite Eggleton's professional devotion to science fiction and fantasy subjects, his paintings of imaginary places and things are rooted in closely observed reality. "It's important for artists to get out and see the world around them," he says, "to understand the natural world. I do plein air painting by the ocean and landscape, where I paint in a style completely different from my science fiction work just for the challenge. The more you understand the natural world, the more fantastic you can make the supernatural world. Form will follow function, regardless of whatever planet you're on in the galaxy."

Eggleton continues, "I've climbed sheer cliff faces in Australia and flown over smoking volcanoes in Hawaii." He notes that his outdoor activities have inspired him to produce a group of paintings that pays tribute to the power of nature and to one of his main inspirations,

People of the Wind. Oils. This cover painting for a reissue of a classic Poul Anderson tale, *The Rise of the Terran Empire: Technic Civilization Saga*, Baen Books, 2009, began with a trip to the West Coast of the United States. Eggleton uses reference photos he's taken of the Pacific Northwest coastline and develops a sketch for the background landscape of a distant world. Once the sketch is transferred to canvas, he uses small brushes and subtle color relationships to build up texture on the alien creatures' wings and fur.

J. M. W. Turner. "Turner is incredible," he says. "He wasn't afraid to move his style in other directions. He never settled. He wanted to keep moving, taking Romanticism and merging it with Impressionism. He pushed the limits. He'd take a sketch and decide it was a finished piece. He shook up a lot of artists of the time with his imagery and approach, and saw things in so many different ways. Other artists I admire include Caspar David Friedrich, Arnold Böcklin, and Winslow Homer. But Turner is tops."

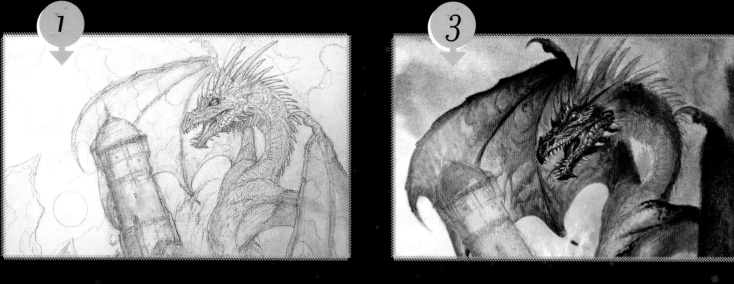

Cover for *Dragon's Ring* by Dave Freer, Baer Books, 2009. Oils.

THE DRAGON'S RING DEVELOPMENT SEQUENCE ① The artist copies his first pencil sketch onto a 24 x 36 in (61 x 91 cm) stretched canvas. Eggleton tends to work loosely on sketches and then tighten up when drawing in the image. ② He blocks in the basic color underpainting in oil. At this point, the artist says that he begins to feel like the painting is really beginning to take shape. ③ The artist concentrates on details, beginning with the head area. He feels that the head defines the rest of the creature and therefore prefers to finish the detail here first. The artist based the image on a few paragraphs from the book.

If you look closely at an Eggleton painting, you'll notice that he manages to create dreamlike scenes by means of detailed realism, textural effects, and intensely saturated color.

Eggleton's decision to become an artist was fueled by many different sources. "Originally, the plan was to get into comic books and strips but, even when I was young, I figured out that it was not such a glamorous life, even though I admired the great art of Jack Kirby, Joe Kubert, and Jim Steranko," he explains. "Because I painted, I was attracted to science fiction and fantasy cover art. An early meeting with artist Eric Ladd, who at the time, in 1977, was getting a lot of attention, convinced me I could do this. So even before I went to Rhode Island School of Design, I knew where I was going.

"Later, as I got to understand painting, I studied the works of those artists I've mentioned and many others, including Fredric Edwin Church, John Martin, John Constable, and Ivan Aivazovsky. I paid special attention to masters of landscape, sea, and nature, to fuel my artistic muse. I tend to think if one wants one's very own style, one needs to study the older masters in museums, rather than contemporary artists because ultimately, it makes you more original."

BEGIN WITH A PENCIL

"Romance and believability are what's important," the artist says. "The scientific content should never draw too much attention to itself. I consider myself a Romantic artist."

In keeping with his Romantic urges, Eggleton takes a loose, painterly approach to science fiction subjects. He believes in the sense of wonder that science fiction evokes, and he tries to keep himself constantly open to its creative possibilities. "Sometimes the work just seems to paint itself. You step back and say, 'Wow, I didn't expect that to happen.'"

Last to Leave. Oils. This personal work was based on a small pencil sketch. Eggleton worked it up into a tour de force of high-key color contrasts for the sheer pleasure of the work.

His favorite tool is the pencil. "Everything begins with a pencil line. Beyond that, it's all subjective. You can do anything with a pencil to start a work of art." He advises beginning artists, "Draw. Draw a lot. Remember, a computer is only a tool; it cannot make you a better artist."

Uncharted Stars. Oils. The artist enjoys adding the detail of an intergalactic cat-carrier to this cover for an Andre Norton book.

Realm of Cthulhu (Haggopian). Oils. Enjoying the opportunity to paint H. P. Lovecraft's famed monster god, Cthulhu, Eggleton uses Arnold Böcklin's Isle of the Dead for inspiration. He pushes the contrasts and color relationships to heighten the dramatic impact of the painting while ensuring that the monstrous image of Cthulhu dominates the composition, both through color and the use of repeated curving architectural motifs.

If he has any frustration with the field, it is in being stereotyped. "I dislike labeling or putting something into a proverbial box. Also, there is a competitive nastiness that has evolved between some artists in the last few years that I attribute to a by-product of art-school thinking."

GETTING BACK INTO OILS

The artist is a great believer in following his own instincts. "The best advice I ever received was: 'Do what you love and the rest will fall into place.'"

Eggleton's greatest delight is the freedom he experiences in the work. "I've been able to do whatever subject I like. I'm fairly free as an artist. Getting back into oils in 2007 was a major step forward for me. In art school in the late 70s I worked in oils. Then, to make a living, I was sure I needed to work in a medium that dried faster, like acrylics, and the favored look then was airbrushy stuff. I grew tired

of airbrush and gave it up because I wanted the more tactile feel of real painting, but I stayed with acrylics. You get a rich look from them because they're 10 percent pigment and 90 percent gel medium. But acrylics also change hues and chroma when they dry because they dry by the evaporation of water from the pigment. This doesn't happen when oils dry, so no volume or impact is lost. Oil paints, which are more like 80 to 90 percent color pigment and 10 to 20 percent oil medium, explode with color in sunlight."

"I'd see a few other guys like Jim Gurney doing oils and thought it looked nice, but mainly what convinced me was watching my wife working fastidiously with oils. She's the one who urged me on to oils again. It was like relearning bike riding. You never completely forget how to do it. Oils are just richer and nicer looking."

HAPPY ACCIDENTS

The artist says that he goes into a trancelike state when he's working. "Once I've got the concept figured out, I can just paint away and talk to people. It's like being on automatic. Things happen: happy little accidents." Eggleton keeps his left brain distracted by music—the 70s pop-rock group ABBA is a favorite—or movies. "Some artists can't take any noise," he says. "Not even music.

Firestorm. Oils.

But often, when doing a very detailed piece, I'll put a movie on so I can sort of half watch it. Usually it has to be something familiar, so my left brain basically goes into autopilot while my right brain works."

STAYING ACCESSIBLE

Eggleton is happy to allow fans to observe his process and has participated in group workshops at conventions. When he was guest of honor at the Worldcon in Chicago in 2000, he set up his easel in the lobby of the main hotel and produced a painting in one day. "I think it's very important for writers and artists to be accessible to the people who like their work," he says.

"It really is the fans who make it all possible. And I love their feedback. I need it. Artists and writers, whether they admit it or not, are the biggest approval seekers in the universe."

THREE COOL FACTS ABOUT BOB EGGLETON

- His nickname is Zillabob.
- He was cast as an extra, running for his life, in the 2002 Toho film *Godzilla against Mechagodzilla*.
- A minor planet, discovered in 1992 by Spacewatch at Kitt Peak National Observatory near Tucson, Arizona, has been named for him: 13562 Bobeggleton.

To see more of Bob Eggleton's work, check out his blog and website at bobsartdujour.blogspot.com and www.bobeggleton.com.

Eye Monster. Oils.

Inspired by 1950s monster films, Eggleton paints a humorous take
in high-key color on the notion of "first contact" between an astronaut

Derelict (top). Oils. Eggleton establishes the color relationships early and allows them to dominate the composition. To heighten their impact he avoids distracting the viewer's attention through details of hardware or contrast. *The Chinese Whisper* (below). Oils. CD cover for The Downliners Sect (2008). To balance his rough sketches of a dragon for the CD cover for this British cult group, Eggleton adds a lion image he has seen in London's Trafalgar Square. Much later, the artist saw an old photo of the group members in Trafalgar Square taken in the early 1960s, showing them posed in front of the very same lion.

DON MAITZ

"No one teacher is likely to teach you everything you need to know. You can learn a lot just walking through a museum or reading a book that interests you. Teachers save you time, and help you avoid misjudgments. But your best teacher is personal experience."

Escape from Below. Oil on Masonite. One of Maitz's favorite color techniques, luminosity, is showcased in this science fiction work where the artist pushes the complementary color relationships and contrast, intensifying their impact.

Don Maitz knows his way around a color wheel. The artist uses color as the vehicle for his powerful effects, pushing the contrasts, the complements, and the tonality until his paintings don't merely speak—they sing.

In addition to beautiful color, Maitz's award-winning science fiction and fantasy work is distinctive for its high energy, sly wit, and wealth of detail. Says the artist: "The challenge is always to bring out intangible things such as pride, adventure, happiness, mistrust, greed, or sorrow through imagery."

While Maitz's fantasy work is known for its hard-edged attention to realistic detail, paradoxically, the artist often takes a softer approach in his science fiction paintings, indulging in painterly effects while keeping the hardware in focus.

Maitz was drawn to fantastic art by a love of literature. Like many artists, he began drawing as a kid, copying comic book panels to see if he could improve upon them. He later attended the Paier School of Art in Connecticut.

Lonestar 2. Acrylic on Masonite. The artist uses color to direct the viewer's eye to his subjects jetting along in space in an affectionate tribute to science fiction pulp art. This painting was commissioned as the cover of the convention program for the World Science Fiction Convention (Worldcon) in 2007.

"No one teacher is likely to teach you everything you need to know," Maitz says. "You can learn a lot just walking through a museum or reading a book that interests you. Teachers save you time, and help you avoid misjudgments. But your best teacher is personal experience."

He graduated with top honors in 1975, by which time his work had already appeared in Marvel Comics. In over thirty years he has taken only a brief break from his work—to join the circus—when he taught art for a year at the Ringling College of Art and Design in Sarasota, Florida.

KEEPING AN OPEN MIND

"An artist's growth requires an open mind," Maitz says. "Tastes shift through exposure. Some things stick in the artist's consciousness and evolve into technique until a style emerges. The more the artist engages his interests and absorbs, the more individual and sophisticated the art becomes. At least, that is the hope."

"I believe that influences grow, especially if an artist wishes to hone his or her abilities and evolve. Very early on, I was influenced by cartoon characters, followed by comic book superheroes. Then I became enamored of the work of Frank Frazetta and Jeff Jones. The Yale University Art Gallery had an exhibit of Edwin Austin Abbey while I was studying at the Paier School, and I was profoundly inspired by it. That led me to discover Howard Pyle, N. C. Wyeth, Frederic Remington, Maxfield Parrish, and other Golden Age illustrators. I also admired the works of J. C. Leyendecker, Norman Rockwell, James Bama, Roger Dean, and more contemporary artists. Then my focus went backward historically to pre-Raphaelite and Victorian painters. I learned useful techniques from the paintings of William [Adolphe] Bouguereau and Renaissance artists. Old Russian painters also captured my admiration. I've since spent time with contemporary plein air painters and frequented many museums, and each time I've come away with a greater range of awareness."

Maitz has worked in Hollywood as a conceptual artist on two feature films: *Jimmy Neutron: Boy Genius* and *Ant Bully*. His scroll of awards reads like an artist's wish list. A perennial Hugo candidate, he won the award in 1989

Babe in the Woods. Acrylic on Masonite.

The artist has remained active in the advertising world as well, with commissions from Eastman Kodak, NBC, and Captain Morgan Rum. Perhaps his most widely known creation is the "Captain" character of the Captain Morgan Rum advertising.

CREATING IMAGES THAT SELL

"Book covers are about selling a product," says Maitz. "You must boil down an entire novel to one image that encapsulates the action, mood, characters, and environment, and do so in a way that entices people to purchase and read the content. The key to this process is to find those sparks in a manuscript that will trigger an image that attracts an audience."

and again in 1993, and was artist guest of honor at Lone-StarCon 2, the 1997 World Science Fiction Convention. Maitz has received ten Chesleys from the Association of Science Fiction and Fantasy Artists, the Inkpot from the San Diego Comic-Con, the Howard Award from the World Fantasy Convention, a silver medal from the Society of Illustrators in New York, and a bronze medal from the National Academy of Fantastic Art. His art has been exhibited at such museums and galleries as the Delaware Museum and the New Britain Museum of American Art.

Two books of the artist's work, *First Maitz* (Ursus Imprints, 1989) and *Dreamquests: The Art of Don Maitz* (Underwood Books, 1994), have become collectors' items, and his work has now been translated into electronic media in the form of screensaver/wallpaper software. His images have appeared in *Spectrum Annual* publications, *Fantasy Art Masters* (Watson-Guptill, 1999), *Infinite Worlds* (Virgin Books, 1997), and *The Chesley Awards Book* (Artists and Photographer's Press Ltd., 2003). Maitz's popular Pirates! calendars continue to sell out each year.

He continues, "Think of freeze-framing a motion picture at the precise moment that suggests what the whole movie is about, and you get an idea of the process. I usually take notes and dog-ear pages as I read the manuscript. From the notes, I research related visual aspects of the story and make small, rough drawings, including compositional elements, simplified figures, and the mood of my interpretation of the 'frozen moment' that intrigues me."

SHAPING IDEAS

"My procedure follows a traditional approach," the artist says. "A few modern tools are injected here and there, but what it comes down to is pigments applied to a surface. I start out with a graphite pencil and white paper. It's unusual for me to pick up a brush and just start painting away on a blank canvas or panel until completion."

"I shape my idea with loose, small sketches of black-and-white patterns. When I find something that rings my bell, I enlarge the drawing and inject more information. I then paint a fairly detailed color sketch. I generally color the sketch in acrylics because they dry fast."

Wizard's Pets. Oil on Masonite.

Transcendence. Oil on Masonite.

"Next I make a line drawing to the size of the finished work. This line drawing is carefully done and may include information from models, props, and other reference materials. These all come into play to allow the patterns, overlapping shapes, and areas of detail to be resolved.

"I transfer the drawing with graphite or oil paint to the intended surface. I'll use Masonite panels, stretched linen, or canvas for oil, and watercolor paper for water media. At an early stage the artwork might look a bit like paint-by-numbers, without the numbers," Maitz explains.

"For my first paint layer I develop the outline into a monochromatic underpainting usually over a toned surface. This one color is used to enhance the drawing with areas of hard and soft edges. I add other colors in a background-to-foreground manner."

"Oil paints are my favorite, as they allow me to be flexible in application and there is a richness of color and depth that I enjoy more with them than with other mediums," he notes. "But I've also used acrylics and airbrush in my work. The idea, intent, and mood of the work dictate the medium. I add detail as I go along, frequently referring to my research material, as I sharpen, blur, lighten, darken, glaze, and scumble areas for texture."

When asked how long it takes to finish a painting, Maitz says it depends on the painting. Complicating his timing is the fact that he usually has overlapping projects in development at the same time, or as he puts it: "lots of pots on the boil."

Out of the Woods. Oil on Masonite.

He says, "I always take as much time as I can get, because it is rare that one cover commission is being done start to finish without work being done on other commissions, or other aspects of the self-employed lifestyle happening in the midst of a job."

Maitz explains, "When I've got a deadline looming, the work day can get much more challenging—and sleep much more scarce! So many factors aren't predictable:

researching elements, finishing elements, just getting it right. The time it takes from work to work varies."

"I might add finishing elements weeks later, even if the deadline is up and the art is off to be reproduced. I may decide to make changes to the painting *much* later. When you consider the fact that oil paints take a year to dry completely before a final coat of varnish is applied, you could add one year to the original painting-time equation," he notes.

To see more of Don Maitz's artwork, visit the artist's website, www.paravia.com/DonMaitz.

Fairy Rebels. Oil on Masonite. Preliminary pencil sketches lead to color studies, followed by a careful line drawing on tracing vellum to refine ideas by referencing photographed models. Maitz next moves to an acrylic Masonite panel, mixing gesso with acrylic ultramarine blue to create a mid-value toned surface, upon which he transfers his sketch by tracing over a sheet of absorbent bond paper placed facedown between the drawing and the Masonite surface.

Earth Song. Acrylic on Masonite.

Never a Dull Moment. Oil on Masonite. Maitz's love of humor and human situations in the midst of fantastic settings can be appreciated here, where a disabled pirate is shown sharing expertise and stories with a younger crew member sharpening the ship's armory. The artist's careful attention to line work and color results in high impact in the contrast of shiny metal against the carefully controlled color relationships of the sails, mast, and woodwork.

Fire Rose. Oil on Masonite.

Wizard's Approach. Oil on Masonite.

Maitz's spouse, artist and writer Janny Wurts, was the model for this fantasy painting, posing in a rented costume. With two artists living together, and a stockpile of costumes, there's always a model in the house. They occasionally work together, as can be seen on The Collaborative Worlds of Janny Wurts and Don Maitz (www.paravia.com).

The genesis of this scene—and the reference for the painting's background—was Maitz's photographs of a castle, emphasizing odd angles and perspectives. He rented a costume from a theatrical warehouse, had his model perch on a tilted plank, then used clamps and string to provide a windblown look. Carefully arranged lamps suggested light sources within certain elements of the painting that provide a regal, otherworldly air to the magician's arrival.

GREGORY MANCHESS

"I like telling more with less. It allows the brain to be a part of the process, and asks the viewer to join in the story. This is why my brushwork is so edited, direct, and yet informative. Nail the values, and color is no longer important. Nail the shapes and forms, and detail isn't necessary."

C3PO. Oil on linen. © and ™ LucasFilm Ltd. All Rights Reserved. Used Under Authorization. "This was a chance to bring some quiet dignity to the bumbling character of C3PO," says Manchess. "I remember hearing George Lucas in a radio interview talking about his ideas for the initial *Star Wars* story. He discussed how it's not really a story about a young farmer turned Jedi, but rather a story arc of adventures in this distant galaxy seen from the perspective of two robots. That put a new angle on the story for me, and so I painted a Sargentlike depiction of Lucas's main character."

Strictly speaking, Gregory Manchess is not a science fiction and fantasy specialist. He is a top-level illustrator—a generalist—in demand by the largest markets, publications, and media. What's more, he's a fine artist whose work hangs in galleries and private collections. Finally, he's an artist's artist whose bravura technique and generosity have inspired a legion of artists with whom he's shared painting tips. Occasionally, he employs his formidable skills illustrating science fiction and fantasy because of the great affection he feels for the field.

Born in Kentucky, Manchess holds a BFA from the Minneapolis College of Art & Design. However, he considers himself mostly self-taught when it comes to drawing and painting. He worked with Hellman Design Associates as a studio illustrator, then left to go freelance in 1979. Rhythm and timing, emotion conveyed through brushwork, and a balance of concept and aesthetics are essential components of his technique.

Canticle. Oil on linen. Cover painting for the novel by Ken Scholes, Tor Books, 2009. Using N. C. Wyeth's illustrations for *The Black Arrow* for inspiration, Manchess makes a series of preliminary sketches, keeping his concept for the final painting in mind. Before he applies paint to linen, he works out his color schemes, value shifts, and atmosphere. He also works out how to add color to the snow so that it doesn't become too monochromatic: The artist wants to show bold colors against cool-colored snow. To spread the color out and make the piece come alive, he adds a touch of cool to the warm colors and some warmth to the cool.

Knight. Oil on linen. Cover painting for *The Knight* by Gene Wolfe, Tor Books, 2004. Irene Gallo, art director. Influenced by Golden Age illustrator J. C. Leyendecker's portrait of Robert E. Lee for the *Saturday Evening Post*, Manchess aims for a similar bold, posterlike style for this book cover.

Manchess's art has been featured on the covers of many publications, including *Time*, *National Geographic*, *Atlantic Monthly*, and the Major League Baseball World Series Program. He has illustrated spreads for *Playboy*, *Omni*, *Newsweek*, *National Geographic*, and *Smithsonian* magazine, as well as countless advertising campaigns and book covers. For Federal Express he created five paintings for the company's corporate headquarters, which were also reproduced and distributed as posters and greeting cards. He has illustrated movie posters for Paramount, Columbia, and Disney, and done conceptual work for *The Chronicles of Narnia*. His portrait of Sean Connery was used in the climactic moment of the Warner Brothers' film *Finding Forrester*.

The artist's interest in history and dynamic figurative work have made his paintings a favorite choice of *National Geographic* on many occasions, including the magazine's 1996 article "David Thomson: The Man Who Measured Canada" and illustrations for "The Wreck of the C.S.S. *Alabama*." The artist has also completed a large portrait of Abraham Lincoln and seven major paintings depicting his life for the Abraham Lincoln Presidential Library and Museum in Springfield, Illinois.

"I was interested in stories at an early age, but found that I grabbed more attention with my drawings," Manchess recalls. "My earliest memories of art are from the newspaper funnies and comic books. I knew from this exposure that strong drawing meant capturing attention. It had definitely captured mine."

He adds, "All the early television I was exposed to was in black and white. So going to see movies in Technicolor was a family event. Everyone piled into my dad's '59 Caddy—the one with the Flash Gordon tail fins—to see

Princess of Mars. Oil on linen. In this personal piece based on *A Princess of Mars* by Edgar Rice Burroughs, Manchess highlights the princess in a compact scene that lends urgency to the action. He crops the composition tightly, saying, "We just don't need to see everything about the figures. What we need to see is what will stimulate the viewer's imagination."

films like *Ben Hur*, *West Side Story*, *Barabbas*, and *Gone with the Wind*. Those movies captivated and amazed me."

"But the color of comics could still hold my eye and draw me into the story. The Flash Gordon strips, full of adventure and technology and vibrant color, could entrance by the simplest comic panel."

He adds, "Comics fed my growing interest in painting and storytelling. They ramped up my desire to say more with less. Drawing trained my eye and painting opened my interest in the narrative. By the time I found the paintings of Frank Duveneck and John Singer Sargent, at nineteen, I had drawn for countless hours, training myself to use form and value."

Manchess notes, "As I said, all the early television I was exposed to was in black and white. Growing up in this 'black-and-white world' with moments of color scattered through it like autumn leaves taught me the beauty of value and simplicity."

Above the Timberline. Oil on linen.

"I like telling more with less," he says. "It allows the brain to be a part of the process, and asks the viewer to join in the story. This is why my brushwork is so edited, direct, and yet informative. Nail the values, and color is no longer important. Nail the shapes and forms, and detail isn't necessary."

Recently, the artist finished ten mural paintings for a *National Geographic* exhibition on an actual pirate ship; "Real Pirates: The Untold Story of the *Whydah*, from Slave Ship to Pirate Ship," will tour fifteen cities.

Manchess's work has also been recognized in the children's book market. His first book, *To Capture the Wind*, by Sheila MacGill-Callahan (Dial, 1997), was nominated for a Caldecott Award, followed by *Nanuk: Lord of the Ice*, by Brian Heinz (Dial, 1998). His second collaboration with Heinz, *Cheyenne Medicine Hat* (Creative Editions, 2006), a story about wild mustangs, was released to wide acclaim. Other books include *Giving Thanks* (Candlewick, 2005), *The Last River* (Mikaya Press, 2005), and *Magellan's World* (Mikaya Press, 2007). He has painted seventy covers for Louis L'Amour novels and short stories.

Manchess has been awarded both gold and silver medals from the Society of Illustrators in New York as well as the prestigious Hamilton King Award and the Stephan Donabos Award for best illustration of the year. The artist has also received awards from The Society of Illustrators in Los Angeles and *Artist's Magazine* and been featured in many issues of *Communication Arts*, *Step-by-Step Graphics*, and *Spectrum: The Best in Contemporary Fantastic*. He is included in *The Illustrator in America, 1860–2000* by Walt Reed (Collins Design, 2003). Manchess has exhibited his work in New York and Hong Kong.

The artist teaches a weeklong, intensely focused painting course along with eight other artists in Amherst, Massachusetts, known as The Illustration Master Class. He lectures frequently at universities and colleges nationwide and gives workshops on painting at the Norman Rockwell Museum in Stockbridge, Massachusetts. A two-hour video of Manchess's painting process is available as a download from www.conceptart.org. To see more of his artwork, visit his website at www.manchess.com.

Conan of Cimmeria. "All of the Conan paintings were painted for *Conan of Cimmeria: Vol. 3*, a special-edition volume of collected Robert E. Howard stories, published by Wandering Star Press," says Manchess. "The challenge here was to not have them look like so many other Conan paintings, yet still be faithful to the text. After reading the stories, I realized that the character is more of a lithe, intelligent, deliberate fighter than a muscle-bound moron swinging an ax. I wanted the art to reflect that. I used my influences from the Golden Age illustrators, seeing the whole project as if they had gotten the same assignment. I wanted to give it that kind of raw-but-honest appeal, with respect for the character, and of course, for the fans."

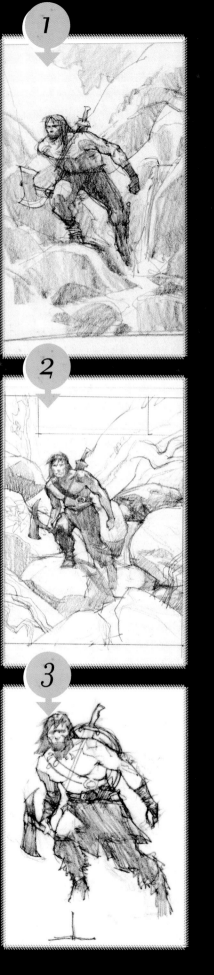

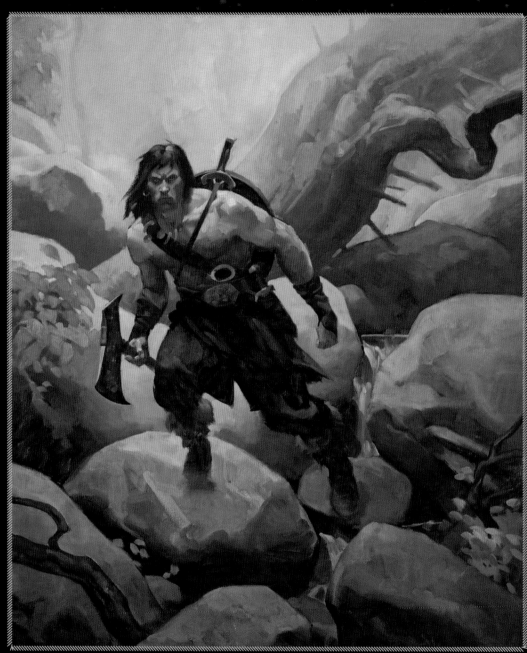

Untitled *(Conan Creek).* Oil on linen. Slipcase painting for *Conan of Cimmeria: Vol. 3*, Del Ray, 2005.

CONAN CREEK DEVELOPMENT SEQUENCE ❶ The first thumbnail sketch gives an overall feeling of Conan's character. Manchess wants to give a hint of the subject's nomadic nature, plus a little background that suggests landscape as bold as Conan, with a little fog to lend some mystery. He searches for the right body posture to indicate curiosity and confidence. ❷ A more finished sketch develops the background. ❸ With the background established, Manchess separates the figure to concentrate on posture and attitude. When satisfied, he projects both drawings onto his canvas to incorporate them into the final drawing.

Untitled *(Conan Lightning)*. Oil on linen. Interior illustration for *Conan of Cimmeria: Vol. 3*, Del Ray, 2005.

CONAN LIGHTNING DEVELOPMENT SEQUENCE ❶ In this first loose thumbnail sketch for a battle scene, Manchess works up a centered composition as homage to Frank Frazetta's iconic Conan illustrations. ❷ In his second sketch, Manchess refines the positions of the figures within the composition, building masses within the frame of the illustration. ❸ For the final sketch, Manchess shoots reference photos for the figures. Establishing where he wants Conan's figure to dominate the rectangular scene, he then piles foreground figures in front, building from middle ground to foreground. Next he designs the position of the background figures, building from middle ground to background. The final lightning bolt, seen in the final painting, connects the visual line through the painting.

Untitled *(Conan Stairs)*. Oil on linen. Interior painting for *Conan of Cimmeria:*
Vol. 3, Del Ray, 2005.

CONAN STAIRS DEVELOPMENT SEQUENCE ❶ After making several preliminary
sketches, Manchess makes his final sketch for a complicated composition showing
Conan running up some archway stairs. He sketches the figure first, the background
second, dealing with the challenge of showing what the subject is running after, the
architecture of the space, and the dramatic lighting. Manchess notes, "Conan has his
back to us here. I had done a couple of other paintings where we see Conan's back.
I like showing the strength of his back and think that it lends mystery and power to
his figure. Not many people have painted him from that angle, but Frazetta did it once
or twice and I always loved that!" ❷ Final painting.

Wizard of Oz. Oil on linen.

WIZARD OF OZ DEVELOPMENT SEQUENCE Manchess paints a boldly updated version of the iconic characters from the Frank L. Baum classic tale, *The Wonderful Wizard of Oz*. "I painted this for an illustration master class I was teaching in 2009. One of the class assignments was to do a painting based on a steampunk version of *The Wizard of Oz*. This interested me so much that, as a result of this painting, I'm writing my own version of the first *Oz* book! Each character has taken a new twist and been 'upgraded' for today's audience. Even Toto is not to be trifled with." ❶ Dorothy as a goth girl. ❷ Scarecrow as a highwayman. ❸ The Tinman as a large robot. ❹ The Lion as a saber-toothed cat.

Sky People. Cover for novel by S. M. Stirling, Tor Books, 2007.

SKY PEOPLE DEVELOPMENT SEQUENCE Manchess says that he released "my inner ten-year-old" for this cover painting. "All those years of studying 60s science fiction covers drove the vision for this one," he notes. "The story hearkens back to those kinds of old-school adventures, so I could create a strange, steamy jungled Venus with dinosaurs, saber-toothed cats, and a crashed spaceship." ❶ This is one of a series of thumbnails Manchess sketches to determine elements of the composition. ❷ The artist toys with including a swamp in the picture for the added interest of its reflections. However, the story is not about a swamp. ❸ He opts for the final sketch of jungle surroundings. Note the changed placement of the vine in the foreground. ❹ The painting in progress.

Directory of Contributors

BROM
www.bromart.com

JIM BURNS
Represented by Alison Eldred
www.alisoneldred.com
c/o Alan Lynch Artists
www.alanlynchartists.com

KINUKO Y. CRAFT
www.kycraft.com

MARTA DAHLIG
blackeri.deviantart.com

DAN DOS SANTOS
www.dandossantos.com

BOB EGGLETON
http://bobsartdujour.blogspot.com

SCOTT M. FISCHER
www.fischart.com

DONATO GIANCOLA
www.donatoart.com

REBECCA GUAY
www.rebeccaguay.com

JAMES GURNEY
www.jamesgurney.com

BRUCE JENSEN
www.brucejensen.com

AVI KATZ
www.avikatz.net

CAMILLE KUO
camilkuo.cghub.com

TODD LOCKWOOD
www.toddlockwood.com

DON MAITZ
www.paravia.com/DonMaitz

GREGORY MANCHESS
www.manchess.com

TOMASZ MARONSKI
maronski.itsartmag.com

STEPHAN MARTINIERE
www.martiniere.com

PETAR MESELDZIJA
www.petarmeseldzijaart.com

PAVEL MIKHAILENKO
www.mpavelart.com

TERESE NIELSEN
www.tnielsen.com

GALAN PANG
www.galanpang.com

JOHN PICACIO
www.johnpicacio.com

DAVE SEELEY
www.daveseeley.com

GREG SPALENKA
www.spalenka.com

SHAUN TAN
www.shauntan.net

CHARLES VESS
www.greenmanpress.com

KEN WONG
www.kenart.net

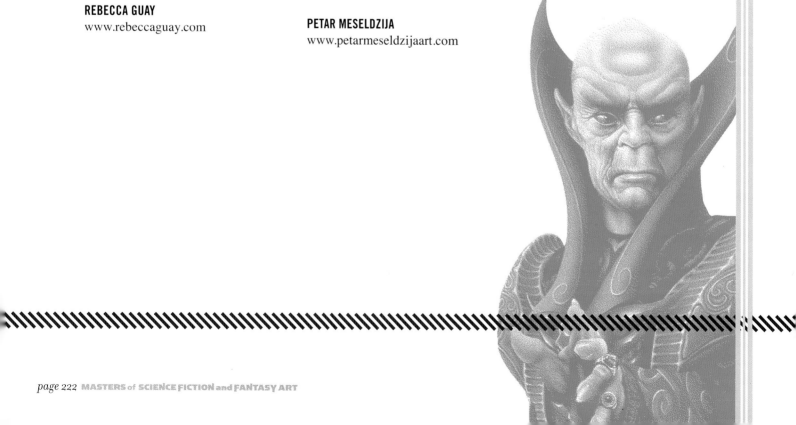

acKNowLeDgMeNTs

This book would not have been possible without the help of many people—and most of you know who you are—but when it comes to gratitude, it never hurts to repeat oneself. To all the artists in this book, my thanks for your generosity and cooperation, with special shout-outs to John Picacio, Jim Burns, and Dave Seeley: Many thanks for great suggestions and much-appreciated encouragement along the way. Ditto for the gang at *LOCUS* magazine: Liza Groen Trombi, Amelia Beamer, Kirsten Gong-Wong Buchanan, Francesca Myman, Carolyn F. Cushman, and Tim Pratt, for aiding and abetting. My thanks, also, to my brother, Mark Haber, and my sister-in-law, Janet Cowan, for unstinting support and well-timed coffee breaks. Thanks as well to Jonathan Strahan and Chris Sokolowski for being, respectively, in the right places at the right times. Special thanks to Carol Carr, for not only floating alongside but occasionally jumping into the water. And, of course, my thanks to my spouse, Robert Silverberg, for keeping the cats fed and the trains running on time.

KAREN HABER

OAKLAND, CA *August 2010*

ABOUT THE AUTHOR

Karen Haber is the author of nine novels, including *Star Trek Voyager: Bless the Beasts*, and coauthor of *Science of the X-Men*.

She is a Hugo Award nominee, nominated for *Meditations on Middle Earth*, an essay collection celebrating J. R. R. Tolkien that she edited and to which she contributed an essay. Her recent work includes *Crossing Infinity*, a young adult science fiction novel of gender identity and confusions.

Her other publications include *Exploring the Matrix: Visions of the Cyber Present*, a collection of essays by leading science fiction writers and artists; *Kong Unbound*, an original anthology; an essay for *The Unauthorized X-Men* edited by Len Wein; and *Transitions: Todd Lockwood*, a book-length retrospective of the artist's work.

Her short fiction has appeared in *Asimov's Science Fiction* magazine, *The Magazine of Fantasy and Science Fiction*, and many anthologies, including *Sandman: Book of Dreams*, edited by Neil Gaiman; *In the Name of the King*; and *The Best Time Travel Stories of All Time*, edited by Barry N. Malzberg.

With her husband, Robert Silverberg, she co-edited *Best Science Fiction of 2001* and 2002, and the *Best Fantasy of 2001* and 2002. Later she co-edited the series with Jonathan Strahan through 2004.

She reviews art books for *Locus Magazine* and profiles artists for such publications as *Realms of Fantasy*.

Visit her website at www.karenhaber.com.